GEORG SIMMEL
Rembrandt

GEORG SIMMEL

Rembrandt

AN ESSAY IN THE PHILOSOPHY OF ART

Translated and Edited by

Alan Scott

and

Helmut Staubmann

With the Assistance of K. Peter Etzkorn

Routledge
Taylor & Francis Group
NEW YORK AND LONDON

Published in 2005 by
Routledge
Taylor & Francis Group
270 Madison Avenue
New York, NY 10016

Published in Great Britain by
Routledge
Taylor & Francis Group
2 Park Square
Milton Park, Abingdon
Oxon OX14 4RN

© 2005 by Taylor & Francis Group, LLC
Routledge is an imprint of Taylor & Francis Group

Printed in the United States of America on acid-free paper
10 9 8 7 6 5 4 3 2 1

International Standard Book Number-10: 0-415-92669-6 (Hardcover) 0-415-92670-X (Softcover)
International Standard Book Number-13: 978-0-415-92669-0 (Hardcover) 978-0-415-92670-6 (Softcover)
Library of Congress Card Number 2004026658

Library of Congress Cataloging-in-Publication Data

Simmel, Georg, 1858-1918.
 [Rembrandt. English]
 Rembrandt : an essay in the philosophy of art / Georg Simmel ; edited, translated, and with an introduction by Alan Scott and Helmut Staubmann ; with the assistance of K. Peter Etzkorn.
 p. cm.
 Includes bibliographical references and index.
 ISBN 0-415-92669-6 (hardback : alk. paper) -- ISBN 0-415-92670-X (pbk. : alk. paper)
 1. Rembrandt Harmenszoon van Rijn, 1606-1669--Criticism and interpretation. 2. Art--Philosophy. I. Title.

ND653.R4S513 2005
759.9492--dc22 2004026658

Taylor & Francis Group
is the Academic Division of T&F Informa plc.

Visit the Taylor & Francis Web site at
http://www.taylorandfrancis.com

and the Routledge Web site at
http://www.routledge-ny.com

CONTENTS

ACKNOWLEDGMENTS

For answering our questions — linguistic, historical, or philosophical — we would like to thank Howard Caygill, Efstathios Mavros, Kate Nash, Antonino Palumbo, Pier-Paolo Pasqualoni, Roberta Sassatelli, and Ernst Wangermann. We would especially like to thank Austin Harrington and Jeremy Tanner for their detailed comments on parts of the draft translation, and Brigitte Scott for patiently giving a professional translator's response to numerous linguistic queries. Any remaining errors are the responsibility of the editors.

TRANSLATORS' NOTE

This volume is a translation of Georg Simmel's *Rembrandt, Ein kunstphilosophischer Versuch* published by Kurt Wolff Verlag, Leipzig, in 1916. We have endeavored to give a close-to-text rendering of the work. To try and make the piece seem less linguistically complex or more "modern" to contemporary English speakers than the original would now appear to a contemporary German speaker was not our aim, and indeed would have entailed précising rather than translating the work. Furthermore, so much of the argumentative, and/or rhetorical, power of *Rembrandt* lies in Simmel's sometimes idiosyncratic use of language that it is vital to convey as much of the feel of the original as possible, rather than simplifying and risking even greater distortion. The text presents many of the familiar problems that arise when one is translating German terms. One particular case is "*Seele*" (soul), the religious connotations of which are stronger in English than in German. We have therefore chosen to translate *Seele* as "inner life" (rather than the alternative "psyche") on those occasions where a secular sense appears to have been intended. But this is, of course, a fine judgment and we lose the occasional intentional ambiguity of Simmel's usage. In Simmel, *Dasein* does not have the sense that it has come to acquire via Heidegger. He uses the term partly interchangeably with *Existenz*, or even *Leben*. We have thus translated it as "being," "existence," or "life" (or, in one case, "presence") depending upon the context. However, the reader should note that the subtitle "Concrete Existence and Religious Life" in chapter 3 is "Das konkrete Dasein und das religiöse Leben." German poses questions of gender bias in quite different ways and places than in English. Simmel, unsurprisingly, uses masculine terms in cases where gender-neutrality would now require a different formulation. In a text of this age it would be both an

anachronism and dissemblance not to follow the author's lead. Finally, *Rembrandt* is a desperately difficult text to translate — perhaps one reason why it has not been attempted before — and errors, including errors of judgment, have no doubt been made. But we hope to have given English-language readers a reasonably unencumbered access to an important work.

EDITORS' INTRODUCTION

Georg Simmel on Rembrandt: Understanding the Human beyond Naturalism and Conventionalism

Rembrandt: An Essay in the Philosophy of Art was Georg Simmel's last monograph. The first edition appeared in 1916, two years before Simmel's death. Although it was published in the midst of the First World War, the work was a great success and had the highest circulation of any of Simmel's works during his lifetime. After this study on Rembrandt, Simmel published, in 1917, a slim volume called *Grundfragen der Soziologie* (Basic questions of sociology), which later became known as his "little sociology," and he prepared one more book for publication, a collection of essays he called *Lebensanschauung: Vier metaphysische Kapitel* (Life-view: four metaphysical chapters). The latter appeared in 1918, but only after his death in September of that year.

All of these publications reflect a fundamental shift in Simmel's thinking, which began with *Goethe,* a lengthy study on the German classical writer and poet, published in 1913. The changes within Simmel's thinking are associated with the *Lebensphilosophie* movement, which had a strong impact on him, and which he in turn influenced significantly. It was wrestling with issues in the theory of art that paved Simmel's way to this new theoretical movement. "By the detour of reflections on the essence of art," Simmel wrote in a letter to his friend the philosopher Heinrich Rickert, he gained several of his general theoretical insights, which he then incorporated into his so-called formal sociology, into his general theory of culture, and into a number of other fields (see Gassen and Landmann 1958, 101). This shift was also reflected in his lectures on education at the University of Strasbourg,

and in essays on the theory of history, especially "Vom Wesen des historischen Verstehens" (On the nature of historical understanding). On another occasion, borrowing a formulation by the poet Friedrich Schiller, Simmel indicated that he used his intellectual engagement with art as a sort of treasure trove for his theoretical concerns: "Through the morning door of beauty you entered the land of knowledge" (Simmel 1989 [1892], 369).[1] The art of Rembrandt was one such "morning door of beauty" leading Simmel to a new approach to the "land of knowledge" in the field of the sociocultural sciences.

A work on a famous artist by a sociologist immediately raises a set of expectations in the reader. We expect to see an emphasis on the contextualization of the artist's work, on the material conditions (social and organizational as well as technological) of the production of that art, on the facilitating and constraining role of patronage, on the significance of reception, and so on. We may also expect to find a critique, and historical relativization, of the notion of "genius" as an explanatory category, and an insistence that aesthetic categories have little or no autonomy from social ones. *Rembrandt* dashes each and every one of these expectations. Simmel's purpose is a long way from that which we have come to understand as the sociology of art. What is more, this is not a book *about* Rembrandt in the sense that, for example, the historian Simon Schama's celebrated *Rembrandt's Eyes* is a book about Rembrandt. Unlike Schama, Simmel is not concerned with the historical context, nor indeed is he much interested in the person of Rembrandt. Nevertheless, the title, taken together with its subtitle, *Ein kunstphilsophischer Versuch,* which we have translated as "An essay in the philosophy of art," is not misleading, but gives a very accurate account of Simmel's project. This is a philosophical *essay* in the strict sense of that term. It is a series of reflections for which Rembrandt's *work,* but not his life or the conditions in which that work came into being, is the occasion. This all but absolute neglect of context and biography is moreover consistent with the methodological recommendations that Simmel has to make: it is the object before us — its meaning, its significance — not the historical context, nor even the psychological state or motivations, or the intentions of its creator, that must be the prime focus of our attention.

A clue to Simmel's concerns here can be found in the preface, where we find a formulation of a common maxim in his work that is nearly identical to that found in one of his most famous early essays: "Die Großstädte und das Geistesleben" (Metropolis and mental life, 1903):

But now here too emerges that which can only be the entire task of these observations: from each point on the surface of being, however much it may appear to have merely grown in and out of this surface, a plumb line can be dropped into the soul's depth such that all of the most banal superficialities are in the end bound to the final determinations of the meaning and style of life via indications of direction.[2]

Here, in the Rembrandt book, Simmel uses the same metaphor:

What has always seemed to me to be the essential task of philosophy — to lower a plumb line through the immediate singular, the simply given, into the depths of ultimate intellectual meanings — will now be attempted on the phenomenon of Rembrandt (3).

To understand this clue we must recognize the significance of the life/form distinction for Simmel. With this distinction, which extends back to his early study of Kant, Simmel generalized the Kantian idea that what appears to us as reality is a formation of "empirical data;" that is, sensuous contents acquired by means of the categories of understanding. Subsequently, this principle became a fundamental axiom for the methodological differentiation of scholarly fields, which Simmel applied to sociology in distinguishing between forms of reciprocal interactions and their contents (e.g., economics, religion, intimacy, art, etc.). Just as the preface to *The Philosophy of Money* (1990 [1900]) argued that a monetary value is not an economic fact per se — as theoretical essentialism would have it — but can be subjected equally to the forms or categories of psychology, sociology, history, aesthetics, and philosophy, so the preface to *Rembrandt* outlines how the experience of art can be approached in different ways. This view respects and acknowledges the legitimacy of different levels of investigation, and resists the reduction of any one level to any other. However, what we find now is a stronger emphasis on a specific conception of life and its implications, one of which is the genuine and undeniable reality of the value and experience of art: "the primary, indivisible fact that the work is present and exercises a direct effect on the recipient" (1). Scholarly attempts to deal with art and its experience can take what Simmel calls the low road — that is, the analytical approach via either scientific means, such as research into the historical conditions, or the isolation of single traits of the work of art and their impact on the experience of art. The latter asks such questions as: "How strict or relaxed [is] the form, the schema of the composition, the use of spatial dimensions, the

application of color, the selection of subject matters, and much more" (1). "However," Simmel continues, "it must be clear to scholarly conscience that neither of these routes leads to an understanding of the work of art as such, or to its actual inner meaning"(1). The second intellectual possibility in approaching art is philosophical — in Simmel's terms the high road—which likewise does not touch upon the experience or value of art itself. The philosophy of art attempts to reconstruct the totality of art with intellectual means, however, and "Rembrandt's art appears particularly suitable as an object of such investigation because deep within its objective character that irrational experience which most closely approximates music is accomplished: that is to say, its own nature remains untouched by analytical aesthetics, on one side, and by a conceptually and metaphysically advanced way of thinking on the other"(2).

The main rationale of what follows on the remaining 160 or so pages after the preface is the convergence of Rembrandt's art with a specific antimechanistic, antirationalistic, antiinstrumental, and antiessentialist conception of life. The consequences for human sciences are far-reaching. We shall briefly take up just two examples: first, the expression and understanding that is the communication of inner life, and, second, Simmel's reformulation of his concept of individuality under the influence of *Lebensphilosophie* and how this is, according to him, expressed in Rembrandt's art. For the mechanistic view, life appears as a summation of its discretely and substantially describable contents. In contrast, for Simmel, "the entire human being [...] is inherent in each separate experience"(6). These two conceptions of life (as sequence and as ever-present totality) find their respective expression in classical and in Renaissance art, on the one hand, and in the art of Rembrandt on the other. The depiction of a movement provides an example of this difference. While the Renaissance portrait is an expression of the self-contained being or timeless qualitative essence of an individual — which incidentally corresponds epistemologically to conceptual realism — Rembrandt's portraits display the historical dimension of the represented person. It seems to be a paradox that despite Rembrandt's often sketchy style, the person in his portraits is much more accessible to the viewer than is the case in the classical portrait with its greater clarity and detailed representation.

Such a concept of understanding is further developed in Simmel's analysis of artistic procreation. How is a piece of art accomplished as a unity in time and space? The common answer to this question is that the artist has an idea in mind that is then realized more-or-less satisfactorily. Such an understanding of artistic procreation is in Simmel's view

an expression of classicist rationalism. To avoid the rationalistic fallacy of an idea guiding an action — compare Weber's definition of action and the whole phenomenological action-theory tradition — Simmel uses the metaphor of a germ cell. Just as there is no similarity between cause and effect, there is no morphological similarity between the germ cell and the fully developed living being; instead, the relation is purely functional. While Rembrandt unfolds his portraits out of such a transphenomenal intuition describable with the analogy of a germ cell and thereby procreates it anew, a lesser artist performs a move-for-move depiction of rationalistically conceived elements.

This can again be generalized into a theory of social action, as Simmel's account of the nature of the group portrait illustrates. Just as a single portrait figure can be developed, so to speak, from the internal and the inner logic of an unfolding artistic impulse or rationalistically out of exterior factors, so the unity of a composition can be constructed out of rationalistic criteria for which symmetry is the most obvious example or, alternatively, by a sort of organic growth. In the latter case, the vital interactions of individuals constitute a higher form of social unity. For Simmel this is expressed and accomplished in highest perfection in Rembrandt's *Night Watch*. In other words, an organic unity is bound to certain contents whereas something nonorganic requires an abstract form to appear as a unity. The latter is an atemporal logical connection of contents. The isolation of such contents and consequent recombination leads to something particular, but never to individuality.

With respect to individuality, we can observe a shift from the early formulation of "the crossing of social circles" to the notion of the "individual law." The theory of individuality that Simmel had developed in his early work "Über soziale Differenzierung" (On social differentiation) (1989 [1890]) can be understood in terms of the well-known formula of the crossing of social circles. Social differentiation leads to a plurality of overlapping communication and interaction units. Each individual is characterized by a specific combination of memberships in such circles, which in turn determines his or her identity. In the study on Goethe we find a chapter where Simmel explicitly criticizes such a quantitative-mechanistic concept of individuality and contrasts it with what he now calls "qualitative individuality" and later shifts to the expression "individual law." About one-third of the Rembrandt book deals with the question of individualization and its opposite, the general or typical common to a plurality of human beings and how this finds it aesthetic expression in fashion or an art style. Whereas a Renaissance portrait attempts to display a figure as a type, and thereby attaches a general significance to that person, his or her social rank,

and so on, Rembrandt's portraits represent an alternative means of grasping a human being: the comprehension of individuality. Rational psychology and sociology represent a refined scientific analogue to the Renaissance portrait in that they use general concepts such as social variables or psychological character traits to identify a person. A human being, however, is not to be understood as a mere combination of such variables. A person without, or better, beyond, such qualities is not lacking identity, but rather has this "beyond" as the prerequisite of a purely *individual* identity. For Simmel, as humans we possess the special ability to understand the individual beyond exterior general categories, and this he characterizes as a particular capacity of understanding. Rembrandt developed this ability to the highest degree, thus making visible the deficiencies of rationalistic approaches.

It is with such an inner capacity that we are able to perceive what Simmel calls the individual law. In the Kantian tradition, the position taken by scientific-psychological knowledge binds the concept of law to something general to which an individual is subjected, such as rationality or morality. Simmel's individual law breaks this connection, arguing that there is a general imperative and necessity to be found within an individual, or an individual case. Rembrandt's portraits display precisely the individual law of the person depicted. Not only is individuality in this sense ungraspable by exterior concepts; it is in direct conflict with the latter. Increased individualism in modernity had to overcome natural and social determinations: "naturalism and conventionalism are merely the artistic reflexes of the two violations [*Vergewaltigungen*] of the nineteenth century: nature and history," Simmel wrote on another occasion (1996 [1911], 341). The one subjugates humans to natural laws analogous to a falling stone; the other degrades them to an administration of the heritage of the genus (see 1996 [1911], 341–42). A good part of social and cultural theories in the twentieth century are the heirs of the intellectual reflexes of naturalism and conventionalism. Contemporary debates are still struggling with the contradictions inherent within these traditions. With *Rembrandt*, Simmel clearly demonstrates a path beyond them. It is this achievement of Simmel's, most clearly elaborated in his study on Rembrandt, that will challenge and hopefully reshape the current debates in the social and cultural sciences.

This emphasis on life and on the individual law, rather than on form and the crossing of social circles, gives *Rembrandt* its distinctiveness and is the source of its potential interest for contemporary debates, not merely concerning the sociology versus the philosophy of art, but also with respect to cultural studies and the study of visual culture (see, for

example, the provocative and contentious comments on photography in Chapter One). From the point of view of much current analysis, Simmel's insistence on the autonomy of the aesthetic sphere and his meticulous avoidance of reference to social, cultural, or autobiographical context may seem hopelessly retrograde, even reactionary. The maintenance of the distinction between the aesthetic and the social realm, usually traced to Kant's influence, is generally thought of as the antithesis of modern sociocultural analysis. But whether in the end we choose to agree or disagree in part or wholly with Simmel's position, in making the case he incidentally levels a series of criticisms against what has become something of an orthodoxy within both sociology and cultural studies, and in particular against the refusal to proffer aesthetic judgments, thus leveling out, or disguising, qualitative differences. As a consequence, we may be said to run into the relativistic danger of "making a genuine virtue of whatever is deemed a virtue somewhere or other" (Hollis 1998, 122). It is in this context that the analysis in *Rembrandt* stands, for example, diametrically opposed to Pierre Bourdieu's sociology of aesthetics, and many of Simmel's arguments can be read as a critique of the position that Bourdieu above all now represents. Take the following statement of the principles said to underlie a sociology of cultural works:

> The science of cultural works has as its object the correspondence between two homologous structures, the structures of the works (i.e. of the genres, forms and themes) and the structure of the literary field, a field of forces that is unavoidably a field of struggle. The impetus for change in cultural works — language, art, literature, science, etc. — resides in the struggles that take place in the corresponding fields of production. (Bourdieu 1993, 183)

Bourdieu is careful to avoid reductionism (the two fields are held separate — why they should then be "homologous" is unclear — and he allows a sociohistorical autonomy for both the field of production and the individual artist). Nevertheless, to Bourdieu's own question, "What happens to the work in all of this?" (1993, 182) Simmel would answer: it gets lost. One of the most intriguing arguments of *Rembrandt* is that, paradoxically, the more we seek to contextualize an object, the further removed we become from it. Contextualization — at least in its conventionally sociological or psychological form — consists in the ascription of secondary characteristics to that object, such that the object itself becomes the mere assemblage of such secondary qualities:

The more we go into details, the more we find traits that we also encounter in others. Perhaps not continuously, but in many respects going into details and individualization are mutually exclusive. If this conceptual differentiation appears surprising, then this is because of our mechanistic habit" (50).

Thus, from Simmel's perspective, a sociology of *cultural works* — as opposed to a sociology of material production or the use and reception of those works — is an oxymoron. From such a perspective, Bourdieu's approach (for all its sophistication) might be said to support Simmel's contention in that it is not the photograph, the piece of music, and so on, that is the object of analysis, but rather the struggles surrounding those works, whether among producers or consumers, within their separate fields. The work itself is in constant danger of becoming merely an instance of a general rule, or the bone of a particular contention.

But Simmel's rejection of conventional approaches to contextualization goes beyond the critique of what are, for him, mechanistic and rationalistic methods. The kind of nonmechanistic link between an intellectual product and its context via the notion of authorial intention, in the manner of Quentin Skinner's influential methodological proposals for the history of ideas (Skinner 1969), is likewise not Simmel's purpose. Even the artist or intellectual's intentions — like the facts of his or her life — are at one removed from the work. In contrast, for Simmel, the creator is no longer divisible from that which he or she has created, but assimilates them fully into their work. "Schopenhauer's incomparable individuality," writes Simmel, "does not lie in his 'personal' circumstances [...] because each of these traits is merely typical. Rather, his individuality, that which was personal and unique about Schopenhauer, is *Die Welt als Wille und Vorstellung*" (50). Likewise, Rembrandt, for Simmel, *is* the work, not the person or the intention lying behind the work.

Simmel's methodological outlook has implications for the substantial interpretations that he offers here of what would generally be thought of as "social facts." This is illustrated particularly in his discussion of piety as displayed in Rembrandt's paintings, etchings, and drawings. Here piety is said to be an inner quality unrelated to social position or to any substantive belief or dogma. At one point Simmel comes tantalizingly close to affirming a kind of Protestant ethic thesis by explaining piety — and Rembrandt's ability to convey it — in terms of the this-worldly asceticism of Dutch Protestantism. But this expectation, too, is dashed with Simmel pulling back from such a conclusion by arguing that even Calvinism has one external necessary condition:

dogma. In contrast: "the people of these peaceful, familiar paintings do not *have* religion as the objective content of life, rather they *are* religious" (117). Their piety is detached even from belief, from dogma.

Clearly, Simmel's arguments here again turn on the life/form distinction and on the notion of the "individual law." The sociocultural sciences are the sciences of appearance, of surface, of form. The metaphors of movement and flow that appear repeatedly in the text convey this. If life is flow, then secondary analysis can merely capture the deposits on the riverbed, the cuts made into the landscape, while the river itself remains a cartographical and mathematical abstraction. And herein lies the fascination of Rembrandt for Simmel. Rembrandt is the painter of life, of movement, of flow. The sitter's past, present, and future are captured in a single moment in a way that necessarily eludes scientific analysis (and indeed — at least to this degree — other artists). It is difficult to resist the impression that Simmel is identifying with this painter of life, particularly in the moving section on the art of old age. Quoting Goethe, Simmel remarks, "Old age is the step-by-step withdrawal from appearance" (96). And *Rembrandt* itself is in this sense a work of old age where Simmel's intellectual project withdraws from appearance, from form.

So, with *Rembrandt* we have a text from one of the key figures in the history of sociology that appears far removed from the course that the sociocultural sciences have subsequently taken. This raises the question of whether what Simmel offers us here is an antisociocultural science, or one in a different mode. But the work is of interest beyond such disciplinary questions. It contains, for example, an extended discussion of Simmel's views on death; views that significantly influenced Heidegger, and thus the course of twentieth-century thought. Likewise, the discussion of religion provides insights into the complexity of the relationship between inner piety and externalized devotion. But finally, this is not least a book about Rembrandt in Simmel's particular sense: it is a book about the artist's works. Simmel seeks again and again to draw our attention away from the general and toward the object itself, not as a "doorless wall" (98) but as a point of access to individuality, to inner life.

SIMMEL'S PREFACE TO THE FIRST
EDITION OF 1916

Scholarly attempts to interpret and evaluate a work of art must choose between two paths. The point at which these two paths diverge is the experience of art; the primary, indivisible fact that the work is present and exercises a direct effect upon the recipient. From here on, the analytical direction, so to speak, takes the low road. It seeks, on the one hand, the historical conditions that allow the work to be classified intelligibly in terms of the history of art. On the other hand, it draws out from the work of art its specific effective forces: the degree of rigidity or relaxation of the form, the schema of the composition, the use of spatial dimensions, the application of color, the selection of subject matter, and much else.

It must be clear to the scholarly conscience, however, that neither of these routes leads to an understanding of the work of art as such, nor to the work's actual inner meaning. This is first because every historical development already assumes the *value of the material's contents* for the sake of which one is concerned with its history in the first place. The reason why we are interested in the historical development of the art of Rembrandt, rather than that of any odd botcher, obviously cannot be deduced from the [historical] development itself; rather, it is grounded in the felt value [*Wertempfindungen*] we associate with his art as such, quite independently of the conditions of its coming into being. The aesthetic analysis to which I have referred, however, focuses upon the work of art as it exists or came to be. Even if aesthetic analysis had thoroughly worked out each component of a painting, this would fully capture neither the creation of nor the impression made by the work of art. Of course, the completed phenomenon of art can be categorized according to a variety of formal and substantial points

of view, thereby splitting it up into a number of separate impressions. But no more than a living being can be animated from the dismembered limbs on a dissection bench can a work of art, reassembled out of such elements, be recreated and thereby rendered intelligible. The work of art corresponds neither to the spatial juxtaposition of aesthetic elements, nor to the historic sequence from which it derives, because that which is decisive is something quite different, namely the creative *unity* that perhaps makes use of such elements as a means, or perhaps attains its tangible, analytically describable surface via them. It is the greatest of self-deceptions to conceive of the essence of art and the rank ordering of its works as the mere addition of these categories. Nor is it the case that the *impression* of the work of art is equivalent to the sum of the impressions of all the aspects and qualities that analytical aesthetics renders prominent. Rather, what is decisive is again something quite holistic emerging out of, or standing above, that singular impression. Any psychological analysis of how this or that color, or color contrast, works, how easy or difficult it is for us to grasp particular forms, what we associate with particular given realities, and the like, simply leaves out the central inner effect that is specific to each artistic experience as such.

In my opinion, this experience finds no place at all within forms of scientific knowledge. The experience exists only in the mode of immediate emotional response, and that we must, as it were, leave standing there untouched. This experience forms the watershed on which the two directions of knowledge of art divide. Namely, while analytical treatment of the individual determinations of the work of art and of its reception remains, so to speak, *in front of* the creative and receptive unity of experience, another direction of reflection, which one may call philosophical, begins *behind* it. The latter presupposes the totality of the work of art — as existence and experience — and seeks to locate the work of art within the full range of the movements of the soul, within the height of conceptuality, within the depth of world-historical antitheses. Rembrandt's art appears particularly suitable as an object of such investigation because, grounded deep in its objective character, that irrational experience that most closely approximates music is accomplished in its purest form; that is to say, through the indifference of the nature of his art toward analytical aesthetics, on the one hand, and toward conceptual and metaphysical ways of thinking, on the other. Yet precisely because of this, the experience becomes an ever more evenly and indivisibly effective precondition of the individual problems with which this way of thinking has to deal.

Herein lies the limit of discussions that throw no light on the work of art historically, technically, or aesthetically, but seek philosophically that which one might refer to as its meaning; the relationships between its innermost core and its outermost periphery in which the world and life are circumscribed by our concepts. That primary experience of a work of art, from which these philosophical extensions are nourished, is not to be determined with objective clarity. No matter how much theory may derive from it, it remains in the form of a given fact and is inaccessible to theory. It is not, of course, determined by random chance, but by an individual directedness from which a variety of lines of philosophical thought can be drawn. One may well claim that each of these groups of lines lead to ultimate decisions, but none may claim to lead to *the* ultimate one.

What has always seemed to me to be the essential task of philosophy — to lower a plumb line through the immediate singular, the simply given, into the depths of ultimate intellectual meanings — will now be attempted on the phenomenon of Rembrandt. Philosophical concepts should not always keep only their own company; rather, they ought to give to the surface of existence what they are able to give, and not attach the condition to it, as Hegel did, that this existence as such should be elevated to the level of philosophical nobility. It would be better to leave it simply as it is and subject to its own immediate laws. Only in this way does it become enveloped by the network of lines that mediate its connection to the realm of ideas. Here, the simple fact is that experience of a work of art that I wish to accept as indissoluble and primary. The view that the philosophical guidelines attached to it necessarily converge at *one* ultimate point, and thus must be made to fit into a philosophical system, is a monistic prejudice that contradicts the — rather more functional than substantial — essence of philosophy.

The barriers to the claims for these investigations to which I have referred result, on the one hand, from this methodological orientation, and, on the other, from the experience that is presumed to be reality and individually determined. They may only demand to take their place alongside other starting points and directions, and to complement these even when they contradict them. What expectations these pages satisfy, or leave unsatisfied, cannot be deduced from the program they contain, but only on the basis of the pages themselves. I say this in order, at the outset, to limit expectations and reduce disappointment.

1

THE EXPRESSION OF INNER LIFE

CONTINUITY OF LIFE AND THE MOVEMENT
OF EXPRESSION

Practical necessities and the division of labor between our receptive and productive forces seldom allow us to experience life in its unity and totality, rather than in its individual contents, fates, culminations: the fragments and parts of which compose the whole. This is based on the fact that our life takes the form of a process with changing contents. The contents, however, besides being aligned in a life course, can also be classified into some other sequences: logical, technical, ideal. For example, a viewed object is not only an act of representation, but is located in a system of physical knowledge; a decision is not only an inner act, but represents a certain point in a series of objective moral values; marriage is not merely the experiences of the two persons, but a component of a historical-social condition. Insofar as these discretely emphasized contents count as "the life," the latter appears to be their accumulation, as if they had divided its character and dynamics among themselves. This notion of life as the *sum* of all sequentially occurring moments, however, cannot be articulated within the continuous flow of real life. It replaces life with the sum of those contents of life that can be described according to *substantive concepts*; that is to say, contents that do not count as life, but as ideal or material configurations that have somehow become fixed.

Yet I still believe in another possible perspective on life: one that does not separate the whole and the parts in this fashion, one for which the category of the whole and parts is not applicable to life at all but that takes that life to be a unified process whose nature it is to exist only in moments that can be differentiated by their qualities or contents. The former perspective gravitates toward the "pure I," or the "mind," that are, so to speak, something for themselves beyond emerging contents expressible in discrete terms. It seems to me, however, that the entire human being — the absolute of mind and I — is inherent in each separate experience. This is because the production of changing contents taking place within human subjective experience is the way life is lived. Life does not reserve a somehow separable "purity" and being for itself beyond the beats of its pulse. In a similar line of thought, concerning the "character" of the human being and his individual actions, Goethe once said, "The spring can only be thought of insofar as it flows."[1] We are concerned here with overcoming the opposition between plurality and unity; the alternative is that the unity of diversity either lies beyond unity — as something higher and more abstract — or remains in the sphere of diversity and assembles itself piece by piece out of its elements. *Life*, however, cannot be expressed in terms of any of these formulas, for it is an absolute continuity in which there is no assembly of fragments or parts. Life, moreover, is a unity, but one that at any moment expresses itself as a whole in distinct forms. This cannot be deduced further because life, which we attempt to formulate here in some way, is a basic fact that cannot be constructed. Each moment of life is the whole life whose steady stream — which is exactly its unique form — has its reality only at the crest of the wave in which it respectively rises. Each present moment is determined by the entire prior course of life, is the culmination of all preceding moments; and already, for this reason, every moment of life is the form in which the whole life of the subject is real.

If one is searching for a theoretical expression of Rembrandt's solution to his problems of movement (whether great or small), it is to be found within the frame of this conception of life. Whereas in classical and, in the narrower sense, stylizing art, the depiction of a movement is achieved via a sort of abstraction in that the viewing of a certain moment is torn out of its prior and concurrent stream of life and crystallizes into a self-sufficient form, with Rembrandt the depicted moment appears to contain the whole living impulse directed toward it; it tells the story of this life course. It is not a part of a psycho-physical movement fixed in time where the totality of this movement — of this

internally unfolding event — would exist beyond the artistically shaped being-in-itself. Rather, it makes evident how a represented moment of movement really is the whole movement or, better, is *movement* itself, and not some petrified something or other. It is the inversion of the "fruitful moment." While the latter leads the movement for the imagination from its current state into the future, Rembrandt collects its past into this here and now, not so much a fruitful moment but a moment of harvesting. Just as it is the nature of life to be at every moment there as a *totality*, since its totality is not a mechanical summation of singular moments but a continuous and continuously form-changing flowing, so it is the nature of Rembrandt's movement of expression to let us feel the whole sequence of its moments in a single movement — overcoming its partition into separated sequential moments. From the way in which most painters represent these movements, it would seem as if the artist had seen, either in imagination or from a model, how a certain movement looks, and had arranged, realistically or not, the picture according to this outcome — perfected in terms of the phenomenon that had reached the surface.

With Rembrandt, however, the impulse of movement — as it emerges from its kernel laden with or guided by its inner meaning — seems to form the basis. And out of this germ — this concentrated potentiality of the whole and of its meaning — the drawing develops part by part, just as the movement unfolds in reality. For him, the starting point or the foundation of the depiction is not the image of a moment as viewed from the outside, as it were, in which the motion has reached its portrayable zenith — a self-contained cross-section of its temporal course. Rather, it contains from the outset the dynamic of the whole act concentrated into a unity. The entire expressive meaning of the movement, therefore, lies already in the very first stroke. This stroke is already filled with the viewing or the feeling that is contained, as one and the same, within the inner life and the external movement. In this way it becomes comprehensible that the figures in his sketches and roughly sketched line etchings (even more noticeably than in the paintings) in which there is only a minimum of lines — one might almost say that nothing appears on the paper — still convey an absolutely unambiguous attitude and movement, and hence the inner condition and intention in its full depth and with full persuasive force. Where the movement is regarded in the definitive state of its representation — in the extensiveness of its phenomenal moment — it requires, in principle, a completeness of its appearance in order to achieve its full expression. But here it appears as if a person wants to express the deepest emotion pervading him completely. He does not have to utter the

entire sentence that logically displays the content of that which moves him, since the tone of voice of the first words already reveals all.

Naturally, that does not mean that there is an absolute difference between Rembrandt and all other artists. We are dealing with differences of principle. As principles, they are diametrically opposed, but empirical phenomena represent a greater or lesser degree of participation in both principles. This is all the more evident as movements of expression in the younger Rembrandt commence from the mere exterior perspective. This can be seen, for example (referring now only to the paintings), in the way the bodies move in *The Rape of Europa* of 1632, or the slightly later *Mene Tekel*,[2] or *The Incredulity of Saint Thomas*. Here we find only the fixed appearance of a moment of movement. Then, around the time of the *St. John the Baptist Preaching* (in Berlin),[3] the movement animated from within itself, prepared in the deepest psychic stratum, begins to appear as that which, with variations right up to the 1640s and even the 1650s, finally bestows unique character on his paintings.

His artistic vision contains not simply the visibility of the gesture in the moment of its representation. His vision's meaning and intensity originate, so to speak, not first on the level of viewing, but already direct and fill the first stroke that, therefore, completely reveals the totality of the inner-outer process (in its characteristic artistic inseparability). Just as it appeared as the deeper formula of life that its totality does not exist outside of its individual moments, but, on the contrary, exists fully in each of them because it consists exclusively in the movement through all these opposites, so the moving form in Rembrandt reveals that there is no *part* in the self-realization and self-presentation, as it were, of an inner fate; that, moreover from a certain perspective of representation, each isolated part is the totality of this inner and expressive fate. That he is able to represent each small part of the moving figure as its totality is both the immediate and symbolic expression of the fact that each of the continuously connected moments is the whole life as it becomes personalized in the form of this particular figure.

BEING AND BECOMING IN A PORTRAIT

The same formula that governs the relationship between the representation of a moment of motion and of the expressed whole inner event determines Rembrandt's fashioning of the portrait as such. The ultimate and most general intention of the Italian portrait belongs to the metaphysics of value of classical Greece: the meaning and value of things lies in their *being*, in their clearly circumscribed essence as

expressed in their timeless concept. The tidal flow of becoming, the historical change of forms, development without a definite point of perfection — all this is at odds with the sculptural sensibility of the Greeks, oriented as it was toward the self-sufficient value of form. The Renaissance portrait aims to capture the self-contained being, the timeless qualitative essence of an individual. The traits of the person are spread out, side by side, in a steadfast form; and although, self-evidently, fates and inner development have led to the represented appearance, these factors of *becoming* are excluded. Like the steps of a calculation where only the result is of interest, they are of no concern. The Classical portrait captures us in the moment of its present, but this is not a point in a series of comings and goings, but designates a time-less idea beyond such a series: the trans-historical form of the spiritual-physical existence. On the one hand, this corresponds to conceptual realism, which draws together the spatial and temporal dimensions of existences into a unique construction that is supra-individual and yet real. On the other hand, it corresponds to our idea of external-natural reality. Although in it each phenomenon is strictly causally determined by a preceding one, the latter is completely and selflessly, as it were, dissolved into its effect. As a thing of the past, it has disappeared and became indifferent simply because combinations of other causes might, in principle, have resulted in the same effect. The Renaissance poses the problem of the portrait in terms of this — partly metaphysi-cal, partly physical — analogy. The fashioning of the inner life as such is different, however. In its course the cause is not dissolved into its effect, nor is it irrelevant to its special destiny. Instead, in the total development of the inner life we sense each present as only possible through this specific past (although singular, artificially isolated, partial courses may display that physical analogy). Here the past is not only the cause of what comes later, but also its contents sedimented layer by layer as memories, or as dynamic realities whose effects, however, *could* not have been derived from any other cause and therefore, paradoxical as it might sound, the sequential form becomes the essential form of each present state of the totality of the inner life. Thus, where the inner life determines the giving of form in accordance with its real character-istics, it does not result in its summary manifestation, in that mode of evident abstraction in which all specific traits represent themselves once and for all in a timeless essence.

In the physiognomies of Rembrandt's portraits we feel very clearly that the course of a life, heaping fate on fate, creates this present image. It elevates us, as it were, to a certain height from which we can view the ascending path toward that point, even though none of the content of

its past could be naturalistically stated in the way that portraits with a psychological slant might seek to suggest. This would be of anecdotal or literary interest beyond the boundary of art as such. Miraculously, Rembrandt transposes into the fixed uniqueness of the gaze all the movements of the life that led up to it: the formal rhythm, mood, and coloring of fate, as it were, of the vital process. We are not dealing here — as some interpret Rembrandt — with psychology in paint, because all psychology grasps individual elements or aspects of the totality of the inner process according to their contents. Art, where it is dominated by psychology, presents a logically graspable element, as it were, as representative of this totality.

A psychological orientation always results in a particularization, and thereby a certain solidification that distinguishes itself from the present, but continuously fluid, totality of life within each moment. In Rembrandt, the portrayal of a human being is filled with inner life to the highest degree, but is not psychological. This is a difference of far-reaching consequence that can easily be overlooked if one is not aware of life as a totality at all times, and as a continuously changing form as opposed to each isolated locally determinable individual quality. For only this dynamic of life, but not its content or character describable in terms of individual concepts, is the architect of our traits.

Just as Rembrandt depicts and brings to mind in the single movement of an expression the unity of its history, beginning with the mere potentiality of its first impulse, so he at the very same moment — "in capital letters" — called up the entire course of personal development into the now of intuition [*Anschauung*][4] in such a way that it is immediately given and can, despite and because of its serial form, be read in a peculiarly intuitive manner from this now. In this way, Rembrandt achieved a previously unheard-of artistic expression, though one that cannot become a method or style but remains bound to personal genius. The portraits from Florence or Venice certainly do not lack life and soul. There is a general design however, that tears the elements away from the immediacy of their experience and thereby from the order of their succession. The form is closed off in itself putting only the *results* of the movement of the inner life at our disposal as data. That typifying style does not need to create a similarity of individuals (although admittedly people all look somehow similar in the art of Sienna and, partially, of Umbria), but it effects a special kind of "generality," namely the representation of the ideal individual, accomplished by the *abstraction* from all of its singular moments of life. In the case of Rembrandt, the generality of the individual human being means the *accumulation* of these moments that somehow retain their historical order.

This highly problematic expression comes close to the addition of singular moments that has just been rejected as an expression of life. This is only valid insofar as one accepts such a dismantling as a psychological-technical tradition, and wishes subsequently to reshape it into the totality of life. Rembrandt's portraits contain the movement of the inner life by way of, or as, this accumulation, while the classical portrait is not only timeless in the artistic sense — that is, independent of the location between a before and after in earthly time — but also possesses in itself an immanent timelessness in the ordering of its moments. Therefore, the richest and most moving portraits of Rembrandt are those of old people, since in them we can see a maximum of lived life. In portraits of young people he achieved this only in a few depictions of Titus via a rotation of the dimension: by garnering to a degree the future life with its developments and fates, and by making visible the future succession of events in the present, just as, in the former case, the succession of past events is made visible.

THE SERIES OF PORTRAITS AND DRAWINGS

And now the continuity of the flowing totality of life, as focused in a single portrait, extends beyond it and is expressed, as real and symbolic, in Rembrandt's evident inclination to capture in painting the same individual at various stages of life. Here on a larger scale we feel once more that life cannot be captured in a single moment of its formation. In the series of pictures of a single person — that is, in the fact, that it is *one* series — what the single picture displays in the form of intensity is laid out in succession. Here we must think first and foremost of his self-portraits and how these, precisely as a series, contrast with the classical conception of the human subject. Titian, Andrea del Sarto, as well as Puvis de Chavannes and Böcklin, each left a few self-portraits in which they intended to capture their unchanging nature once and for all. But, as in Rembrandt, just as the whole life flows into each moment that is represented as a picture, so it also flows further into the next painting — dissolving, as it were, into an uninterrupted life in which the paintings rarely denote a pause. It never *is*; it is always *becoming*. I know very well that one wants to deduce the extraordinary number of self-portraits and family portraits from purely artistic problems in painting. Assuming that all these arguments are correct, this isolation of a "purely artistic" interest seems to me to be a completely artificial and quite unreal abstraction in view of the logic of intuition in the representation of human beings in each portrait. This is intelligible only in the context of a period in which a per se

quite justified response to an art that conveyed anecdotal and some nonartistic "ideas" severely damaged the sense for the unity of a work of art. The absolutely unique power and depth with which these paintings situate the whole person would be too strange a coincidence had Rembrandt really only *intended* what today the abstract artistic view calls the "pure artistry of painting." In any case, as the paintings stand there, their painterly problem appears simply to be the depiction of the totality of a human life, but as a problem of painting and not as a psychological, metaphysical, or anecdotal problem. Just as this was already accomplished in individual paintings beyond the crystal-like limits of classicism, so it became, as it were, explicit in or expanded into the majority of portraits of a single model of whom he could not have enough. Through each of, or rather *as*, these series resonates a life that is always new in its unity and always a unit in its novelty. It would be wrong to say that the components of these series respectively "complement" each other, for each of them is in its own right already an artistic and living totality, because the secret of life is just this: that the whole life is in each moment, and yet each moment is unmistakably different from any other. Therefore, the revelation of his view of life, though admittedly such a theoretical formulation would have been far from his thoughts, is only completed through the artistic fact of these series — in the first place through his self-portraits. Finally, this knowledge of life, which speaks through artistic creations and not in theoretical concepts, is once more symbolized in a quite different turn in his series of drawings. However much the expressive movements of his paintings and etchings display the continuity of life, they are as a whole still closed, self-sufficient constructions that place creative life out of itself and within firm boundaries, into the objectivity and detachment of the completed work of art. The drawings, however, are more like stages through which this life passes without a pause. They are like individual consummations of life's course, instead of somehow being dammed up as in the paintings. Many exceptions not withstanding, their totality has a different character from drawings by other masters. Either these are more like paintings — their intention, whether realized or not, is the construction of art that stands for itself, delimited by an ideal frame — or they are sketches or studies, fragments or experiments, whereby their meaning resides in contexts of a technical or preparatory nature.

Rembrandt's drawings draw back from this alternative. They have something characteristically unfinished about them, as if one follows immediately on from the other, like one breath to the next. And yet, none has the quality of a sketch — of pointing beyond itself. It is at the same time totality and being in a state of flux: a quality that is inherent

in our every living act, and only in this. One may well say that only Rembrandt's drawings in their totality reveal the fundamentally living essence of his art, which has concentrated itself in his paintings and their expressive movements into an individual objectification.

RESERVE AND OPENNESS OF THE PORTRAIT FIGURE

Perhaps another characteristic contrast to the Renaissance portrait can now be clarified. I said that the latter displays its character timelessly, as it were, in an abstraction that eliminates the vital movements of its development and only records its pure contents. Whether or not that which is so recorded is represented within this style with utmost clarity, the distinguishing feature of the mystery or enigma of the personality thereby determines its impression to a greater rather than a lesser degree. For there is something dark and clouded in our inner-exterior being that can be understood, as far as this is the issue at all, only through the life process of its becoming. Insofar as the classical portrait achieves the highest self-contained unity of style and impression *above* the level of this flow, the depicted personality acquires the characteristic reserve that is conspicuous in so many Renaissance portraits. There are two remarkable aspects. One is that a feature that in fact is only characteristic of a style, a design principle, which only guides the depiction as such, expands into a quality of the depicted subject. The stylization in the Renaissance, according to whose perspective the model makes its entrance as the timelessness of its pure form, excludes in a certain sense and to a certain degree the understanding of this model's temporally developed life. And whereas each mature artistic observation keeps separate the character of the representation and the character of the represented (the representation of sensuality or of banality does not need to be a sensual or banal representation), here the character or effect of the style as such seems to project itself inevitably upon the personal reality of the object. That the human being is grasped here in a layer of his appearance, keeping us away from a certain intuition of his life, gives the impression of the inaccessibility of this *human being* as a subject beyond art!

And it is no less remarkable that it is precisely the clarity and, in a sense, rationalistic determination of the depiction achieved by this style that shifts its contents so enigmatically and impenetrably! This leads to the far-reaching insight into the divergence between the atemporal logical connection of contents (even if we are dealing here with the logic of intuition [*Logik der Anschaulichkeit*]) and of their vital connection accomplished in the stream of time. It demonstrates

to what extent the understanding of the unity of the former leaves the latter a secret. The effect of Rembrandt's paintings is just the opposite. His figures appear to us as though shaken out of the depths of life, interwoven with long-running strands of fate. None has the typical enigma of the *Mona Lisa*, or Botticelli's *Guiliano de' Medici*, or Giorgione's *Portrait of a Young Man* in Berlin and in Budapest, or Titian's *Young Englishman* in the Pitti Museum. Compared to these, Rembrandt's manner of viewing and presentation is incomparably vibrant, dispersing into the dusk and, so to speak, the infinite — and lacking in logical transparency. For all that, however, the portrayed human subject is so much more accessible to us: illuminated to its depths, an understandably familiar being. This is not at all because Rembrandt's models were less complicated, more straightforward people than those complex Renaissance Italians, possessed as they were of every cultural refinement. Rather, it is because Rembrandt's intricate conception of the human being, which is richer in elements and apparently less clarified, makes the sequence of developments and fates of the inner life that shaped the present appearance emotionally more accessible within, and empathic with, this appearance, and thus more intelligible from within. In the clear harmony and complete balance of the Renaissance portrait, the elements carry each other, as it were. The corporeality, permeated through inner life, is formed according to the laws of the presently graspable. In the Rembrandt portrait the visible elements (besides their immediate relation *to each other*) are shaped as though from a point lying behind them. In their sensory perception we witness the dynamics of life and fate that forged the elements. That which the categories of intellect can express only in a contradictory and highly incomplete fashion is here artistically accomplished: the figures' living process of becoming what they are has been shaped into a purely visual representation without any literary or nonartistic association. The depiction of the immediately observable is absorbed into the temporality of a long life course according to its power and rhythm without the temporal sequence being destroyed by the spatial sequence, or vice versa. The free-floating, self-supporting quality of those other structures is replaced by the stratification of the past. The present is brought into effective contact with the stream of life by the stratification of the past, which somehow loses itself in the dark.

All the art of the Italian *Seicento*, for all its expressive passion, is guided throughout by the tendency toward rationalistic clarity. Each figure should unambiguously display that which goes on inside itself. Each affect should be exactly displayed down to the last detail.

Movements and posture are intensified to an impossible degree, such that the viewer can be in no doubt about the person's sensations. Cartesian "clarity" is sought. A deep inner shamelessness lies therein, even if the subject, conceived of as a real entity, does not touch the area of shame. One has to keep in mind this characteristic of the highly cultivated, and in various ways affected, Italian society — eager for good manners and prestigious representation — in order to properly appreciate the pure spirituality of the miller's son (ill-educated in literature), who, during his period of highest productivity, camped in a miserable inn with a peasant girl as his lover, who would have appeared to those decorative Italians as a barbarian — and who, in the expression of all inner life, displayed the highest degree of tenderness, restraint and modesty that are the unsought traits of the soul when it really appears purely as soul.[i]

Certainly, the seventeenth century rediscovered the inner life in its own fashion, with sharper consciousness than previously, as Descartes did with the *Cogito ergo sum*. Yet, for its expression, the Baroque only possessed mechanistic means, which, to reach their goal, were excessively intensified without being able to grasp inner life, since this was located from the outset at a different level. It is in the nature of life, however, that real understanding is absent as long as one demands from it self-contained clarity. And it is clarified for the observer's view only when its limpidity is developed out of its darkness, which also remains as darkness. This is a relationship that continues, even more generally, in the theoretical field: until now, the striving toward logical-conceptual clarity in the representation and solution of certain ultimate facts and problems always derived from a fundamental uncertainty, which is carried on into the apparent, no less uncertain, results.

In other words, as much as being appears to be more vivid, more certain in form, less problematic than its coming into being, the former still remains puzzling and inaccessible whereas the latter, lacking all these qualities, is nevertheless emotionally much more accessible to us, and we can assimilate and make intelligible each stage of its being. Perhaps this is because understanding is life and only the living can really be understood through life. That enigma, intensified until it becomes uncanny, which is often inherent in the classic portrait, perhaps derives from the fact that it represents a *being* that has been relieved of its temporal vitality. The Rembrandt portrait seems to us to interpret its own puzzles because it emerges out of life that is always becoming and subjected to the fate of time — to that which it nevertheless continues to adhere.

THE CIRCLE IN THE DEPICTION OF A PERSON

Here, of course, a circle seems to be unavoidable. We have before us the depiction of a contemporary appearance in which, if I am interpreting it correctly, the subject's inner history is sedimented, as it were, and its coming into being as lived from within is still vivid, thereby extricating a particular way of being understood. But this temporal and multifarious history is only to be felt through the atemporal, unique view! Let us call this for a moment the "present" of the depiction. In this way this present should be indicated to us via the past; this past, however, is only to be interpreted via the present! This entire form of interpretation — that the appearance should be understood via that which in turn can only be understood via appearance — seems to universally govern the representation of human beings. This is so because this representation is a sensory-spatial one; a mere ordering of colorations that attains meaning for us only because it expresses an inner state, be it general or individualized. In order to know this inner life, however, we have no other source of evidence and no indication other than each given bodily appearance. The circle, though, does not seem to be irresolvable, since it rests on the by no means indisputable assumption that the inner life behind a human appearance becomes accessible to us in a quite distinct and separate way from that in which the body is accessible; that we have an immediate perception of the latter, but deduce the former via a mediation. This is perhaps an artificial separation. Just as the human subject is an indivisible unity — a life as such — that brings forth and forms the so-called bodily and so-called inner life in a unitary process, so, too, the subject as observer has a corresponding capacity to perceive another human being with a unitary function in which sensory and mental perception are no more separated by an internal dividing line than are the corporeal and the inner facts of life.

The dualism of the sensory-corporeal and the inner life is transcended in Shakespeare just as it is in Rembrandt. It would be a gross misunderstanding to construe the love between Romeo and Juliet as the outcome of, and directed toward, mere physical beauty simply because of its lightning-fast appearance. The whole person loves the whole person, and wherever such love appears it is irrational per se, and its miracle is not diminished in the least, or made more transparent, where individuals have come to know one another's entire inner essence over the course of five years. Sensual desire is not the cause, but rather one of the peripheral manifestations of the central fact of love. Just as here one perceives the body and soul of the other as inseparable, so one perceives it with one's own body and soul in their inseparability. The object and the subject of love each have effect as an absolute unity.

It makes absolutely no sense to speak of the body and soul as though they were the parts from which a human being is assembled. Once one has dualistically torn them apart, then it is, of course, difficult or impossible to reassemble them. So long as we assume that we can only "perceive" the physical, then it is by definition the case, and also a *petitio principii*, that we have to "deduce" inner life. Just as we have a complete existence, perhaps we also have a complete perception, which, for some reason, reflection separates, maybe because it does not extend to all dimensions with the same certainty and cannot determine the "soul" as unambiguously as it can the "physical." But this no more excludes that unity than the fact that the point of sharpest vision and the edges of the field of vision have very different degrees of clarity renders optical vision less than a unitary function.

What we call self-consciousness or inner sense is not the spatial or temporal sequence of the perception of individual life elements, but rather the knowledge of the *unity* of all of these or of our person, no matter at what point in our life story it appears, and irrespective of the extent to which we can define more precisely that which we have referred to here as "unity." This function, whose bearer one may call the complete sense — clearly without being able to demonstrate its organ — and which has unambiguously proved itself with respect to one's own person, may also find its object in other persons. The formal unity of perception of such a sense can fill itself with other selves just as it can with its own. Much speaks for this. As we have long known, much of that which we believe we "see" directly is in fact not seen at all, but rather, as one says, is "deduced." Upon closer analysis, that which is perceived purely by the senses melts away more and more into the total impression; it merges continuously into that which is accessible to us in another mode, such that the unity of the object we examine makes the division between the unmediated and the mediated experience seem quite problematic and artificial. Perhaps the Kantian insight that we also perceive the empirical object only by means of the faculty of understanding as it is applied to sensory material points in this direction: if it is true that intuitions without concepts are blind; concepts without intuitions are empty,[5] so it is through their synthesis that unity is created. But this is still a question as to whether or not this unity corresponds to an originally unitary function whose separation into concept and intuition is not even prefigured in its own structure. This motif, with a variation that is perhaps not even so very important, leads to the realization that both the image of a physical as well as an inner person is acquired by means of a fundamentally unitary function that is only in retrospect divided into intuition and psychological

construction via perspectives that to a degree come from the outside. Among works of sculpture, Michelangelo's creations may be said to express this most forcefully. The artist creates a physical form that appears to be objectively pervaded by inner atmosphere, such that a single internally indivisible act of the viewer takes both in. Here physical design and inner meaning are merely two words for one and the same existential fact that is far too unified for its perception to be pieced together out of a purely visual and a purely interpretational function.

The circle whereby the inner life must be comprehended from out of the body, and the body, in turn, out of the inner life, is a consequence and a proof of the *unity* of the phenomenon. Because as soon as a being that is unitary in itself is broken down into a duality of elements, it seems that each must unavoidably be erected upon the other. The circle is not defective; rather, it simply means the fact of that unity. That it is continued through our observation testifies to the essence of the animated body. Of course, in the complications and decompositions of empirical life, the circle does not emerge in its absolute relativity, in uniform simultaneity, but rather as something rendered asunder with an alternating supremacy of one or the other element, suggesting an apparently separate functioning. But perhaps it belongs to the essence of *art* to do justice to unity. Art in particular represents human appearance in such a way that the duality of the physical and the inner conception — of perception and interpretation, into which the inadequate relationship of the observer to the observed often stretches the observation — vanishes. For this reason, the circle vanishes even more clearly in the case of a portrait than in any other objectification of the human being. Here, it also expresses the unity of the formative perception that corresponds to the unity of being.

Subjectively, this unity is continually experienced. It is, however, typically the case that such a unity, at the very instant that it is objectified by means of our inner categories (that is, withdrawn from experience as such), disintegrates into elements that seem to be heterogeneous. The same recognition, the same praxis, immediately strives to reunite that which, by whatever means, has been divided. Taken absolutely, this is for both an infinitely distant point. Only art, whose objectifications preserve the closest relationships to the subjective immediacy of experience, seems to succeed in relatively unrefracted reflections of that unity; not a reunification — a synthesis in which the seams never disappear — but rather the reflection of an original inseparability that is presynthetic because it is preanalytic. Seventeenth-century Italian art theorists traced the value of a portrait completely back to its

psychology. The "*espressione*" was evidently usually the main concern. I would like to believe that Rembrandt would have rejected this completely and that he simply wanted to paint a human being the way they appeared — more precisely, his vision of this appearance — but for him, in his artistry, "appearance" had not yet divided into body and soul. It is interesting that at the same time in Holland, in particular, the soul and the body were so dualistically and radically driven apart within the field of philosophical theory that, in order to facilitate convergence, religion and metaphysics had to be consulted. In the face of the absolute absence of influence exerted by the body and the soul upon one another, Arnold Geulincx had to call upon a personal God who, upon the occurrence of a physical event, brought about the corresponding sensation, and upon an act of will the corresponding bodily movement! Spinoza pulls the threads even further apart in that inner life per se and physicality per se express the complete being, each in its own particular language, in such a way that there is no place in either for the other, so to speak. The empirical harmony between them is only possible because the being expressed in them, or as them, is one that is absolutely unitary, incapable of any differentiation. For art, however, the unity is not something intellectual behind the elements, but rather their immediate evidence itself. In the case of Rembrandt, this unity is not loaded with raging dynamism as is the case with Michelangelo. There it has attained its greatest force of impression because it seems to stand immediately before the rupture. With Rembrandt, it has more the character of a calm self-evidence. In any case, it seems to me undeniable that Rembrandt, at the peak of artistic representation, neither interprets the body through the soul, nor the soul through the body. In art, one should never speak of "means," except in a purely technical sense and with respect to the stages *prior* to the completion of the individual work of art. This would be tantamount to disparagement. The artist may consider with what means a certain effect might be achieved. In the completed work of art, and in its undivided impression that does not lie behind its immediate totality, there is no differentiation and classification according to the intellectual-practical category of means and end. Schopenhauer's proposition is valid: "*die Kunst ist überall am Ziele*" [art attains its goal at each and every given point/moment].[6] Even the solution that immediately suggests itself, namely that each element in a work of art is simultaneously a means and an end for every other element, leaves its essential unity behind, and has recourse to a certain independence of elements that they precisely transferred to the final totality of the work of art. Certainly, this teleological association of elements is deeper and more vivid than the

mechanistic one that clings to the mere juxtaposition of the elements — to the significance of the individual element as such (naturally to be understood *cum grano salis*). In the last instance, however, both are located on the same level: both are external or internal linkages between parts that are understood as separate and do not capture the unity that lies beyond each division as the work of art presents itself in its pure and consummate essence. Perhaps both of these conceptual principles do not behave differently with respect to the problem of life. Perhaps a living creature as such is also a unity that our reflection breaks down into parts and then, in mechanistic or teleological fashion, attempts to weld together again, whereas no such method proceeding from the parts is capable of reaching the primary indivisibility of the thing. Thus, in any case, a work of art cannot be understood as a synthesis of its parts as if they were ends and means, because, as complete, it possesses no "parts" in that independent sense that makes such a synthesis possible. For this reason, the portrait — at least in the perfection achieved by Rembrandt — does not perceive body and soul in an "interaction" such that one would be the means of representing or interpreting the other, but rather grasps the totality of the human being. This does not mean the synthesis of body and soul, but rather their indivisibility.

THE ANIMATION OF THE PORTRAIT

Now, however, the problem in the philosophy of art with which we started reappears. What I said about corporeal and mental unity in Rembrandt's portraits — about the division of these elements merely by later reflection — is, to be precise, in the first place only valid for human beings' living reality. Their appearance *is* not merely a piece of substance colored and formed in a certain way, but rather a complete existence that the viewer — no matter whether out of forces within us of which we were unaware — is really able to imagine as such, as physical-psychic unity. The painting appears to confront us with the mere physical object that is abstracted from it because it contains not the life and soul of the model, but rather its objectively ascertainable physical forms and colors. Thus, the problem arises as to how one can also immediately read the whole inner personality out of the painting. It is pointless to discuss the explanation that we would know from experience the affiliation of a particular inner life to a particular body, and that the painting reproduces within the viewer the latter's association with the former. If the inner image of Ephraim Bonus, or that of Jan Six, shines through with absolute (even when not conceptually

expressible) clarity, then the conjecture that experience had taught us that persons with this particular appearance fixed in the painting always possess a particular inner constitution is completely senseless. I have neither ever seen persons whose appearance is so similar to that of Bonus or Six as to be confused with them, nor would it be tolerable to piece together the convincing correlation between appearance and inner life from disparate experiences of the individual components of such personalities. The view that one explains the animation [*Beseeltheit*] of the portrait via empirical psychological associations is the crudest effort within a common tendency, namely, to seek the workings, the real meaning for the viewer, not in the work of art as it stands within its immediate boundaries, but rather to allow it validity only as a bridge between and indicator of something that, as it were, stands behind it: an image brought forth within the viewer that contains something else — yes, perhaps is other than the viewing of the work of art confined to itself and enclosed within the frame. Is the work of art only a "symbol" — a means — to enable us to imagine something that its given appearance does *not* present? Clearly, the problem of animation belongs to this general question, the principle of which will be discussed later. If it is correct that the portrait — itself a physical entity — is only able to record the physical form of the person portrayed, and if, however, only the living reality of the human being presents its animation as a unity with this form, and if nevertheless the portrait awakens the full idea of animation, so this idea must spring from a source other than within the painting itself even if it is channeled to us via it!

I believe that this conclusion corresponds to traditional concepts, but not to the facts. It appears to me much more to be the case that it is here that the deepest divergence of direction between photography and the work of art opens up. The viewer should not pause over a photograph. It fulfills its duty all the better the more it "reminds us" of the original, eliminating itself so that we subjectively believe that we are seeing the model.[ii] Because it really only reproduces the corporeal, *the photograph* would be senseless or unbearable if it did not direct us via a psychological path back to the full reality of its original. In contrast, the greatest Rembrandt portraits — which are, of course, only one extremity of a range of mixed manifestations of both principles — appear to us as merely the expression of his vision. The observing eye is captured by the appearance as it stands there and does not transpose it back into the category of reality. By this is not meant that solipsism of a particular artistry that renders the human form on the canvas only as an ordering of colored marks, a focus of optical stimuli, a particularly complex ornament. Everything spiritual and extrasensory that inhabits

his figures remains, rightly, intact. But it is all the same whether or not this is valid for persons beyond this vision. It is — as its definitive source — valid for the person within this vision itself. Here, in fact, something is achieved that appeared conceptually impossible: the impression of the material picture alone that only reproduces the corporal cannot be expressed in terms other than that life and soul as they are immediately given with, and experienced in, the material picture, and not by referring back to its real existence in the sitter. This impression must in fact also be acknowledged even where it is for us logically contradictory and psychologically unanalyzable. And I really cannot see myself being in a position to completely resolve this problem. Such an explanation in terms of psychological association fails completely. No less so does the analogy with photography where surface verisimilitude is able to lead beyond itself to the real image of its original; with which move, however, the sphere of art is abandoned in favor of reality. Even accepting that one can only approximate its purity, the principle of art directly demands that the work's content, stimulus, meaning be found within and proffered out of it alone. Once it has absorbed what it wants from worldly reality and the material has become art, then this form can never again become a bridge across which we return to reality. Now, if the portrait, representing the physical physically, radiates — according to the effect on the viewer — that inner vitality that does not seem to belong to the physical phenomenon of the model but only to its full reality, so this achievement *perhaps* has its basic precondition in the fact that the figure, unlike in photography, is not taken from immediate appearance, but rather is in its turn the creation of a mind. The old phrase "the mind fabricates its body" may be problematic because the real "construction" of the organism is a matter of unified life upon which only retrospective reflection divides body from soul as autonomously working fractions. The corporeality of the portrait, however, insofar as it is art, really is fabricated by a mind. To use this to interpret the animation of the portrait in such a way that a parallel is drawn between the animation of the painted appearance taken to stem from its creator and the animation of the real appearance, seems, on first sight, to be the most enormous paradox. In fact, the artistic mind may well create the construct as its objective product without being the subjective mind of that construct immanent to it in the same way that the living soul stands in relation to its living body. And since the portrait of a person makes present to us *his* mind rather than someone else's, merely by pointing toward the creative force — which is clearly that of a mind, but not that of the model — the problem of how *this* is possible is left unaddressed.

Examined more closely, however, this seeming paradox — even apparent absurdity — is a generally recognized and continuously realized possibility whose least ambiguous embodiment is in the actor. The actor finds the role as an objective given, as an — in an intellectual sense — external complex of words, conditions, actions. And out of those forces that reside exclusively within *his* soul, he fills this — to him quite external and foreign structure — with a life and animation that fully corresponds to the objectively given complex. He supplies this with the stage figure's own inner life, which cannot come into being other than from within (that is to say as) the actor's own inner life. Here is an absolute fact that one should not pass over merely because it is unexplained. We can think, speak, and act "from within the soul of another;" that is create structures that are only possible because of a mind being, as it were, their body. But what the inner life now provides for this creation is, so to speak, only the dynamic, and no longer the inner life experienced as *its own* qualitative personal I. The inner life really can fabricate such a body that emerges from it as its real production but that nevertheless in its quality and its expression is that of another inner life. Possibly this is merely the reinforcement and development of the basic fact that the subject in its consciousness (which always remains its own, whose total content one can characterize as "modifications of self-consciousness") represents a "you," a "not-I"; that is, an "I-for-itself." This "you" is not merely an external impression for this "I," as trees and clouds are. It is subjectively closer than that, something that is an inner content, but not itself an inner life, and at the same time more distant because the "you" cannot simply be addressed as "my conception," but rather must be thought of as a being-in-itself. In short, the "you" is probable a primary immediately experienced category that can be traced back no further. The transformation of the "I" in this way is probably carried on in actions whose subject counts as a "you" where we do not externally imitate the thought or mode of expression of another, but rather produce it out of an inner spontaneity that for us, and for a third party, appears to be transposed into that of another subject. Where the historian makes inner connections between the recorded history of the external actions of a personality, he must draw them up from within his own soul although he, as a subject, has never experienced them, and they are perhaps quite foreign to his own nature. The dramatist forms his creations out of essential features, allowing them to be moved by impulses that only in the moment of their creation arise within him but that, so to speak, do not dwell within him but are immediately there in and as those figures. In all manifestations of this kind — of which, as mentioned, the actor comes

most readily to mind — each objective structure is carried or formed by an immanent inner life and is its expression, while in fact it is the inner life of the creator (which transcends that of the historical or dramatic figure) that provides the conveying and forming expression.

If one sees in this series a consistent primary phenomenon whose metaphysical depths may not be illuminated, so the "animation"[iii] of the portrait — or that of pictorial works generally — which clearly belong to this series, is no more, but also no less, intelligible than any other case. If one admits these manifestations, as one must, then the animation of the corporeal picture on the canvas is by no means any longer an isolated paradox lying outside our normal range of experience. It really derives from the fact that it was an inner life that created the picture. And the fact that this is a different inner life from the one that is invested in, and speaks objectively out of, the painting cannot very well be a contradiction that negates this interpretation, because the same type of thing is realized in countless examples experienced daily.

SUBJECTIVE REALISM AND THE SELF-PORTRAIT

What we gain from recognizing this is that in order to think of the animation of the portrait as possible at all we do not need to go beyond the work of art. If one adheres to the view that animation exclusively adheres to the reality of subjects, then one can seek it only outside the work of art itself; either within the living model for whose representation the picture serves only as a transmission and symbol for the viewer, or within the artist who attires his subjectivity in these varied forms as though they were his own garments. But the expatriation of the inner life from the work of art itself flatly contradicts the impression made by the great portraits. This impression at least becomes conceivable when we remember that the creative mind objectifies itself in the constructs of autonomous characters with their own shaping and logic that are in boundless measure independent of the character, shaping, and logic of the personality who created them. Perhaps, as already stated, this cannot be explained through further tracing back because it is rather a primary function of human inner life that in turn is the explanation for immediate phenomena. This describes, however, only one end point within the unity and immanence of the work of art that can perhaps never be fully attained in its reality. Somehow, two temptations cling to the free self-sufficiency of the work of art due to its worldly condition: the path toward the real model,[iii] and the determination by the subjective personality of its creator. Both are clearly derailments from the pure artistic will into mere reality, the one

finding its extreme in photography, the other in the lack of self-control or in the bias with which the artist always expresses only his own restricted "I." In the actor's art, which offered the most appropriate analogy, two concomitant extremes drive the pure artistic form into reality. On one side stands the imitator whose performance fakes a real course of action outside the sphere of art, a course of action that should lie within the category of the real for the audience and in which the stage merely enables him to move. The contrast to this is the subjectivist actor who "plays himself" in all roles. He cannot achieve the metempsychosis of his "I" into a subject who is qualitatively unrelated to him — who transcends the contrast between "I" and "not-I" within the all but unanalyzable unity of the work of art. The work of art is always an objectification of the subject, and thus takes its place beyond that reality that clings to an object-for-itself or subject-for-itself. As soon as it relinquishes the purity of its position in the beyond — whether merely to represent an object, or to articulate a subject — so in this measure it slips out of its specific category and into that of reality.

The safeguard against either possibility is, however, as already suggested, never absolute. And particularly with respect to the portrait, it would be bureaucratic narrow-mindedness to downgrade the meaning of specific works in which one or other intention toward, or out of, reality makes itself felt, merely for the sake of the purity of the concept of art. Where anything great or vital is accomplished, the question whether we can locate it under this or that category is quite secondary. And we must not prescribe to artists — because that title entails duties — what they "should do" on the basis of such categories.

Particularly in the case of Goya, one gets the impression that his portraits are signposts, as it were, pointing in the direction of the real person. This is all the stranger because he is the artist of the most autonomous, reckless, self- and world-upending fantasy. Part of the strangeness of many Goya paintings — not only his portraits but also the quite fantastical scenes — is that through them, as through a magic mirror, one sees through to the reality of human beings and processes. In contrast, the realism of subjectivity is difficult to demonstrate among the great portrait artists. In a particular — clearly considerably modified — sense I would like here, however paradoxical it may seem, to think of the most objective painter, to think of Velázquez. I have the — naturally unverifiable — idea that Velázquez's feel for life was an exceptional strongly cohesive *power* [and] that, in contrast to both his individual gifts and to the qualitative colorings that determine the basic feelings of other natures, he was above all of an *energetic* nature. This power was clearly not, as with Michelangelo, titanic, taking the world

on his shoulders even if he breaks under it, nor that of muscular athleticism, as with Rubens, but rather it lies within its intensity, in an undeflectable development fit for any task. That Velázquez's personality compared to his peers — compared to Raphael and Titian, Dürer and Holbein, Rembrandt and Hals — exhibits a degree of colorlessness, although certainly not indeterminacy or insignificance, can be traced back to his personal, subjective being, which was based more in an inexhaustible life-dynamic than in very individual coloring of this dynamic. Now, clearly he did not transpose this into his portrayed figures in the way that Greuze — perhaps the clearest example of questionable subjectivity in portrait painting — directly infused his models with his own sickly sweet, vain, sentimental character. Nevertheless, I have the impression that Velázquez would have posed the question of their life force to each of his portrayed figures as though his instinct told him that this was their constant common denominator, whose exactly determined measure he makes us feel in each one, whatever their individual differences. The mighty, unyielding life force of Duke Olivarez[7] and of Juan de Mateos,[8] the decadent weaknesses of Philip IV and his brothers, the inner emptiness of the puffed-up strength of the fool Pablillos,[9] the hard-bitten dynamic of the court dwarves,[10] the dubious vitality of the King's children — each one of them is placed on an exactly determined point of a scale of pure force that the viewer clearly discerns. If this interpretation is correct, we have with Velázquez an — if also rather peculiar — example of the subjective realism of the art of portraiture for which the subjectively real component of the artistic personality determines the portrayal.

Now, although neither this subjectivism, nor that objectivism that seeks to call forth an image of a real living subject via the painting, are somehow *absolutely* eliminated, Rembrandt's portraits do at least demonstrate the farthest distance from these two forms of realism. In this respect only Titian and Tintoretto can be compared to him. In his case the overcoming of these two forms of realism is somewhat more succinct, however. The unity of artistic objectification of the subject is, so to speak, more noteworthy because it arises from a greater tension between the opposites. Rembrandt's artistry appears, on the one hand, more personal, more subjective, than could be accommodated within the stylized intentions even of the Venetian artists, and, on the other hand, much more than they were, he is concerned with the individuality of the model — with the layers of the model's most inner and specific life. Two temptations could thus have been strong for him: to use the model merely as material or as apparel for the immediate mood and impulsiveness of his own strong subjective reality, or, alternatively,

to bring the fully grasped life of the model into immediate reality, allowing the impression of reality to speak in place of the artist's vision.

If the objectification of the subject is the formula that points beyond these two false paths, then a quite specific demeanor of the *self-portrait* manifests itself. Since the external reality of the living model and the artist's reality that dictates from within are given as a unity in consciousness, these two temptations in fact meet but can also easily mutually neutralize each other. The self-portrait is the school and to a degree the prototype (in which the contrasts are not yet divided off) for shaping the creative mind into the form of a different individual exterior as though it were *its* interior; a specific artistic process that automatically transcends both kinds of realism. In fact, through the self-portrait Rembrandt could again and again most easily orient himself toward that which was a fundamental, perhaps the fundamental, essence of his art of portraiture. If this discussion were concerned with the problem of how mere bodily phenomena in a painting can make us feel the animation of the subject (which only unites in living reality), and if the fact that it is a creation of an inner life that infuses this phenomenon with itself offered a solution that is not called into question by the divergence of the creator and the represented personality because the transposition of one's own into foreign individuality shows itself to be a quite general ability of the human mind as well as a specifically artistic ability, then this reveals the particular function of Rembrandt's self-portraits. This is not something isolated and to a degree coincidental, as it is with other painters, but rather accompanied him through his whole career, and in many ways delineated its high points. Here, where the unity of the internal and the external was immediately experienced, he consistently trained himself in the depiction of this unity, for which task he possessed a matchless talent. In objectifying this unity in artistic forms in ever-new ways, he more and more found, as it were, the general formula for such unity. His artistry as such lifted him — and here most evidently — in equal measure above the reality of his subjectivity and above that of his models. Thus, that which his portraits represented was no longer a corporeality abstracted out of a whole life, but rather his vision was from the start this whole life in the unity, or as the unity, of all its elements.

ARTISTIC PROCREATION

With this discussion culminating in the problem of the self-portrait, I approach a deep, but in no way yet elucidated, aspect of artistic creation. Every work of art has some form of *extension* in space or time in which

its parts — colored or formed pieces of material, words, movements, tones — range themselves with or alongside each other and form a unity. This unity must somehow be there from the beginning and determine the creation, otherwise it would be inconceivable on which basis the artist should be able to gather together the individual materials as something that fits together and forms a totality. It was perhaps the feeling for this that allowed aesthetic theory to frequently locate the nature of the work of art within its "idea." This of course was a typical error that places, as though by a rotation of coordinates, the general concept, abstracted from the appearance, *before* appearance as its original cause or real bearer. The view that the artist has an "idea" in mind that he then "realizes" in detail or in individual form is a classicist rationalism that has even less to do with real artistic creation because the idea is hardly anything other than a redundant duplication of the work of art through which it — actually unchanged — is transposed, if not theoretically then perhaps intuitively, onto the conceptual level. As already suggested, the instinct that is at least observable here, namely, that the spatial extension of the finished work of art, is not the primary factor, that the mind cannot produce the multiplicity of individual parts instantaneously in *one* creative moment and therefore, in order for such coherent diversity to come into being, a simple unity must already exist; this instinct — in the form of the theory of the "idea" that the artists must carry out — has achieved only deceptive satisfaction. It seeks the solution, as it were, from above, from that which is already formed, while, so it appears to me, the solution must be sought from below, from that which is — compared with the portrayed figure — something quite formless and dark. I am convinced that the whole spatially extensive formation of each work of art originates from a spiritual germ that is itself formless, since forming is only possible through something which is spatially extended, no matter how paradoxical it may seem at first that, for example, the sufficient reason for the coming into being of a painting existing only as colored spatial extension can be found in an inner structure in which no spatial extension can be found — that has no morphological similarity at all with that which finally emerges out of it. One must free oneself from the prejudice that such a similarity between cause and effect must exist; a prejudice that makes mischief everywhere, and that also determines the doctrine that the idea is the genetic starting point of artistic creation. Moreover, one must make do with that which is here meant by the germ and its maturing into the fully developed living organism. This is only an image, even though clever speculation could deepen it into a real lawlike rule that would be common to both phenomena. Neither does

the germ or seed contain the living organism in miniature, but rather has a purely functional relation to it insofar as it exclusively contains the potential energies that are directed toward the particular organism. A melody is not a series of tones following each other, but rather a unity in its own right that is not demonstrable in this temporal diversity as such, but that nonetheless determines it. This unity must be available in some form in the creator of the melody before and with which it unfolds in that series of individual tones, just as the germ cells do in the arrangement of limbs of an animal as it comes into the world. The expression that the composer is "at once" struck by a melody (i.e., instantaneity of time) can easily be misunderstood. As it stands there completed, as an unavoidable time-consuming series of individual tones, it *can* in no way have had its origin in that pure, nonextended instantaneity. If this is required precisely for this origin (because only this is in accordance with the unity from which the temporal series of tones is determined), so there remains only the assumption that the original act of conception *does not yet contain* this tone series — that the content of this act is a spiritual entity whose unity includes no multiple extended *actu*, but is its potentiality, and unfolds itself as in organic growth. This structure does not become evident, but rather remains, as one says, unconscious, because its becoming evident would precisely mean that it is now separated out; that it has attained a mature state of differentiated organization.

Perhaps the application of the same hypothesis to representational art is now less surprising than it was on first sight. If one compares an inferior portrait — particularly one with a dilettantish character that nevertheless conveys a convincing similarity to the model — with a master portrait, say that of *Jan Six* or *The Jewish Bride*,[11] so one gains the impression that the painter has transferred each individual aspect as they appeared to him move-for-move and in the same sequence onto the canvas. With Rembrandt, however, it is as though he traced back the appearance of the person to a unified trans-phenomenal intuition of essence that he then entrusted to its concentrated driving forces out of which the forms' spatial extension unfolded in free organic growth. This appears to me to be the real creativity in the art of portraiture: for the artist the examination of the model is only a conceiving, a fertilization, and he procreates the appearance anew. It grows once again on the soil and under the specific categories of artistry, as the development of an inner structure that I have compared to the germ cell. It is precisely this form of production that appears in Rembrandt. This also explains the absence of detail, the transcendence of the small and the individual aspect of appearance in favor of their broad essentially decisive features.

Thus it becomes clear that this germ — which originated in deep unconsciousness and is growing further out of purely artistic driving forces — does not strive toward so many details and specific traits as does the physical growth of an organism. It does not contain — and this demands no further justification — the same number of potential elements as the germ does for the organism. All of these enter the picture only where reality is immediately transposed into the painting without having first entered that dark pre-extended spiritual state, and once again grown and differentiated itself, so to speak, out of the spontaneity of this state. Naturally, in most cases it will turn out to be a matter of the combined working of both forms of production. In the case of some portraits it appears to me that one can particularly sense this duality within them, for example, in those of Jan van Eyck, and perhaps also in some by Dürer. With Rembrandt, however, what is above all decisive is that re-formation emerging from within: the "*Stirb und Werde!*"[12] of appearance between which lies the sinking into that — in itself unified — moment of conception, unfathomable, like the emergence of life itself. Given these preconditions, it also becomes understandable when customers of Rembrandt's portraits complained about "poor likeness." For although further growth out of a germ consisting of a peripheryless center — which now required no examination of the model because the growth is now precisely only the self-development of already concentrated energies — is naturally carried out in the direction of the perceived extensive impressions. The complication and the life of its own of this mental evolution fails to assume liability for the similarity. With this process, the deepest essence of the represented person can perhaps unfold in a purer and more authentic form than can physical-organic development with its restricting coincidences and distorting aberrations. The phrase discussed above — "the soul fabricates its own body" — is here raised to a higher power. Not the soul for-itself, but the essential unity — of which body and soul is only a retrospective abstract separation — constitutes the content of that primary creative, not yet "formed," germ-formation that only in conformity to the laws of the energies gathered within it, is the driving force of the physical form of the portrait figure. This procedure, too, of course, has its degrees of adequacies, degrees of suitability of the model's personality with the artist's powers to conceive, and to fashion. The immediate "similarity" of physiognomy to physiognomy is endangered, however, in the case mentioned in which that germ develops only the mental-artistic form of the ultimate truth of that personality, and with its undeflected inner logic develops the physical picture, and also in the other case in which the artist's subjectivity somehow renders

that starting point incongruent, however meaningful the final result may be.

That precisely this *immediacy* of the relationship between the reality and the work of art is ever more rigorously negated, now appears to me to be one of the essential duties of the theory of art. It must be acknowledged that art is an absolutely self-sufficient structure and, as a way of forming the contents of the world, does not live off the borrowings from that other forming that we call reality. That all great artists have tirelessly studied natural reality is not a falsifying instance. Because, if, as I assume, the work of art emerges out of an inner germ that does not at all contain the work's concrete final extension, but of which the latter rather represents a totally allotropic stage of development, so none of the directions are prejudiced by conditions and stimuli required by the artistic inner life in order that the germ comes into being in the latter. Precisely the deeper and the more autonomous the creative strata of the personality in which this happens are, the richer and more precise must be the material supplied to them in order to stock the germ with contents — as they also exist in the form of reality — at all. This is why the most individual artists, who create from the greatest depths, require the most intensive fertilization by the contents of the world (that are clearly *given* to them in no other form than in that of reality and that they bring forth — functionally completely independent from this form — as a new artistic creation). The lesser artists, who create out of superficial layers that have not been concentrated into that nonextended germ and who therefore capture the occurring images more immediately, as it were, in their extension, do not require such an abundance and potency of material. They are not worse artists because they have studied nature less carefully; rather it is the other way around: it is because they are lesser talents, and therefore work with more direct superficial transposition instead of working from a spontaneous germinal force, that from the outset they do not require such an extensive and rigorous assimilation of a mass of material. They do not require such a large material "reserve army" (to use Marx's expression loosely) for their production.

The concept of individuality toward which the discussion so far has been moving, and which will be later presented in a purer — for Rembrandt decisive — meaning, must provide one of its functions for the problem at hand. The whole theoretical and moral quarrel between the corporeal and the inner life, or between the senses and the spirit, will lose its field of battle as soon as the human being regards the fact that he is an *individual* as the essence and the meaning of his life. If one grasps this concept in its pure meaning — as indivisible — so it must

evidently be the common substance or base of those separated or diverging parties. The sensual and the spiritual as abstract concepts may not have anything to do with each other. As soon as they come alive — that is, realize themselves in an individual — they are this individually determined sensuality, and this individually determined spirituality. Therefore, they have something in common and indivisible in the fact of that individual determination. The individuality is either the root or the higher expression that the strangeness or divergence of soul and body does not touch, because individuality gives to each their singular color. That the corporeal individual and the spiritual individual cannot be highlighted and signified as an identical phenomenon may give intellectual conceptualization, but certainly not life and art, pause for thought. Here one knows *immediately* that the individual is not a mechanical piecing together of a body and a substantially heterogeneous inner life — a notion that is totally meaningless and cannot be realized. In contrast, we know that even though the corporeal as such and the spiritual as such may be foreign to each other, the concrete individual is nevertheless a unity. Therefore, only individuality that alone joins that general foreignness can unite body and soul, and — whether conceivable or not — bears the unity of elements. It is clearly a constant experience that the deeper we grasp a person's individuality, the more his exterior and his interior indivisibly merge for us, and the less we can we think of him as separate. The turning away in Rembrandt's art from the "general" in human appearances, its maximal carving out of the individual, appears to be one of the inner paths on which the overcoming of the spiritual/corporeal dualism is accomplished; or better, in following this path an overcoming in the strict sense is *a priori* unnecessary.

LIFE'S PAST IN THE PAINTING

Can this motif succeed in illuminating the specific achievement of Rembrandt, namely, the making visible of the past in the person's present? We saw that, according to Kantian preconditions, the simplest spatial intuition of objects already comes into being through the combined effect of the sensory and the intellectual function, although for immediate consciousness of reality the object is given as a complete sensory unity. Subsequent investigations have extended this into the empirical realm by demonstrating the supplementary interwovenness of the merely deduced, nonperceived, and even nonperceivable, into the apparently pure sensory image of the object. It would, as it were, be to take the same aspect from another angle if I now conversely assumed

that the double function of corporeal intuition and inner interpretation with respect to persons is in reality and in art one and the same. Insofar as one spiritualizes sensory seeing, one may render spiritual seeing sensory. That we "see" the spiritual meaning of a body in the same act as we see the body appears as a paradox only because of gradual differences and accidental shifts. But even accepting this, it must be still more paradoxical if not only the actual inner being is given in the momentary viewing of this bodily form, but also the past that has itself developed toward the current inner being and corporeal phenomenon. The circle touched on here, however — namely, that we understand the "present" of the appearance out of its past, but that past, however, can only be deduced from that presented present — appears to me to be resolvable, even intelligible, only under these conditions. What must be overcome is the obvious but vapid idea that a sensory present is given, out of which the inner past is reconstructed through an intellectual method, and/or is projected onto it. In fact, art has specific means available (which become particularly evident in Rembrandt's later portraits) with which to free itself from this rationalist necessity. Clearly, we must not think of it — as an earlier preliminary expression could lead us to — as though a fixed order of individual scenes or acts in life, each limited and separated from each other by a temporal frame that now counts as empty, becomes visible through its contemporary phenomenon. Rather, it will be the whole continuous stream of life because this flows ceaselessly into it. Perhaps in relation to the human image, the idea, taken from mathematics, that we perceive the human image in a temporal and physical sense in its absolute current state, is not at all applicable. That within the objectivity of scientific abstraction it is only a matter of a nonextended presence may be the case, and this remains open. As a real experience of intuition, the phenomenon of a human being is a totality that somehow transcends the moment — something standing beyond the contrast between present and past, and perhaps even future. As we have long known, within historical knowledge the present can only be grasped through the past, but the past can only be interpreted via the experienced present, so this circle, too, whose elements are certainly of less conceptual clarity, points toward the unity of understanding that our unavoidable analytical methods split into those mutually dependent parties.

It is remarkable how the sharply focused antivital momentariness of the picture occasionally also turns up in Rembrandt. Thus, for example, *Josephs Blutiger Rock* (with the Earl of Derby)[13] displays a crass restriction of the whole complex of representation to an absolutely unextended — and thus frozen — moment. But this, and perhaps a few

related works, fall totally outside the nature and uniqueness of Rembrandt's art. Where the latter appears in its purest form — particularly in the late portraits — precisely that specific *life* characteristic for which there is no isolation of the moment is accorded its unambiguous right. It does not matter whether we have a unique given quality and unchangeable colored image physically before us. The question is exclusively what it means for us, within us, as our active gaze. Just as for this the division between the corporeal, as perceived by the senses, and the inner life, as the intellectually added construction, have already ceased to exist, so now does the corresponding division between present and past. Rembrandt's depiction of persons allows us in each case to view the totality of the life despite the fact that this as concept and as external reality is formed in the sequence of past and present. We see the whole person and not a moment of his life from which we *deduced* earlier moments. For life *is* immediately nothing other than the past becoming present, and where we really see life, only a pure prejudice will allow us to claim that one merely sees the frozen present moment. It is in principle all the same whether we acquire the view of the whole life by and by, whether particular experiences and conclusions have psychologically preceded it, whether it remains always incomplete and merely an approximation.

It was the concomitant turn of thought with which Kant neglected the apparent necessity first to *deduce* the object of external perception. Because it is only our representations that are given to us (that is, as events occurring purely within ourselves), so it seemed that we can only deduce the external world that is never immediately accessible; causes external to us from the effect within us. In contrast, Kant demonstrated that the external world also consists for us entirely as our conception, that therefore no principle distinction is to be found between the external world and the supposedly in itself self-certain inner world, and that the external world that is only conceived is given with the same certainty without requiring a deduction. It appeared to me reasonable to assume that an analogous case holds for the knowledge of the body and inner life of another human being that appears to require the same deduction, but in the opposite direction. Supposedly here in particular the appearance of the body is immediately given to us, and we must "deduce" the inner life to which it is bound. But perhaps this division emerges, no less than that criticized by Kant, from a rationalistic prejudice; perhaps we perceive a human being immediately as a unity in which the body and inner life are epistemologically equivalent even if empirically the knowledge of the latter is uncertain, ambiguous, and incomplete. And it is no different with the concomitant conclusion: even if

now the corporeal-inner existence of a person is given to us in one principally indivisible act, so this could in any case contain only the presence of a moment while the past, as something that no longer exists, would be accessible to us only via a deduction from the effect to the cause based on the present. In this respect, however, perhaps the past relates to the present as does the soul of the other, as we conceived it, to his body; or, as in the Kantian case, the external existence of things to inner representation. The "present" of a life cannot be grasped at all with the isolation and precision of its mathematical concept. That we really *see* life in its transcendence of each *point* in time and in cross-section may be possible because the process of seeing is itself a life process. One does not usually reflect sufficiently this self-evident fact, because we think of the content of this process as fixed "images" and, by projecting them back, as it were, conceive seeing as a sequence of such enclosed images. Seeing as a life process that participates in life's general character, however, means that the division between past, future, and present is not applicable in the way required by grammatical-logical rigor. Lines of demarcation bring this alternative into the continuous flow of life only retrospectively. The foundation and exposition of this life-concept belong to another place. Here it should merely indicate that the viewing of life transcending momentariness, does not require a miracle on the part of the viewer. On the basis of that concept of life, it is quite intelligible that both of its manifestations — as viewer and as viewed — possess the same freedom from the mere rational shackling to the moment. Where we perceive life, and not a frozen cross-section that only offers a *content* but not the function of life as such, we constantly perceive a *becoming* (for otherwise it could not be life). Only where the characteristic ability is exercised, namely in viewing the now in the continuity of a process that reaches out toward the now, have we really *seen* life. Clearly, how *far* we look into this sequence, how *large* a portion of what we call the past, viewed as a unity, is quite problematic and variable.

Rembrandt has the ability to extend such a temporal sequence, which, despite keeping this form, is still *one* act of viewing within us into an undeterminable distant time, or, more exactly: to allow the one to emerge out of the other. One must not give in to the lure of the concept of temporal sequence as though individual stations, as it were, determined by contents were built one after the other. This is because temporality would then only be the external form of an arrangement of clear-cut factual contents of life, while here we are dealing precisely with a stream of becoming in which the self-sufficient meaning — merely with regard to the contents — of the single moments (that is,

uncontroversial for other categorizations) is dissolved absolutely. Furthermore, we are dealing here with the fact that each figure is viewed as having emerged from, or emerging out of, the fleeting rhythm of life, fate, development. It is, so to speak, not the form in its current state that Rembrandt presents, but, rather, precisely the whole life that has been lived up to, and viewed from, the perspective of this moment. Kant, whose intellectual directive points toward the formed quality of the contents of being and toward logic and trans-individuality, and thus represents the opposite pole to Rembrandt, once expressed a speculative thought that is nevertheless somehow related to this interpretation of the viewing of vitality. He speaks of the process of perfection that not only demands immortality because of the inadequacy of our empirical morality but presents itself to our understanding as never-ending. This would, however, make us worthy of (transcendent) bliss before the eyes of God because God as "The Eternal being, to whom the condition of temporality is nothing, sees in what is for us an endless series the whole of conformity with the moral law, and the holiness [. . .] is to be found whole in a single intellectual intuition of the existence of rational beings."[14] The type of intuition that Kant presupposes is clearly a trans-temporal and intellectual one, but it practices its unified power, which transcends everything diversely extended, on the same object as does the sensory-artistic intuition of Rembrandt, namely on that temporal life extended via an endless continuous variety. Just as in viewing the human inner life as perfect the eye of God does not wait until a fixed state of total perfection is attained within a particular moment in time that now persists, but rather the ceaseless process of an elevating existence offers Him the unified picture that can be called perfection for a human inner life, so with Rembrandt, in his most profound portraits, the essence of persons appears in a unity that does not emerge at a point of development that is at last reached, but rather combines the totality of a steady development. And this combination is not that of an abstracting concept, but rather that of a specific viewing for which concepts are as inadequate as they are for Kant's presupposed divine viewing of an inner life living towards an infinite time. Just as the division between the inner-subjective act of representation and its corresponding object is a retrospective abstraction, while originally the unified, content-determined image is present — not yet differentiated into subjectivity and objectivity — so similarly, where we perceive lifein general, the absolute division into a solid, isolated now, contrasted with an extended past, is a matter of intellectual reflection. In reality we perceive in the first instance and immanently a temporally extended unity that does not separate out into discrete

moments. And just as this viewing with respect to its object is neither the isolated "now," nor its extended past, but rather the flowing unity of both, so, with respect to the subject, is it neither isolated sensuousness, nor an isolated intellectual construct, but rather a total unitary function that is differentiated into each only when viewed from other perspectives.

Herewith, the problem of movement of which I first spoke is situated in its proper place. With respect to each "represented movement" the question arises above all as to why the one, frozen, temporally nonextended moment presented by the painting can make visible a temporally extended movement. This is not achieved by the lesser artist, where the figure rather appears in its posture as though frozen stiff. This is also the case with the snapshot. Where the absolute momentary phenomenon is externally reproduced, Zeno's proof of the impossibility of the flying arrow applies: because at any given moment the arrow is at a particular point, so it is at rest at that point, however brief the moment. Because it rests at any point, so it always rests and cannot move at all. The fallacy is that the arrow should rest at all at any point whatsoever. It does so only in the artificial and mechanical abstraction of the bad artist and the snapshot photographer. In reality, however, it goes through each point and does not linger however briefly; that is, movement is a particular type of action that is not made up out of moments of repose. The real movement of a body does not display the body's separate positions, but displays the steady movement through certain spaces that, had it *not* moved, would have been "positions." It is thus a principally different way of viewing as that understanding of the, so to speak, mechanical-atomistic standpoint for which only the moment and the present "exist."

Of Baroque art, especially architecture but also in an analogous sense in the other representational arts, it has been said that in the place of the stonelike crystallization, as embodied in the formal ideal of the Renaissance, the organic had been introduced — a swelling and contracting, a waving and vibrancy of material. It is quite right that the Baroque replaces the stable, abstract form with living being, but, however, only with the *mechanical movements* of this living being. This is the time in which mechanistic psychology emerges, for example Spinoza — that adversary of Rembrandt. Certainly, the artistic appearance is now determined by innervations with inner life, irrespective of the internal laws of the form and material as such. These innervations come to a halt in the character of mechanical movement, however — in floating and falling, pressing and pulling, stretching and swinging. This is quite different from the movement in Rembrandt with its real

and complete inner life. This is why we also have the theatrical and inwardly unconvincing character of Baroque figures. It thus appears significant to me that bad historical or genre paintings often appear as though they do not represent their object immediately, but rather as though it were presented as a "living picture" — that is, the vital artistic meaning of a life process should exhaust itself in a moment in which the essential temporality of the process is abandoned. It is not located within the trans-temporal, rather, simply into a nontemporal realm; not into another order, but into no order at all. It is like a bad actor playing toward the "rewarding" moments between which the real continuous action is to a degree missing, while artistic actors avoid this chopped-up pointing and hold their representation steady, allowing the totality in principle to be seen in *each* moment. The movement-style of the perfect work of art induces in us such a view into temporal totality. Clearly, if one takes that external perspective, even this style cannot show any movement, but only a frozen moment. However, the undeniable difference of impression in contrast to the concomitant style in a poor work of art demonstrates that here something different and something more must be present. One should not believe that we are dealing here with figments of the imagination about particular previous and particular subsequent states. This belief, again, would have a mechanical and singular character as its precondition, and the life movement would be split up once more into individual, internally unrelated phenomena of contents.

THE REPRESENTATION OF MOVEMENT

What is it then that moves within the picture? The painted figure itself does not move, as it does in cinematography. So it can only be that the imagination of the viewer is aroused to complete the movement before and after the represented moment. But it is precisely with respect to this self-evident conclusion that I have my doubts. If I examine more closely that which becomes conscious to me about inner life when I see the flying Creator in the painting of the Sistine Chapel ceiling, or the Maria as she sinks back in Grünewald's *Crucifixion*,[15] I find not a trace of the stages before and after the represented moment. This would be quite impossible because the viewer Simmel cannot reconstruct how a figure by Michelangelo might look in any posture other than that which it displays. In this case, it would be a Simmel figure, but no longer a Michelangelo one, and would therefore not be a moment of movement of the figure in question. Rather, in a way in which the perception here is distinct from the perception of real movements only

through its intensity and compression, the pictorial gesture is immediately charged with movement. However paradoxical it may sound, the movement is immanent to the gesture and not subsequently added by the time before and after. Movement is a *quality* of a particular viewing. If movement in its logical-physical sense therefore demands a temporal extension; if in turn our viewing, likewise in its logical sense — that will clearly shortly show itself to be unreal — just takes place in each unextended moments, so this contradiction would also resolve itself if movement can also occupy that snapshot image of the object, as color, extension, and, all of, its qualities do. It is only that *this* quality does not lie so immediately on the surface as others; is not so simply graspable and demonstrable via the senses. The artist brings movement to its climax, however, by knowing how to bind movement into a factually static painting. And only then when we make it clear to ourselves that we, too, vis-à-vis reality do not "see" things the way they are captured in the photographic moment, but rather movement as continuity made possible, as suggested, by the fact that our subjective life is itself a lived continuity and not a composition made up of individual moments that were neither a process nor an activity, so then we realize that the work of art offers much more "truth" than does the photographic snapshot. In this case we do not need to appeal to the so-called "higher truth" at all to which the work of art — in contrast to the mechanical reproduction — is said to be entitled. Rather, with total immediacy and in a completely realistic sense, the painting, whose impression concentrates continuous movement via some means, is closer to reality (here merely meaning the conscious perception of reality) than is the snapshot. It is through this concentration into a focal point of viewing that movement first acquires its aesthetic *value*.

Where movement within the painting is really nothing other than that which supplies the represented moment with one or more prior and subsequent moments through association and imagination, I cannot see what qualitative aesthetic value this mere addition of moments could contribute. In my view, the situation here is the same as in the case of the meaning of the third dimension in painting, where making it tangible at the presented figure counts as an artistic value. Taken as a reality, the third dimension is absolutely only the tactile. Were we to experience no resistance on touching an object, we would have only a two-dimensional world. The third dimension dwells in a world of a different sense than does the colored surface of the painting. If the third dimension is added to the colored surface through associations based on all types of psychologically effective means, it would merely be a numerical multiplication beyond the already available

quantity of dimensions — an appendage to the given that is merely formed within the viewer's inner reconstruction, and in which I cannot recognize an artistic value as an element formed by a creative spirit itself. If the tangibility of the third dimension is to have this value, then it must be an immanent quality of the immediately visible work of art itself. In a transposition, whose paths cannot yet be described, the tangibility in which the third dimension is exclusively constituted acquires a new *qualitative note of the pure optical painting* in which the painter's sphere of achievement is restricted. This painting as an artistic object is not enriched at all by mere *association* of the third dimension (via which this would still keep its meaning as a *reality*). Rather, the painting would receive only a borrowing from another stratum that cannot be combined organically within its own. In contrast to the deceptive artificial tricks of the panorama, that which we call the three-dimensionality of the body in the painted work of art is now a category of *optical* impression; an enrichment and an interpretation, an intensifying and increase of attraction of that which is viewed as such. What is "added" to this with respect to space is precisely analogous to that which is added with respect to time [in the problem of movement]. That which appeared to affiliate itself by association, from outside the immediately viewed object (i.e., the stations of movement prior to and after it, the third dimension behind the surface), reveals itself to be a particular qualification of that which the work of art really is: an intuitive entity purely enclosed within itself in time and space. As I have already said, such qualification of the immediately visible carries the artist to his greatest height and purity. Although it is only a matter of timeless impression, it can only be characterized with temporal concepts. We experience the moment of movement as the achievement of the past and as the potentiality of the future: a force concentrated in a single inner point, as it were, transforms itself into movement. The more purely and strongly the movement is grasped, however, the less intellectual and imaginative association is required of the viewer. Rather, its categories lie immediately within the viewing, not outside it.

Thus, I am not examining here in which particular transformation and ideality the artist remodels that inner impulse within himself which, in connection with visible representation, forms the artistic unity in which bodily movement is still concentrated, and out of which it unfolds. With Rembrandt, in any case, this must have transpired with unbelievable strength and certainty of direction, such that the moment in which the gesture of the person (and the "posture" as the sum of the gestures) is captured really *is* the whole movement. He makes visible that this is a unity in its inner and impulsive sense, such that if one

grasps a single moment, the latter represents its totality; its already past as its origin and course, its future as its effect and still charged energy. I said earlier that a life is a whole life in each single moment as life is nothing other than the continuous development going through substantial contrasts because it is not made up of pieces and therefore its totality does not lie beyond the individual moments. Now, this is also shown as the essence of the individual movement, and it makes clear now why a minimum of strokes, with which some of Rembrandt's drawings and etchings suggests movement, fully represent its expressive meaning. When the movement is really captured from within and artistically executed in its full power, direction, and unscathed unity, the smallest part of its appearance is already the totality, because each point contains that which has already occurred, because it had determined this, and that which is still to occur, because this determines it. Moreover, both these temporal determinations are concentrated in the single, unique visibility of this stroke; or better they *are* this stroke.

It is out of the essence of life, for whose sake the static brush stroke becomes perceivable as movement, that the history of the personality becomes visible in the fixed physiognomy of the most perfect Rembrandt portraits; and this, as it were, in *one* act and as a qualitative condition of this single view. Above I interpreted the difference between this and the Renaissance portrait such that the latter seeks the being [*das Sein*], but Rembrandt seeks the coming into being [*das Gewordensein*], of the person. There we see the form into which life has finally molded itself and therefore can be viewed in timeless self-sufficiency; here we see the life itself, grasped by the artist in that moment in which it brings its flow into unmediated intuition by transforming the past continuously into the present. Thus, it becomes quite clear that Renaissance art, although highly abstract vis-à-vis life, is perceivable in a much higher degree of optical-sensory purity, while Rembrandtian art is more likely to presuppose a viewer who is a whole person: the totality of life in its perceptive function. That vital analogy between a single movement and the physiognomy of the portrait also suggests an analogy with the genesis of the latter. What was decisive there was that the inner concentrated dynamic rather than the external phenomenon of a moment is the starting point, and that the representation corresponding to the real movement, albeit in an artistic-ideal transformation, unfolds out of the inner impulse that, in an unfathomable way, seems potentially to contain within and release out of itself the energy and direction of bodily action. So it now appears — admitted all expression here is merely symbolic — that in each of the great

Rembrandt portraits a life with which the concentrated potentiality of its source realizes itself in a process of becoming has been lead toward the visible appearance. It is developed from the *inside*.

THE UNITY OF THE COMPOSITION

The difference stretches across the individual figure into the structure of the painting as a whole. The unity of the well-composed Renaissance painting is external to the content of the picture itself. It should be thought of as abstract form: pyramid, group symmetry, contraposition within and between the individual figures; as forms whose independent meaning actually could also be filled with a different content. Aside from this form, however, which is grounded in an external meaning, the painting often has a very limited unity. It consists, rather, of a series of parts arranged alongside each other which, because they are evenly executed, completely lack an organic relationship. This sentence is, of course, only partly true for Italian art. In Giotto no inner estrangement between the compositional form and the figures' own life can be felt. This is because the latter are not strongly individualized and claim no existence beyond the function of their given pictorial form, and also because the form here is not yet a geometrical, but an architectonic one. The geometric schema of the later compositions has an abstraction whose emptiness and solid autonomous meaning is not to be completely overcome by any realization, however inventive and lively in detail. We can, however, call a form architectonic that does not emerge out of an individual vitality but immediately out of, and identical with, the material extensity and dynamic intensity of its realization. The architectonic principle stands beyond the opposition between schematism and life. In Giotto, the groups do not grow as groups out of the individual vitality of the figures, as in Rembrandt. However, they grow just as little as the completion of an already existing schema with its own geometric meaning. Rather, it is like a building in which no part has a life of its own, but each deploys a unique mass, form, and power and thus allows an architectonic unity to emerge immediately to which nothing is comparable. If one has rightly emphasized that it is initially with Giotto that the ground really displays the load-bearing power for the weight of the figure resting on it, so this is merely one aspect of the architectonic character of his visions.

In Raphael's depictions of the Madonna, the geometric motif may essentially determine the composition. They are of such an artistic power, however, that — so to speak, at least retrospectively — the life of the figure fits smoothly into this form without inner contradiction

and without random form. In contrast, in the Castelfranco *Madonna*,[16] the triangular composition is undoubtedly something mechanical and without proper relation to the lyricism of the overall mood of the painting. It is, however, interesting how much this mood and the deep [increased] beauty of the figures get the upper hand over the clumsiness of the geometric form in such a way that for many the total impression excels that of Raphael's corresponding works, even though in the latter the geometric schema and its vital content form a much more natural harmonic unity. Only in the case of the lesser masters does it become quite evident that the schema, and the way it is filled with living beings, is guided and drawn apart by totally incoherent inner impulses. It is not to be denied, however, that the rationalistic drive toward clearly graspable, self-contained exterior form that lies within the Latin character supports such schemas; schemas that appear empty and mechanical vis-à-vis their content because of their self-sufficient meaning. The art of poetry appears to me to confirm this inasmuch as the sonnet is the specifically Latin verse form. Here we find that clear unity that allows no continuation and therefore has, on the one hand, undoubtedly a timeless and ahistorical character so that within the sonnet one can "tell" no story, while on the other hand it closes off that path toward infinity that is the richness, and perhaps also the seduction, of the northern peoples. (In Dante's verse form, which is in principle without limitation, is symbolized the Gothic spirit within him.) The sonnet is similar to the classical ornament with its self-regressing forms, in contrast to the northern European that seeks to stretch into eternity. This in a way tendentious and mercilessly emphasized perfection of form favors the sonnet as the verse form that above all encourages superficial playfulness, is most empty and most formalistic, unless — just like the geometric schema of pictorial art — a singular genius surmounts this danger. Now, in Rembrandt, the total form of a group painting grows out of the life of the individual figures; that is, the life of the individual is exclusively determined from their own center, to a degree flowing beyond it to meet that of the others in order to create a mutual influencing and reinforcing modification and union. There is no general form that one could take from the totality [of the painting] as conceivable and meaningful in its own right, or that one could classify as a schema as in geometrically composed paintings. This may be the grounds for the forceful impression given by *The Night Watch*[17] — namely, that the unity of the painting is, as it were, nothing in itself, not to be abstracted from the painting, not based on a form beyond the fulfillment of its purpose, but rather that its essence and its power are nothing other than the immediate interweaving of

the vital forces that break out of each individual. It already would go too far beyond this immediacy — would already construct a too abstract unity — were one to wish to speak of a complete life borne by the painting. Life instead remains immersed within each individual figure and, insofar as it radiates from each to each, it does not give up its center to a unity lying beyond itself. It is only the whole general space that can be flooded with a living wave in this constellation. If one somehow dared to characterize — with unavoidably subjective symbolism — the magic of the painting, so one would have to say: it is the space itself and not merely the appearances within the space that has here become living movement. Because the total unity of the painting, which one experiences as something intensely alive, does not in a way culminate in a form that is valid in its own right and conceivable as detached from its content, but rather consists of the sum of the figures that nevertheless do not fall apart but, as suggested with their intense vitality possess, so to speak, adhesion to each other. Therefore, really only the medium they have in common — space — appears to be a great unity filled with life, and thus itself alive, through the spheres of life organized within it.

This contrasts sharply with the feeling for space of the Italian Renaissance, in painting as well as in architecture. Here space is the solidly built stage that offers moving people an unmoving fixed point. The Latin demands, and by the way not first in the Renaissance, the clear perspicuity of space, its static form, which, as has been already said, is compatible with the movement of persons within it, but not with its own. To the highest degree — even to the point of a kind of materialization of space — it appears to me that several Gothic churches in Sienna demonstrate this. In St. Francesco and St. Domenico one gets the impression that the inner space is not simply a part of the whole space limited by the walls, but is rather like a physical construction; a substance of self-generating form, as though if one were to pull down the walls, this fixed spatial cube that is limited by itself would remain standing intact. In complete contrast to this, the space in northern European Gothic itself appears to be in movement in which every [viewer's] step changes the view of the whole, just as the progressing life changes its scenes. Here space has no form fixed within itself, but rather always appears to open itself anew. This is why the relationship of persons to the purely spatial is different in Italian churches and in northern European Gothic churches. The unperturbed way in which the life of a people takes place in the former is clearly related to the fact that the building is experienced here as the objective ground on whose stable form one can impose all this. The space of a Gothic church here is, so to speak, in a much more unstable, disturbable balance. It is as

though it had a movement of its own into which one might place oneself without unsettling it through movements that belong to external orders. The secret of space in *The Night Watch,* however, appears to me to formulate this configuration in a quite different, but nevertheless somehow still related, way. Here space has neither the fixed arrangement of Renaissance space, which is merely most clearly effective in the churches, nor a vibrant, variable life of its own, as in the Gothic. Rather, it is as such completely indifferent, but nevertheless so *capable* of movement that it is pulled along by the currents of life flowing within it. The power of this vitality is sufficient to shake it out of its rest and thus to impose a totally unique unity of the whole movement.

One has to be clear that that value of a painting we describe as its unity can be produced in a greater variety of ways than our classically influenced way of thinking generally recognizes. This familiar concept clings to the *form,* which, with respect to its fulfillment, somehow autonomously refers back to itself, and thus represents in a certain sense a unified concept. This type of unity is, however, clearly not bound to organic fulfillment, but rather can realize itself equally successfully in the formal unity of an inanimate content. In contrast thereto, however, there is a unity that adheres immediately to its realization, which can only consist of this material because it can only arise out of it. This is the unity that is exclusively of organic being. The unity of organic being cannot be thought of as a form that can be filled with some qualitatively different content. And from a majority of such beings a structure can come into being that is in turn a unity, because it displays in a vital sense its unified parts in an interwoven and grown-together way. This is because it is the essence of life to reach and radiate beyond itself without losing its unity; to surround itself, as it were, with a sphere beyond that which is primarily tangible. Its unity always remains bound to its center in that it interacts with, pervades, and melts into the sphere of others. Inherent within the Germanic disposition, in contrast to the classical, is from the outset a different capacity to feel unity. Dürer's *Melancholy,* Holbein's *The Merchant Georg Gisze,* many Dutch still life paintings — all of these display a series of individual objects alongside each other, which, from the point of view of classical art, appear accidental and disjointed. Although it did not appear as such to their creators, however, the yearning of the Germanic spirit for the classical is intelligible in these terms. *This is because the inorganic attains visible unity only in abstract geometrical forms;* it cannot attain a meaningful, that is, unified, form through interior growth; it lacks that moving sphere through which one living being can unite with another. That earlier lack of coherence in German

art was therefore certainly a contradiction. The characteristic nonclassical unity toward which it strove was not to be reached through inorganic material. This is why, unless my impression deceives me, we experience paintings in this category as much less piecemeal and accidental the moment they consist largely or exclusively of human figures. This is demonstrated with very remarkable nuance in the paintings of Brueghel the Elder, particularly those that are relatively large scale. According to their abstract schema, one would assume that they were as colorful and diverse as possible. In their concrete totality, however, they do not affect us in this way. A most powerful elementary life appears to stream through them, which is clearly quite undifferentiated, and which in a particular painting neither acquires individual coloring nor reaches beyond this particularity so that it is, so to speak, all the same which piece of this life (in itself to be consistently characterized in its entirety) this or that painting cuts out. The unity here cannot be read as a closed formal correlation of parts, but rather stems from, or coincides with, the unity of that general life which in its great or small parts is one and the same. Obviously, this vital unity has nothing whatsoever to do with classical composition. It can exist instead as such without any concerns at all about classical composition. In each individual figure, however peculiar its action and posture may be, this strong characteristic rhythmic life is always in the same manner — yes, in equal measure — perceptible, and gathers any number and arrangement of individual figures into a unity. As has been suggested, this is attained only under the condition that the individual figures are undifferentiated. The higher stage in which purely *individualized* objects of life converge into a unity without needing classical geometrical formal structure was first reached by Rembrandt, most evidently in *The Night Watch*. Only here has the striving toward that specific unity become self-evident.

The Night Watch is one of the most puzzling of paintings. How these configurations, running confused and without plan and, according to conventional concepts, formless, all over the place, could create a unity of the whole — without which the powerful impression of the whole would be completely impossible — cannot be explained in terms of such concepts. But in that *The Night Watch* takes a certain number of vital beings and only those as the content of the painting, and gives voice to the secret of their pure vital interactions, has it satisfied purely, for the first time in the history of art, the old Germanic drive toward a unity that is not that of the closed form but can only be realized through the individual bearers. The unity here — at once profound and unstable — is reached via a much riskier path than in the

classical work of art, in which the unity, through the autonomous preexisting meaning of the form, carries a certain guarantee that it cannot disintegrate and must be understood. Herein lies the profound relation to the principle of individuality: individuality is that structure whose form is absolutely bound to its reality and cannot be abstracted from this reality under the condition of or in order to gain an autonomous meaning.

CLARITY AND DETAILING

For the concept of form as introduced here, a quality that we touched on earlier is of the greatest importance, namely, the graduation of degrees of clarity within Rembrandt's paintings. The domination of classical form with its striving toward a geometric, clear simplicity therefore has, according to the principle of linearity, precisely such a quality. Not even the colorism of Venetian art can deny this. Clearly, the *colors*, which open up their own space for shades of clarity in Rembrandt, in and of themselves represent a deep contrast to the principle of form in its essentially linear and plastic meaning. Whereas form to a degree represents the abstract idea of an appearance, color stands both prior to and beyond this. It is more sensuous and more metaphysical. Its effect is on the one hand more immediate, and, on the other, deeper and more mysterious. If form is to be characterized as the logic of appearance, color signifies instead the psychological and metaphysical character of appearance, thereby once again proving that these two quite distinct intentions share an opposition vis-à-vis the logical principle. This is why thinkers largely interested in logic often reject the inclination toward both the psychological and the metaphysical in equal measure. And this appears to me to be the most significant context that leads Kant, in his aesthetic table of judgments, to reject color in favor of form. If one is clear that color is the scene of *gradations*, of the greater or lesser strength and weakness, the values with their endless quantitative possibilities — in contrast to line (just as in turn psychology and metaphysics contrast with logic) — so it is also clear that with the domination of form and its geometrical inclination the *even* exposition of all parts of the picture is achieved. Within the geometrical figuration everything is treated equally. Aiding lines that are destined to disappear again may be present, though these are not concerned with the figuration itself but with the intention of demonstrating mathematical proof. The geometric tendency and the clarity of all that which is presented are merely two expressions of the same rationalistic cast of mind. However, what is in the deeper sense decisive

is not yet this clarity, but much more the evenness of the execution. Here it is all the same whether the style of painting is vibrant, colorful, boundary-transcending, or a strictly linear and punctilious filling in with the brush. This evenness is not only the opposite of real visual experiences, it is, far more so, of an absolutely inorganic and mechanical nature. Where the image of objects is taken from *life*, and in its reproduction is saturated by life, there is also unevenness in the execution; [in the] fore- and background, not merely in a spatial but also in a qualitative sense. Life is the ranking of priorities: emphasized important matters and neglected inessential matters, the determination of midpoints and the graduation toward the periphery. It is, as it were, an inner form that does not contradict the above claimed always and already present totality of the life course, because it lies at a different level. Thus, with respect to the world, life has, if you will, something unjust about it. But all genius can be expressed in such a way that it provides us with the conviction that this accentuation which is immediately dependent on the subject and not on the object, nevertheless does deeper justice also to the object — clearly not in its strict cutting-off isolation, also perhaps not in pure cosmic contemplation that permits no differentiation of meaning among elements. However, the relationship between subject and object, *which is also an objective fact*, is expressed accurately only in these distinctions. Goethe once spoke of "particular phenomena of humankind" (namely, the "forms of living being and action of individual souls") that "are externally erroneous, but internally truthful."[18] Something similar can be found in the hierarchical differentiation of the images of being [*Daseinsbilde*], which are specific to his *living* conception, in contrast to the artificial equalization of the mechanistic. Here the structure of this image, viewed externally, is uneven, but from inside is unified. So is life itself. Viewed with regard to its phenomena, results, projections, which the individual deposits externally as his own contents of existence, it is uneven and accidental, discontinuous and unjust. Viewed from the inside, however, all this, at least according to its idea, is the consistent, necessary, appropriate development of a unified germ.

The diversity and gradation of clarity, however, serve precisely the specific form that pertains only to the respective figuration. Each Rembrandt painting — yes, perhaps each in which we sense a specifically Germanic life — has only *its* form for which no other contents can be substituted. The painting as a whole is individuality; that is, the forming of a material that can only exist with this material. The essence of individuality is that the form cannot be abstracted from its content and still retain its meaning. Clearly, we shall see later that the principle of

life and that of form, according to a deeper meaning, stand in a certain relationship of mutual exclusion. At this point one can say that the human individual, really grasped as pure individuality, is the unrepeatable form. The same holds true for the group painting, which Rembrandt, in a way unknown before, weaves together out of individuals without reaching out to a "higher unity" or abstract form beyond them — and yet, particularly in the gradation of clarity, inspires the breath of *one* life into the whole. However, this contradicts that concept of form that defines it as something general that can be repeated at will and in any material. Rembrandt has been accused of "lacking form" because one perfectly naturally equates form with general form. This is the same error as when one identifies the law within the field of morality with the general law, not thinking that an individual reality may perhaps also correspond to an individual law: an ideal that may be valid only for this existence in its totality and particularity. The form, as worked through by Rembrandt, corresponds exactly and exclusively to the life of the respective individual. It lives and dies with him — in a solidarity that does not permit a general validity or tolerate a different specialization beyond that individual.

At last the problem of individualization and that of clarity of representation are intertwined to a point where a contrast arises with the conventional way of imagining. One is generally used to assuming the convergence of detailing and individualization in representations of every type. In that measure in which one goes beyond precision in details and representation — instead of getting involved in each obtainable detail — retains its grasp on the complete impression, on the concentration of the larger whole — in exactly this measure it appears to be directed not toward the individual quality of the object, but toward the general, toward that which is held in common with others. According to the conventional structure of our concepts, the so-called "general impression" of an appearance contains that which it has in common with others, and that which only conveys the individuality of appearance through the addition of specific and ever more specific modifications until it reaches its unique and unmistakable shape. But another stance appears quite possible to me; one that transcends the naïve identification of detailing and individuality. At least in many appearances it is precisely the specific, the minutia, that which turns the large general overview into the details of immediate reality — it is exactly this that is the general, and it is exactly this that a large number of appearances have in common. It is precisely only in disregarding all of this in favor of the unity of the appearance not sundered into details that one grasps its individual essence and uniqueness.

The monographic representation of great thinkers offers — in a certain transposition — an analogy. What we like to call the "personal" aspect of people — the external circumstances of their lives (their social position, whether married or unmarried, rich or poor) — is precisely that which is not personal about them. It is precisely these differentiated parts of the total personality that are shared with countless others. In contrast, the intellect [*das Geistige*] — its objective achievement, that which reaches beyond all such particularities — one does not characterize as logical and general, but is a generality all the same insofar as countless others can participate in it because it is the common property of the whole of humanity. It is exactly this that must be thought of as the very personal. That which is the most general for humanity or for culture is, for its creator, that which is most personal. Precisely this marks the uniqueness of this individuality. Schopenhauer's incomparable individuality does not lie in his "personal" circumstances — that he was born in Danzig [Gdansk], that he was a bachelor unworthy of love, that he fell out with his family, and that he died in Frankfurt — because each of these traits is merely typical. Rather, his individuality, that which was personal and unique about Schopenhauer, is *Die Welt als Wille und Vorstellung*, his intellectual being and activity, which appears all the more individual the more one turns away not only from the particular circumstances of his existence, but also from the details of his achievement on an intellectual level. Their particularities and peculiarities may here and there remind us of other creative minds, but their general unified continuity is absolutely synonymous with, and only with, Schopenhauer.

It might well be true in any case that the real individuality is that which reaches us as the most general — transcending all detail — impression of a personality. The more we go into details, the more we find traits that we also encounter in others. Perhaps not continuously, but in many respects going into details and individualization are mutually exclusive. If this conceptual differentiation appears surprising, this is because of our mechanistic habit. Clearly, in external and inanimate matters, the phenomenon gains particularity and relative singularity to the degree to which more individual traits become evident. In exactly this measure the chance of the reappearance of the same combination becomes lessened. Here the individuality of an image really will be reached via the detailing within its content. And this occurs, too, in the case of mental objects insofar as we observe them in terms of their psychological exteriors; that is, in a mechanistic fashion. Here, too, the extent of the singularity grows in proportion to specifiable individual features. Clearly, though, the secure reaching of a real individuality in

this way would be a never-ending task. If, however, a mental existence is grasped from within — not as the sum of its individual qualities, but as a living thing whose unity produces or determines all those details, or whose dissected parts are these details — such an existence is there from the outset as a full individuality. The more each detail extinguishes its particularity in an individuality, the fewer the independent borders with which one detail contrasts with the other, the more we sense that individual life for which the transposition of any element into another life becomes a senseless notion. This is in no way the case as long the details in their sharp delineation configure the whole. This is so not only for an isolated human being but also for the whole configuration into which context each merges into the landscape — with air and light, with the surge of color and form, be it that the figure develops itself out of these as their pinnacle, be it that all these together forms its extended body. The individuality of the configuration as a whole — its uniqueness due to the fact that each part exists and has sense only in relation to precisely this center — will in any case be favored by the absence of exact details. This is because such detailing bestows on the parts a particular existence that in principle facilitates their employment in another context and relieves them of the uniqueness of their present significance. This appears to me to be the deeper connection through which the commonly border-blurring, vibrant, and unclear in Rembrandt's way of painting can become the conveyor of his tendency toward individualization.

LIFE AND FORM

However, this individualization — as I sought to interpret it here as a life that is developed and grasped from within — bestows a different sense or another type of "necessity" on the "form" than does classical art. Rembrandt's predilection for ragged appearances, for the proletarians whose clothes, due to the haphazardness of their poor lot, appear in formally quite senseless tatters, seems almost to be a conscious opposition to the latter's principle. Compare this to the few equivalent figures in Italian painting whose threadbare rags are accommodated within a principally formal concept. In classical art, form means that the elements of appearance determine each other via a mutually effective logic; that the shaping [*Geformtheit*] of one immediately demands the shaping of the other. With Rembrandt, form means that a life flowing from a source has brought forth precisely this form as its result, or as the clearest instance of intuition of its totality as it exists in the form of becoming. It is as though Rembrandt experiences in the

symbolic representation, in which the artist reconstructs his object within himself, the total life impulse of a personality as though it were gathered together at one point. And he develops this through all scenes and fates up to its given appearance so that — fully corresponding to the individual movements — this apparently individual moment stands before us as something that developed from a distant beginning and concentrated its coming into being within itself. That which we have just articulated merely as a principle, but in the nontransparent, confused reality of experience can be perceived only imperfectly and accidentally, namely, that each moment of a life is the whole life — or, to be more precise, is life as a whole — artistic expression makes manifest in its purity and clarity. If each Rembrandt face finds the determination of its actual form in its whole history, so its individual contents cannot be read out of it. Rather, this alone becomes visually convincing: from the beginning, and in the potentialities of this being, a course of becoming leads up to and determines this actuality. It has come to be that which stands there [in the painting] through life's inner dynamic and logic.

Precisely this is foreign to Rembrandt: that the actual appearance purely as such — independent of that which in a historical-biographical sense exists before it, in a transcendental and mental sense behind it, in a physiological sense inside it — could possess a formal law that would belong to its self-sufficient appearance. Nothing like *contrapposto* [counterpoise] is, except by accident, to be found in his case.[iv] Everything is determined from the inside. And the wonder is that this produces a *pictorially* valuable appearance, just as it is a specific miracle of art that the greatest among the works of art that strive in the reverse direction — from the pure appearance toward its purely artistic forming — thereby simultaneously attain the expression of all inner, rather than immediate visual, values. But it still explains why some mere painters could and would not understand Rembrandt's means and effect.

Here once again the contrast between the Renaissance portrait and those of Rembrandt is to be formulated on the basis of the ultimate categories of the conception of the world. The two concepts between the interpretation and evaluation of which being has to decide at each point are: life and form. According to its principles, life is quite heterogeneous, distinct from the principle of form. Even if one says that life consists in continuous change, and in the destruction and re-creation of forms, so this, too, is easily misunderstood. It appears to presuppose that somehow — ideal or real — fixed forms exist, each of which is accorded only an extremely short duration in that life creates or reveals them. However, that which we really call life would then consist only in

movement that shifts between one form and the next, and would only exist during the interval that transforms one [form] into the other because forms, as somehow stable entities, cannot place themselves within life that is absolutely continuous movement. If we take this last notion seriously, than we cannot in principle arrive at that stability without which the concept of form is unthinkable. It may be unavoidable to label that which the inner restless dynamic of the living produces externally, its form, but we thereby introduce a concept that belongs to another order. Because form means that the phenomenon that the life process drives from within to the surface, or as its surface, becomes itself detached from the process. It acquires the solidity of an ideal existence by recognizing that its elements are united by and *mutually* dependent upon a new law of intuition purely as such (even though that intuition is fed from life). The form *cannot change itself* because changing itself means that there must be a subject that persists as such through the changes of its appearance. It means that one appearance and another (may these, as appearances, still have something in common or nothing at all) are associated through the identity of a force that drives forth from both of them and is effective in each. This is why only the living can change. Just as the logical mutual exclusion of unity and diversity is not valid for its construction, but rather the diversity of the organs functions as a unity that is indivisible in itself, so the diversity of the "forms" that a living being displays in the course of time is the inner-directed transformation of a unified being. The form, however distilled into a separate being in its own right, is complete. A somehow different form is not the earlier one that would have "changed itself" (if the figure of speech asserts this, then it reads something internal and living into it); rather, they stand unconnected, side by side, somehow rendered comparable only by a synthesizing mind. Through their distinct relations to time and to energy, form and life are absolutely divided. Form is timeless because it consists only in complementary and related contents of intuition, and it is powerless because as form it *can* have no effect. Only within the underlying continuous flow of life with its causal processes does this stage continue in further effects. But with the surface phenomenon — as soon as one has extracted it at this point — life has landed in a dead end, as it were. Or, viewed differently, its currents washed the respective form ashore — into a phenomenon that exists once and for all, and has absolutely no development — that the viewer combs off. The current itself develops in the continuing effects of its force without, as it were, concerning itself with the image that it may provide for some external perceiving view.

This corresponds, of course in countless gradations, to the principal difference between the two possibilities of the portrait. The problem of the classical portrait is form — that is, only after life has attained a certain phenomenon does this achieve for the artists an ideal existence of its own that can be presented according to norms of line, coloration, spatial clarity, beauty, and character. The artist abstracts the phenomenon from the life process that created it, and thereby only the *immanent* laws of their *forming* become valid for it, just as abstract concepts have logical relations among each other that are quite distinct from those through which the individual things underlying them are linked in fact. Naturally, we do not thereby abstain from the "animation" of the portrait, because the inner expression, in the sense discussed above with respect to the Renaissance portrait, is an immediate quality of the corporeal phenomenon itself. But also, within this style, the being that has a soul is not a life process in temporal development, but a being in a resultlike quality — a timeless definitive entity extended through and together with the dimension of the corporal phenomenon. In contrast, the form proffered by the Rembrandt portrait does not emerge out of the principle of form itself. It is not determined by the ideal norms or relations that allow the parts of the phenomenon to restrict and balance each other. Rather, a life driving from within — which that style allows to disappear behind the phenomenon — is here illuminated in the instant in which it emerges into its surface. This surface does not bear itself, so to speak, free floating because of the laws of timeless representation, but rather because of the dynamic of becoming and fate whose presence — borne by its past — means exactly this present phenomenon. In classical art, life only appears to have the purpose of bringing out form, and then, however, to step back behind it allowing the form its self-enjoying play. With Rembrandt, conversely, form is only the respective moment of life. Herein lies the never-receding focal point of its determinations. Correctly understood, a form is only the accidental way in which its essence — that is its becoming — turns outward. As in all great art, in classical as in Rembrandtian, in the last analysis art is about the unity of life and form; about the artistic achievement of that which appears unachievable in mere thought. But classical art seeks life via form. Rembrandt seeks form via life.

The basic categories — as they are effective in art — are not, however, exhausted with the distinction between viewing substance either from the standpoint of life or from that of form. At any rate, *weight* is a factor in the first place due to its adherence to the material in the three-dimensional works of art. The absolute weight of stone, metal, wood, pottery; the relative weight of the individual parts; the

reactions that absorb or distribute gravity correspond in respect to the purely optical impressions of the object to quite specific inner sensations. It must remain unexamined now whether this is about mere associations or experiences gained elsewhere of lifting, shoving, being pressed, or whether other, more immediate, forms of reactions are at work. The sensations of gravity fit, in a similarly unknown way, into the *optical* representation, thereby becoming aspects of the aesthetic pictorial impression. They are, however, in their characteristic also a quality of the two-dimensional work of art. It is not only that we attach a feeling of gravity to the pictorial reproduction of an — as an objective reality — heavy object, and let that which is so experienced codetermine the pure artistic effect. Rather, quite independently of some archetype [*Urbild*] and its weight, line-work, planes, colors function (even in purely decorative use) as measures and relations of gravity. Here we clearly find a significant moment within art that lies beyond the life principle and form principle in their usual sense because it is bound to the undifferentiated substance. Examined closely, in this sense weight is to be located after all among formal moments. Weight gains its aesthetic meaning through its greater or lesser quantity, through the relations of the individual parts thereto, through the play between the burden and its bearer. Decisively, weight, too, is a singular quality of the material, although the most general one and that most immediately associated with its extension. With respect to art, it therefore stands as a coordinated element, and as a single quality alongside color, spatial form, and texture, but not yet as the ultimate — lying absolutely beyond all singularities — that can be said of the matter experienced in the work of art. This is, rather, substance in general — the simple *being* of the material that absolutely did not enter into its quality, relation, difference, design — that which is the basis of all movement and gravity, forming and living.

Here, where we are concerned only with the explication of subjective aesthetic facts, I do not touch on the critique of this concept brought forth by physics and by epistemology. These may even dissolve "substance" completely into relations and oscillations. However, such a decomposition does not affect the layer of substance intended here assomething that is effective through a quite specific feeling. All sculpture, in the widest sense, seeks, via design, to overcome this dark substantiality of being. Its opposite is not the *senseless* form of lumps of plaster, or the unworked block of marble out of which a meaningful form is developed, but rather that which is absolutely foreign to form and never perceivable and is overcome by *every* forming. If one compares the Olympian sculptures with those of the Parthenon, one

feels in the former how they, so to speak, have just lifted themselves out of that original source [*Urgrund*] — that materiality of all being — that cannot be described further. This materiality is still perceivable in them, and only on the surface has it given way to that form whose differentiation and movement is divided from the core — as the real and unified essence of the structure — only by an ideal line. In contrast, in the Parthenon sculptures, this is fully grasped and permeated in the design. The mysterious unity of the substance in general is not perceptible here because it has fully melted into the respective particular form. One is inclined to compare the art of Olympia with pre-Socratic philosophers, and that of the Parthenon with Plato. However much more perfect, thoroughly designed, and so much more spiritual and subjective the cultural constructs of the Athenian heyday are in comparison to those other artistic and intellectual [cultural constructs], the latter appear to have arisen more immediately out of the origin of things and [appear to be] bound to it without a clear line of demarcation. The Athenian works, however, float, as though released, in the bright realm of the spirit. They have become life — have become form, right into their innermost core.

The role of substance is again modified particularly in the weighty massiveness of Giotto's figures. In the almost unstructured compactness with which, for example, the monks sit there in the Florentine apparition painting[19] or the praying suitors in Padua kneel,[20] the whole corporeal existence is represented by the, so to speak, poreless, unflowing clothes. Here the decisive impression is not only of weight, but precisely of a substance that cannot be further described; of an emphasis on the corporeal being. But substance is not — as in the case of the Olympian or some ancient Egyptian sculptures — something perceivable behind the surface, not something released by the form by which it is covered up. Much more in accord with Italian nature, which always drives toward the surface, even this undifferentiated entity, this mere presence of the bodily mass, still is at work as form. One sought to interpret this effect so that under the heavy, simple spread clothing the living and thoroughly structured body could be felt. I cannot feel that way. The naturally existing duality in a realistic and logical sense between clothing and body is here specifically overcome by the artistic vision, in that Giotto goes back to what these have in common: the pure substance of the tactile being, so that precisely thereby these existences acquired the essence of their visibility. I actually can neither feel something behind these clothes, nor are they, as with some artists, hollow wardrobe pieces that lack the required respective body. Giotto

raised himself above these alternatives by lifting that substance of the bodily completely out of its darkness beyond form and life, and by obtaining the visibility and perceptibility of his figures immediately by it, that is, made it in a way to form.

Thus, life and form — the metaphysical parties that otherwise divide up the essence of given structures between themselves — appear here as common opposition to that hardly nameable basic concept or basic material of being. As already mentioned, just as sculpture — understood purely as the will to visible design — is about the overcoming of this undifferentiated matter, so it appears that life, too, can be interpreted in terms of the same tendency. While that dark substantial being resides absolutely in itself, life is that which at all points wants to go beyond itself, reaching out beyond itself. By pervading substance with itself, life sets it in inner motion, in contrast to which the mechanical is only a pushing to and fro that leaves its inner essence untouched. That life continuously draws inorganic material into the organic process is only one side — a phenomenon or symbol of the deeper metaphysical direction of life in general with which it dissolves the individual essence of its substance in or through itself. It is quite remarkable, and indeed signifies one of the ultimate possible conceptualizations of being, that its great sense-giving categories — life and form — are born by a substance that is prior to all designation; a substance that continuously becomes absorbed and vanishes, so to speak, in life and form, but which nonetheless can somehow be felt through them. The extent to which this is the case belongs to the decisive differential factors of the impression of the living beings and works of art. In many ways it has been said of the essence of the organism that nothing living is completely living — that there is in each of them something that is still dark, not yet been fully vanquished and pervaded by the motion of life, or whatever one wishes to call it. If we speak of stages of life, if we claim to see in some appearances a more complete, stronger inner (not only outwardly) living quality than in others, if this more definitive life simultaneously appears as a more definitive individuality, then all this means that there is a concomitant retreat of that unsignifiable something that gradually enters into life and that — as that which is always vanishing but has never vanished — is always constant, quintessentially unified, and thus untouched by individuality.

Whether in the Gothic the dissolution of matter occurs through the ascent into the vague and vanishing, or through the displacement of the weight-bearing elements (which thereby make matter perceivable) onto the exterior of the church, or through the breaking through of the

stones into the ornamentation that permits it to appear as a weightless unfrozen point, whether through the bending of the body that appears to negate its natural structure or through the unrealistic size of the head as the bearer of expression (on which the whole body often hangs like a loose, needy little bundle), the principle is always the same: material should not exit. But not such that now in its place, as Plato wished, there should be form, but the pressing, self-elevating, self-fleeing of the soul. The significance of the Gothic is not *life*, however. For that there is too little oscillation, polarity, elevation, and seepage in it. The essence of the Gothic lies in a straightforward orientation of the soul toward transcendence that has left behind its life, or for which life is merely a bearer irrelevant in itself. It is precisely here that we see that the Gothic in its purest and most authentic type (i.e., in the French Gothic, whose further development was later redirected by the German) has by no means the antirational character that the common contrast with the classical and with Italian Romanesque often makes us believe. The striving toward clarity and mathematical precision lies in this linear art, which clearly, as such, already means a struggle against the three-dimensionality of matter, a peculiar rationalistic mystique. In that this art, in contrast to other types of linear art, emphasized the thinness and endlessly elongateable nature of the line, the medieval conception of the soul acquired the deepest symbol with it. But in the verticality and one-dimensionality toward which this style aspires life, with the self-unfolding of its diversity within unity and its unpredictable radiation, cannot be accommodated. Rembrandt's religious paintings are the exact opposite of the innermost principle of the pure Gothic insofar that the former piety proves itself to be the way in which the soul *lives* in all the abundance, colorfulness — yes, coincidence — with that which is characteristic of its form of life. Here a fourth element occurs. Beyond the form and life, substance still stood. And now the soul stands equally there in contrast with substance — not its life, but rather its transcendental destiny that now is, so to speak, *its* substance. Life and soul are not congruent, but only crosscut each other; each is more general than is the section in which they overlap. *This* soul is not individual. The Gothic soul, because the transcendental is essential to it, has no individuality. Only life is individual. Only in the form of life is the soul individual as the substance (at a lower level) is [individual] only in the form of form.

I am following here the structure of the concepts with which we divide up the idea of the world [*Weltbild*] not beyond that point at which the polarity of form and life underpin at all the even unity of

substance. If physics and metaphysics also dissolve these into relations, before that dissolution has gotten far it reaches a point at which the feeling of life and art in its variety may well be interpreted only in terms of the differentiated perceptibility of this substance in all that is living, and in all that is formed.

2

INDIVIDUALIZATION AND THE GENERAL

TYPE AND REPRESENTATION

The relationship between life and form expounded here makes clear why the portrait figures of the Renaissance always appear to be somehow typical, while Rembrandt's give the impression of individual uniqueness. The norms, on the basis of which elements of appearance purely as such are formed into an optimum of artistic visualization, are unavoidably of a *general* nature. They are in a certain respect analogous to natural laws that determine very diverse individualized phenomena as a uniform behavior insofar as these phenomena, with all their differences, provide the same conditions of applicability for the law. So it is characteristic for the Greek sense of form (as expressed in poetry just as in sculpture) that early Hellenism created a plethora of new metric forms, which, however, very soon gave way to the domination of the hexameter and the distich. In the final analysis, the Greeks find a small stock of forms that present themselves as the generalized representation of very diverse contents and shades of emotions more pleasing than individual, and therefore unavoidably novel, forms that develop anew on each occasion around each distinct material. In the classical period, the elements are formed as if to evoke the most favorable impression in a typical viewer with respect to characterization, beauty, and clarity. This "as if" should indicate that its content does not require a conscious, or even abstract principled, intention, on the part of the artist.

Here, too, perhaps a very general characteristic of Mediterranean peoples is revealed: to adjust their behavior to the presence of a viewer. Even today, a quite characteristic difference can be observed when we hear a worker who is walking alone across a field singing, unaware of being noticed. The German not only sings "for himself," but also as though out of an inner mood, be it cheerful or sentimental, or is simply moved in a way that wants only to be expressed, such that it does not matter to him — to put it in somewhat stark terms — how it sounds. On the other hand, the Italian sings at such moments as if for an audience, and as if standing on a podium. In Italian Baroque this gains, like a number of deep and vital characteristics of the inner life, an externalizing, exaggerating, and at the same time rationalizing expression, namely in the complaints of the theoreticians of art about the popular dissemination of portraiture, which in their view should retain the mission of exerting a refining influence on the viewer through the depiction of especially outstanding personalities! The entire range of stylistic phenomena is colored by this basic notion. One merely has to look at an Italian cupboard or a chest next to a piece of German Gothic furniture. In the former case stands the facade of a palace in miniature; the taste of a people who for the most part live outdoors and who transfer their representation oriented to a public even into the forms of interior furnishing is predominant.[i] The forms of a Gothic cupboard, in contrast, do not tolerate an enlargement beyond the dimension of the room (except perhaps for tracery detached from the actual structure). They withdraw from that which one might call public effect, and from that which has not only a numeric but also a qualitative meaning, and which applies to the tectonics of the Renaissance in its smallest works. Out of the term "*Gemütlichkeit*," which the Romance languages do not even possess,[1] speaks, only on a smaller scale, just this directedness toward personal intimacy — the diametric opposite of representation, and of being seen. Whereby this latter is undeniably, in the best cases, the exterior of a certain kind of heroic greatness and magnitude that cannot be found as easily in the former. Furthermore, from this characteristic results a certain lack in Germanic peoples of values of aesthetic sensibility; values into which Romanesque culture had educated itself.

This seems to me also significant for Greek art in contrast to the Germanic principle (however rarely its *completely* pure expression is to be found outside Rembrandt). The human being of the Greek statue has the pride of his beauty, and the consciousness to present this beauty to the viewer. As soon as the surface phenomenon, with which life as its result presents itself to the outside, becomes the self-sufficient

material of artistic design, the decision to direct interest toward the viewer has been made.

This ideal viewer represents a decisive moment of the whole classical style. One only needs to compare an Italian burial with one of Rembrandt's. In the latter each appearance is completely individual, and one could not name a law of form that would stand evenly above them all. Their unity, however, lies in the fact that each of the figures completely dissolves in the act of the respective emotion. Despite its quite unique appearance, none of the figures seeks to stand there as something like a being for itself. With the Italians, in contrast, all figures have the formal type in common, but it is their special quality that each should be beautiful for itself. Losing oneself in the process as well in emotion transcending mere existence finds its limit within the intrinsic aesthetic value, and in the emphasis on the individual, which, as it were, is never forgotten and which spiritually always remains separated from that which individuals feel, and from their self-classification. Each participant in Raphael's *The Entombment*, for example, is not only there for the event but also, as themselves, for the viewer. Thereby, however, he is at the same time confronted by the viewer as someone who is worth viewing, who demands recognition, who takes pride in himself. Being confronted with someone and being-for-oneself belong together. In contrast, Rembrandt's figures never think of the viewer, and precisely, therefore, do not think of themselves. The proportion of self-assertion and self-denial, which somehow determines each human existence, stands in the case of these figures between atypical individuality and the dedication to the events and inner reactions thereto; while in the Italian work those elements stand in the design, on the one hand, within the common style of a general law that requires a viewer, and, on the other hand, in a proud representation of individual self-awareness and self-control. Clearly, though, the latter design of those basic proportions is endowed with a certain grace and refinement that is lacking in Rembrandt's figures. It is not as if they display the opposite of these qualities in any sort of positive sense. They are simply completely untouched by the whole polarity of refinement and lack of refinement. For the latter — as they appear with respect to Renaissance figures — depends on the real or ideal presence of a vis-à-vis; or, rather, this refinement, although a form of personal conduct, itself consists in a peculiar mixture of reservation and representation toward others; of a proud distinction and at the same time of a need to be seen and recognized by the other.

The portraits of Frans Hals in which the represented person is almost always in a relationship to a third person who is not depicted have a

quite different meaning again. This is because this third person stands completely in the ideal space of the picture. Therefore, one has associated the special talent of Hals for group portraits precisely with this feature, just as if only the otherwise invisible correlate of an individual is made visible in them. Indeed, the ideal viewer in classical-Romanesque art is not the living individual standing in front of it — because to involve the viewer always means a sort of coquetry with him that constitutes one of the crudest, inartistic effects — but in turn stands in a totally separate transcendental stratum: the figure not an individual within the work of art, as in Hals, nor an individual outside the work of art, as in the latter case, but an absolute universal related to that "idea" of the depicted person of which both its empirical reality and artistic representation are specific forms.

Perhaps that characteristic classical conception of human beings is tied to the feeling that only peers can acknowledge each other. For this can have the consequence that the individual has to be reduced to a general human in order to affect the viewer and mediate an understanding. Where the ideal viewer is a determining factor, the individual becomes insignificant in comparison to the general, as though there were a general humanity in which there is free traffic, as it were — that is to say, in which the individual components (e.g., the type of viewer and the type of object) mutually understand each other without difficulty, whereas this is no longer the case as soon as the levels below this one — that is, that which is contiguous to individuality — are at issue. In that view in which only like can understand like, fundamental features of the Greek worldview meet: an aristocratic attitude in which the noble closure of the circle corresponds to the inner parity; a basic metaphysical-monistic feeling; and an attitude toward sensuous-naive visuality for which the relationship of objects has to be conveyed by an external equality. Since, accordingly, that principle is deeply rooted within the Greeks, its continuous striving toward typification, and toward intellectual and artistic disclosure of the general, becomes understandable on the basis of which the subject would gain an affiliation to other subjects or objects. Here once again we are reminded of the above-mentioned characteristic of Mediterranean peoples. Those who seek to represent themselves, through their actions and being, to another person — be it in more acute or more chronic form — easily slips into the behavior of a type. For such persons want to represent — even in the absence of special emphasis through vanity — something. And from the beginning, this something is not mere individuality, limited in itself, but something transcending it. It is as a something somewhat transpersonal; conceptually expressible in a way the pure

personality never is. In many ways it can be observed that human beings, when they want to present themselves to others, transcend the point of the personality as it is merely in itself; that they present themselves as bearers of an achievement, as representatives of an idea, or of something somehow more general. They adorn themselves (which should by no means be regarded as something inferior, but as an expression of a special attitude toward life) with a broader circle around that point of the personality, which *eo ipso* means something general, even if the content of their intention is ultimately only the "I." What is ethically meaningful in this Greek point of view is that if a person represents something in a conceptual or sociological sense external to himself (beauty and grace, strength and specificity of his circle), freedom and responsibility are not thereby taken from him. In a metaphysical rendering, all this is reflected in Plato's idealism. Here, individual objects represent something general; they are not simply themselves. Just as in Greek sculpture the figures know that they are being viewed, and therefore have to represent something, so, too, must the individual objects. They acquire their whole meaning from the idea that they represent. The touch of play-acting that one can feel in Greek culture and which determines the form of dialogue of Platonic writings, is connected to this structure. There exists a deep connection between the representation-for-each-other and the typification of one's own image that understandably enters into the ideal constructions of human beings in general, and whose domination within classical art led to the proposition that the portrayer has to elevate and restylize the model into a "type," a proposition that is justified in respect to the Greco-Roman orientation toward life, but is an erroneous one-sided-ness when understood as a general *objective*-artistic necessity. At least in terms of extent, Rembrandt was the first to free the individual as an artistic construction from randomness. He gave to it that which — in a probably rather unclear expression — we call "necessity," without achieving this at the price of a generalization toward a type. The solidarity of necessity and generality, as taught by Kant, may be valid for theoretical propositions (he himself had already transposed it in a thoroughly questionable way into ethics) because the claimed general validity of a morally necessary maxim for all subjects in general is, as already suggested in an earlier context, certainly opposite to the mor-ally necessary actions that spring forth from the basic uniqueness of the individual, and which are thus void as a general law. Even more one-sided, however, is the transposition of that correlation into the artistic realm. Here, Rembrandt made clear that out of the innermost life of a person appearance can be developed into a convincingly necessary

form that in no way borrows this development from a general law. The form is, moreover, so completely identical with this individuality that its repetition in another individuality may well be possible by chance, but makes no sense as a general principle.

TWO CONCEPTIONS OF LIFE

If the way in which Rembrandt makes a personality comprehensible has a different goal and takes another path than that which is mediated by a type, then this reflects the far-reaching difference between the two modes in which we know a human being at all. The first ascribes general categories to the inner life: a person is clever or stupid, generous or petty, good-natured or malicious, and so on. This is, at a higher level of refinement, the path taken by scientific psychological knowledge. Strictly speaking, though, my knowledge of the mind is not enhanced by it. I must already know all these states and conditions, and what I learn is only that they have manifested themselves yet again in such and such a combination in the case of this particular human being. I do not, thereby, know this human being from within, but rather my knowledge flows from concepts that I have already brought with me. That this type of knowledge is, despite all its significance and indispensability, only secondary, is demonstrated by the simple consideration that I can only know *which* of the concepts that were already available to me are applicable to a person on the basis of an immediate knowledge that is not to be grasped conceptually. The first stage of this immediate knowledge has already been acquired at the moment in which — in brief — the person enters the room. In this very first moment we do not know particular facts about him, nor any of the aforementioned categories. Nevertheless, we still know a tremendous amount: the person, and that which is unmistakable about the person. The bodily uniqueness upon which this first presence fixes is a symbol, or perhaps more than a symbol, of this. And there is a continuous developmental series of knowing which commences at this first moment, and continues in the same fashion, which merely deepens and increases this initial, completely indivisible, knowledge without thereby being increased in particular *installments*. It remains something completely unified, reflecting this singular individuality, and its deepening and enhancing is unrelated to the fact that the other series of insights is progressing as well in accordance with specifiable single qualities. What is decisive here is not that which is beyond all doubt (that a human being is an entity which cannot be assembled from the sum of their specifiable qualities), but rather that the cognition of

precisely this individuality is carried out, as it were, with a particular sense that absolutely does not coincide with the senses of the cognition of describable qualities. Rembrandt must have possessed such a sense to an astounding degree. Out of his portraits shines above all essentially that which we know about a person at first sight, as something completely inexpressible, as the unity of his existence. For only the totality of the human being (that which Rembrandt makes visible as the total course of his fate) is unique. All individual characteristics are generalities. The Italian portrait is essentially directed toward the latter. In that it conceives of the human being as a type, or even as a plurality of generalities, it poses it rather *opposite* to the viewer, or the viewer opposite to it, whereas the understanding of the totality encompasses to a higher degree a melting into, an empathy, that, in the moment of contemplation, allows the subject-object setting to immerse into the greater indivisibility of intuition.

But herein, of course, lies precisely that which determines the classic style in an eminent sense as a *style*. For style always means a *general* form-ing that is equally effective for any number of quite distinct phenomena, a unity of the feeling for life that flows forth from all of these as soon as they are subject to that design. In that classic art designs phenomena under the primary category of their being viewed, it gains, with the ideal viewer, a *terminus ad quem* whose supra-individuality and typical man-ner allow these diverse phenomena to flow into the uniformity of *one* principle of form. Regardless of the "how" of the style, classical art as such thus appears, in comparison to Germanic art, "stylized." It is in this context that, out of the classic principle of pure form — that is the imma-nent law of surface elements of the stage of life that has cut itself off from its development — emerges the character of the type, the general that (aside from a limitation that has to be dealt with later) characterizes the Renaissance portrait. It must also be added that the form as such is com-pletely of a supra-individual nature; its relationship to the multiplicity of material things entering into it in their entire diversity and constituting their equality is analogous to the relationship of the general concept to the singular case subjected to it: wherever the principle of form guides, the path leads beyond individuality. With total consistency this principle arrives at the point characterized by the architectural theoreticians of the High Renaissance: architectural beauty must be produced once and for all out of the universally valid proportions of the mass of the material. The absolutely general form, developed purely out of the material principle, is inherently diametrically opposed to the principle of life.

Therefore, wherever the latter principle is dominant, the path back leads to individuality. Whereas form as such adheres to abstraction, and

thus to generalization, life is bound to individual creation. Naturally, one can also form a general concept of life or of the living, but, in a totally different sense and proportion, the individual has a life of its own just as it has its form of its own. Form is not nailed to reality; it has an ideal validity that can be taken on by any number of realities. Life, however, is as such only real, and therefore contains in all of its sequences that uniqueness that possesses each piece of reality as reality. That the same existence should occur twice is quite nonsensical, whereas the same form can occur in two, or in an unlimited number, of existences. If a human phenomenon is to be understood from out of the life process (rather than of out of the rational or visible logic of the closed complex of a phenomenon itself), then it simply emerges from an absolute uniqueness and individuality of existence. This existence may share its form (or, what is equivalent in this respect, its contents) with countless others; it may have and must have absorbed a great deal within the current of its life that others — that the world — offers it. But even taking all of this into account, it still remains only this one [existence] in its temporality extending from one noninterchangeable point of being to another noninterchangeable one. As previously stated, its form and its contents may be comparable, but its process is beyond the alternative of comparability and incomparability. It has the uniqueness of pure becoming that cannot at all be expressed by means of qualities conceived of as static or dynamic. It is the meaning of the "individuality" of Rembrandt's figures that the life process itself becomes visible, but not as a qualitative difference or uniqueness of being demonstrable by specific contents, since this is a thoroughly relative and random individuality. Even if an existence, in one or all of its stages, would look exactly the same as some other one, it would nevertheless still be, with all of its preconditions, derivations, and borrowings — as a life process; as a reality of becoming — just this unique current. The sensed individual uniqueness of a resulting specific appearance of the surface phenomenon of a life is only a synonym or a symbol for the fact that its process of becoming is invested in it; that the life process — as such a single series of unmistakable events existing only within it — is what is really seen in this given [appearance].

Notes on the Individuality of Form and on Pantheism

The Renaissance was certainly pantheistic-minded. However, that actually did not well match the self-sufficiency of the sovereign inherent value of forms. However trans-individual the form in

relation to empirical reality may be, it is nevertheless something individual in relation to the undifferentiated totality of being. Precisely because of its exclusion of continuity and movement, each form is separated from each other quite clearly and in a completely unaffected way. The pantheism of the Stoics overcame this contradiction because a mythic-hylozoistic attitude was still effective in it, for which each part of being that we (irrespective of with what kind of subjective arbitrariness) regard as "a thing," is filled with inner life. In that the Stoics presupposed a divine soul of the world as a basic force in all being, the contradiction between the individual character of the singular appearance and the overall animation of the universe, between the sum of individual entities with inner life and the unity of the soul of the world, merged as if, in Rousseau's expression, the *volonté de tous* would coincide with the *volonté générale.*[2] Each piece of the universe appeared as filled with inner life in itself, organic, precious, precisely because the residing force of the soul of the world determined its form.

Now, for the Renaissance, pantheism was probably compatible with the enthronement of form, in that the pantheistic divinity was not yet felt in its full contradiction to the Christian God. The God, who is a person — that is Himself something of form and individuality — is compatible with the singularity of the things of the world. He may be conceived of as being as mighty and unified as one wishes, nevertheless He *has* the world; He *is* not the world. Only when God is totally absorbed in the world, or the world in God, is His unity from the outset the unity of the world and does not allow an absolute separation of its elements; does not allow that being-for-itself that borrows individual pieces of reality from their form, even if their matters are thought of as continually connected among themselves.

Giordano Bruno, who is regarded as the epitome of the Renaissance philosophers, seems to me to express in this respect rather the basic feeling of the Baroque: the dissolution of meaningful form, in its specificity, in favor of a general coherence. This alone is the unified and absolute, within which each element gains a meaning only in relation to the others. For Bruno, all phenomena that shape themselves as fixed forms nevertheless merge into each other. Imagination can mold anything out of anything, even that which is conceptually contradictory — for example, the beauty and the ugly touch each other in that each has a minimum coincidental with the minimum of the other. The legitimacy of the

imagination, when it transfers each individual design into each other by despising all predetermining rules, lays in their inner relationship, in the identity of essence that is rooted in divine unity. Here pantheism has taken the path which indeed does not deny the existence and the meaning of separate forms of things from the outset (as happened later in its highest stage with Spinoza), but nevertheless softens them; mixes them up with one another; breaks through their special privileges; acknowledging them in relation to and within the central underlying and comprehensive unity. Now, with Bruno the stage corresponding to Baroque is reached in contrast to the naturalness with which Stoicism let divine total unity induce its life into individual form, and in contrast to the strictness of form of the High Renaissance whose pantheism seems to be compatible with it, because in this the theistic — somehow individualizing — conception of God still takes effect.

With Rembrandt, we are not dealing with a total life that dissolves forms and is still in some way exterior to them, but rather with purely individual life. Forms do not disappear in the unity of cosmic life like the particular in the general, but the individual life dissolves form from within. *This* is now the general and disappears as such (in the opposite direction to the former case) in individuality.

DEATH

The expression of the connection of the life-principle and individualism, and their common opposition to the classical type of "timelessness," includes yet another element: death, whose relation to all these motifs is highly significant, but which can only be expressed in words as if from afar. Above I spoke of the past life of the personality that Rembrandt renders perceptible through the imprint of fate in the sitters' features, conjuring up the succession in the momentary look, and [I said] that, among his portraits of young people — which provide less material for this purpose — only a few portraits of Titus contain and disclose a foretaste of the course of life as though time had been reversed. Nevertheless, *one* future moment, which after all makes life into a totality precisely by breaking it off, inhabits all Rembrandt portraits: death. From the outset it has to be admitted that what is said about it is completely unverifiable; not merely in the sense of a hypothesis that will perhaps never be proved beyond doubt, but is in principle capable of being proved. Such interpretations belong to a totally different

stratum in which success lies much more in an immediate consent than it does in proof. This will certainly become the case for the interpretation of a work of art where its plurality of diverging impressions are experienced in harmony with each other, and as belonging together in a unified way through the newly emerging concept. Naturally, where this occurs it can only be verified as a fact, but not deduced from the logical force of the concept. Given this reservation, the moment of death — inherent in all living things — as captured by Rembrandt, seems to me more emphatically and more compellingly tangible than anywhere else in painting. A certain sensibility toward the relationship of life and death seems to me to exist with him (the theoretical expression of which would have been far from his mind), and he seems to possess the deepest insight into the significance of death. I am convinced that this insight depends entirely on one's giving up the conception in terms of the *Parcae*: as if in a certain temporal moment of life's thread, which until then had been continually spun as life and exclusively as life, had been "cut off," as if life were predetermined to confront death at a certain point in its course, but only then, in that moment, comes into contact with it. Instead of this conception, it seems to me beyond doubt that death *inhabits* life from the onset. Indeed, death reaches macroscopic visibility — absolute domination, so to speak — only at the moment of death. But life would be different from birth on, and in each of its moments and cross-sections, were we not to die. Death is related to life not like a possibility that at some point becomes reality, but rather our life only becomes life as we know it, and is only formed as it is, in that we (whether growing or fading, on life's sunny uplands or in the dark shadows of its decline) are always and already *such beings that will die*. Clearly, we shall die only in the future, but that we shall do so is no mere "fate." Even though linguistically we are inclined to consign death exclusively to the future (i.e., as something that is unreal because it becomes important for our praxis only in that hour), the awareness that we shall die is not simply an anticipation, an idealized foreshadowing of our last hour, but is the inner ever-present reality of each moment. It is a coloration and shaping of life, without which the life that we have would be changed beyond recognition. Death is a quality of organic existence, just as it is a primordial quality, a function of the seed that we express thus: someday it will bring forth fruit.

Now, his way of experiencing death seems to speak out of Rembrandt's conception of the human being only there, where he draws this conception up from the ultimate depths; not in an elegiac or emotionally emphasized sense, because the latter originates precisely there, where death appears as a violation of life from the outside, as a fate that has

waited for us at some point on the course of our life, unavoidable as a fact, not as a necessity out of the idea of life itself but as that which contradicts it. If death is conceived of in this way — as an extraneous power over this life — then it attains the atrocious, deplorable character against which one either revolts heroically, or toward which one lyrically subjugates oneself, or with which one has nothing to do inwardly. The last of these is universally represented in "dances of death," in which this conception of death as exterior to inner life is pertinently symbolized in that death becomes visible as a being standing spatially outside its victim.

It is different, however, if death is immediately felt with and within life as one of its elements. Now we are no longer "threatened" by death as by an enemy (or as by a friend) coming from afar toward us, but rather death is from the onset a *character indelibilis* of life. Therefore here there is, so to speak, little to be made of the matter. Death is within us from our first day on, not as an abstract possibility that at some point will realize itself, but as the simple concrete fact [*So-Sein*] of life, even if its form and its measure are highly changeable, and if only in the last moment it permits no deception. We are not "under the spell of death." This can only arise where the functional and immanent element of death is hypostasized into something substantial and into an independent separate figure. Rather, our life and its whole appearance would be totally different from the onset if it would not be pervaded by that which we call (according to its definition) death.

One of the deepest typical conditions of our worldview becomes valid here. Many of our essential determinations of being order themselves into dichotomies such that one concept finds its meaning in the correlation with the other: good and evil, masculine and feminine, credit and debt/blame [*Schuld*],³ progress and stagnation, and numerous others. The relativity of the one finds its limit and form in the other. But now these two relativities are often once more embraced by the *absolute meaning* that one of them attains. Certainly, good and evil, as relative terms, are mutually exclusive. Perhaps being in an absolute divine sense is absolutely good, however. And this good contains in itself the relative good and the relative evil. Certainly, mental progress and mental stagnation fight each other irreconcilably. However, perhaps the world-process of the mind is an absolute progression in which that which is empirically designated as such is something relative, and in which that which we call stagnation also aligns itself as a mode of progression. And so perhaps life and death — insofar as they seem to exclude each other logically and physically — are still only relative opposites, embraced by life in its absolute sense that underpins and embraces the mutual limitation and conditioning of life and death.

Whether one expresses the immanence of death in life metaphysically one way or the other, the most profound Rembrandt portraits seem to me to announce the basic fact itself. To grasp this, and the uniqueness of his art that lies therein, requires a further examination of his relationship to the classics.

Even a general impression of classical art and that of Rembrandt allows us to say that the former is directed in a certain way to the abstract forms that life sediments and solidifies at its surface; the latter, however, is directed toward life in its immediacy. Greek art does not want to detach itself from life, does not want to relieve itself of life as perhaps the Egypt-hieratic and the old East Asian art do. However, its intention is after all not the respective unique sequence and individuality in which life temporally goes by, but the structure — at least apparently detached from this flow — in which solidified life articulates itself outwardly. Greek art thus seeks the laws in which the elements of its phenomenon belong together, and which, precisely as law, are detached from all time and from all individuality, and are not, as with Rembrandt, nourished, elevated, and lowered in each moment by the inner, invisible, and, if one wishes, formless liveliness. In classical art, the individual construct owes its meaning to the general lawlike form and precisely out of this already mentioned representative character originates the (in a certain sense) theatrical character that adheres to Greek art — yes, perhaps to Greek life. The individual here is not simply itself but represents something general, just as the role is something ideal, something general, that gives to the individual actor the meaning and content of his existence.

To represent something trans-individual (and thus fulfilling the value of individuality) gives grace and pride to the Greek appearance, but also [gives it] its dependence on being looked at and being recognized. And this is why the principle of generality links itself to the direction toward the outwardly constructed; toward that art-phenomenon of life that congeals the movement of life into a solid construct. To the highest degree, Plato has (as I have also mentioned already) expressed this abstractly in that things are for him nothing other than the representation of the idea; not meaningful in themselves, but insofar as they transfer something general into the form of visible reality. For Plato, the individual thing is the actor of the idea: it plays the role that is ideally prescribed to it and to innumerable other individualities, and, like the actor as such, it is a thing only on the basis of this general order. The idea can be represented by many individual things, just as a role can be performed by many actors.

Here, indeed, I repeat, lies the deep relationship between the classical turning away from pure individuality and the turning toward the

self-sufficient *exterior form* of life that obeys its own laws and that conceals life's invisible inner current that is not graspable in fixed structures. Rembrandt, however, infused his most perfect portraits with the tidal flow that overflows with the movement of the full life itself, each form from within. And only now, looking back to our interpretation of death, does this attain its full significance. Those portraits contain life in its widest sense, which also includes death. Everything that is merely life, such that it had estranged itself from death, is life in its narrower sense; it is in a way an abstraction. With many Italian portraits one gets the impression that death would come to these people in the form of a dagger thrust. With Rembrandt's portraits it is as if death were the steady further development of this flowing totality of life — like the current with which it flows into the sea, and not through violation by some new factor but only following its natural course from the beginning. Rubens's figures have seemingly a much fuller, less inhibited, more elementally powerful life than do those of Rembrandt, but at the cost of representing precisely that abstraction out of life that one gains if one leaves death out of life. Rembrandt's figures have the half-light, the muteness, the questioning into the darkness; exactly that which in its clearest, finally, absolutely dominating appearance is called death, and which, regarded superficially, precisely to that extent appears to contain less life. In reality, they contain precisely thereby the *whole* life. This is valid mainly, though not exclusively, for his late portraits. If one looks carefully at the Dresden self-portrait with Saskia,[4] his unadulterated joy of life appears a little artificial, as if it came momentarily to the surface of his nature, whose depth, however, is malformed by grave, inescapable fates reaching from afar. This becomes almost frighteningly clear when, by way of comparison, we look at the laughing self-portrait of the Carstanjen collection (of thirty-four years later).[5] Here, the laughing is unmistakably something purely momentary having, so to speak, come about as a coincidental combination of life-elements, each one of which is quite differently tuned. The whole is as if infused by, and oriented toward, death. And yet, between them exists a quite uncanny similarity: the grin of the old man appears only as the further development of that youthful joy and as if the element of death in life, which in this joy had withdrawn itself into the deepest, most invisible, strata, has now been driven up to the surface.

It is only in Shakespeare's tragedies, I believe, that death has a corresponding significance for life. With all other dramatists, death appears to me like the *deus ex machina* that cuts off the entanglements of soul and fate when they have of themselves reached the stage of insolubility.

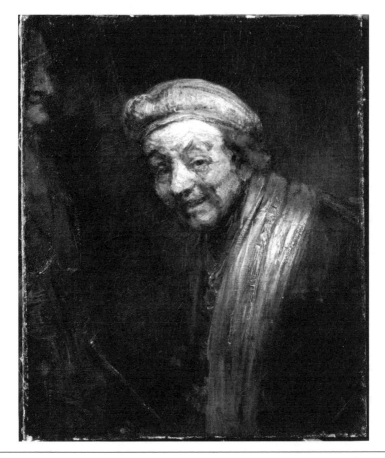

Fig. 2.1 Rembrandt. *Self-Portrait* (1666–1669). With kind permission of Rheinische Bildarchiv Stadt Köln.

That the hero dies is not necessary here from within and from the onset, but, rather, he finally has no other choice in the face of events that are in and of themselves developed out of pure laws of *life*. He does not bring death along with him, as it were, but only confronts it at a certain point, toward which, of course, his path has been leading. Shakespeare's tragic heroes, however, have death in their life and in its worldly condition in a way as its *a priori* determination. Death is not the consequence, but the immanence of the singularity of their lives. The ripening of their fate is simultaneously the ripening of their death, as if each were the expression of the same fact. Therefore, when death really occurs it has only a symbolic effect. Laertes's poisoned rapier and the somewhat drawn-out effects of Juliet's sleeping draught are such exterior and cheap means that the indifference toward the way in which

death realizes itself at a certain moment becomes perfectly clear. Therefore, only here death is truly tragic; for we shall call tragic only that which destroys life but nevertheless emerges out of life's own law and meaning — that which, though overcoming the will of life, still at the same time and thereby fulfills life's ultimate, most secret, order. Therefore, however, only the really tragic Shakespearean heroes die this death. Those subordinates, who also perish, do not because only in the former cases is life so great and wide that it, already or still as life, can include death within itself.

In general, the thought of death has a remarkable relationship to the artistic representation of the human being. Not only because the portrait can live for centuries or millennia, but also because, insofar as it is artistic, it lends its contents, *timelessness,* a tension can be felt, namely that it represents a still perishable being. In life's motion, which also, sweeps the observer along in its current, death, which is entangled with it, may completely disappear for us simply because it is, irrespectively for now whether this is justified, quite constantly considered — as being always the same and general. Common consciousness, however, eliminates this in order to cling on to the importance of the diversity of life. However, where the configuration loses this immediate movement, which deceives us in a certain way about death and seems to deny it, death is made visible by a heightened sensitivity toward it. This at least seems to me to be one of the most vital differences in the impression made by the real, and that made by the artistically reconstructed, human figuration: for the latter, because it stands in the sphere beyond the flow of life, death somehow becomes perceptible precisely by its opposition to this sphere — precisely because death is a stronger opponent of the atemporal than is life. It is precisely in the portrait figure that death, the ephemeral in our life, the *destiny of transience,* appears to me to be woven in (clearly with very different degrees of clarity) in such a way that it cannot be extracted without destroying the whole.

Within this generality, major differences emerge, however. It was not a concern of classical art to bring out the whole depth of the opposition between the temporality of the mortal nature and the atemporality of its design in art. Moreover, classical art, with some important exceptions, sought to bridge the gap, to unify it, in that it elevated its object in its whole quality and meaning into the sphere of timelessness. It accomplished this by *typifying* the object. Only the individual dies, the type does not. In that it moved away from the former and represented the latter, it reduced the tension between the art form as such and its respective content. It placed the idea of timelessness above both. It already had reduced the objects as an artistic material to that stratum, or that meaning, in which they

entered into general style as though automatically and without resistance to that which from the outset and can already be regarded in themselves as timeless — that is, to their type, to their abstractly (though not conceptually) expressible, general nature. In terms of what could be seen in it and what was taken out of it by artistic creation, the object itself had to remain in close proximity to the style that determined the artistic creation. The artistic atemporality at first holds on to that object that it could assimilate: the immortal in human appearance; that which is precisely the genus, the type, of each appearance; that which in appearance is foreign to death.

Nothing can demonstrate this connection better than the fact that the relationship is also constituted in exactly the same way but in the opposite direction. That perceptibility of death in the greatest Rembrandt portraits corresponds to the extent to which they adopt the absolute individuality of the person as their object. And this is understandable from within. The type, I said, does not die, but the individual does. And the more individual, therefore, a person is, the more "mortal" he is, because the unique is simply irreplaceable, and its disappearance is therefore all the more definitive the more unique it is. Those organisms where the individual being reproduces itself simply by division into two beings and thereby disappears totally, definitively constitute the lowest level of individualization; and it is precisely to them that the concept of death has been declared inapplicable because their disappearance leaves no carcass. The absolute dissolution into the continuation of the species, not even permitting a carcass, negates death. Therefore, with peoples who, either out of underdevelopment or in principal out of their societal culture, exclude individuality as an actual value-principle, we find a great indifference toward death. Anyone who limits, or, if one wishes, expands, his nature to that form in which they are identical with their type, with the general concept of their genus, would be in a deeper sense present *in* all time and be *above* all time. Whoever is unique, however — whose form disappears with him — he alone dies definitively, as it were. In the depth of individuality as such the fate of death is anchored. Goethe apparently felt differently about this in that he granted human beings immortality only to the extent of their significance. Thereby, however, he looks in another direction than that now taken by our gaze. He is worried by the contradiction between the *measure of power*, which the important personality feels from within, and life's duration that does not allow this power to unfold toward its end. He therefore postulates a continuing existence in which power can realize itself and have its full effect. He speaks only of the "activity" that has to survive worldly existence — not, however, implying

that the form of worldly individuality can hope for it. Yes, he presupposes for it, in the absence of a clear idea, precisely "another form of existence."

With respect to that ultimate relationship between individuality and death, however, a new difficulty arises as soon as individuality becomes the object of art, to which it nevertheless now owes immortality and atemporality. Classical art is spared the tension originating thereby, precisely because it had the type as its object, possessing this quality intrinsically. To this extent, the artistic intention and object, therefore, pointed in one and the same direction. Something questionable, and somehow contradictory (however deeply meaningful this contradiction may be) therefore adheres to all artistic representation orientated toward individuality. Thus, all particularly individual portraits have a weak or strong tragic element. Thus, all tragic heroes in Shakespeare are distinct individualities, whereas all his comedy figures are types. Thus, Italian art has something joyful because it typifies, while Germanic art, with its individualistic passion, often has something ragged about it — that peculiar incomplete character in contrast to the roundedness of the classical. Germanic art's striving towards infinity — as if one is driven from each final and calming solution further on to something that first has to be attained, or never can be attained — is perhaps fed by the irreconcilability of individuality into which death is woven, with that art that, purely as art, stands outside death. Life, however, creates itself only in the form of individuals, and therefore the opposition between life and art stretches itself most forcefully between them. The individual nature dies most profoundly because it lives most profoundly. The most extreme heightening of the idea of individuality in lyrical art of which I am aware grounds itself precisely in the interpretation of that art that allows it to inhabit all life, that which we know of as an indissoluble determining factor. As Rainer Maria Rilke expresses it:

> O Herr, gib jedem seinen eignen Tod,
> Das Sterben, das aus jedem Leben geht,
> Darin er Liebe hatte, Sinn und Not. [6]

Here, though in idealized vision, the generality of death negates itself. Precisely thereby it is immediately lowered into life itself. For as long as death stands exterior to life, as long as it is identified with the figure of Death [der Knochenmann] who acts as its signifying spatial symbol and who approaches us suddenly, death is one and the same for all beings. Along with its opposite-of-life, it loses its ever-present equality and generality. To the extent that it becomes individual in that

each dies "a death of his *own*," it is captured by life as life, and thus bound to its form of reality; to individuality.

Thus, if one grasps death not as a violent creature waiting outside — as a fate coming upon us at a certain moment — if one moreover comprehends its insoluble, deep immanence in life itself, then the death secretly casting its shadow out of so many Rembrandt portraits is only a symptom of how unconditionally, in his art, precisely the principle of life connects itself to that of individuality.

CHARACTER

Now, with this form of individualization it is at first surprising (yet understandable on closer examination) that Rembrandt's faces actually display little of that which one calls the "character" of a human being; of that which is continuously effective and given to the human being once and for all.

Our life course — its activity as well as its passivity — seems to us to be determined by the mutual workings of this invariable factor of our quality of being in interaction with peripheral or external events. The direction of the art of portraiture, culminating in Titian, continued by the portrait busts of Bernini and Houdon, and taken up again especially by Lenbach, seeks to read this "character," this subjective *a priori* of the life course, from the total appearance, and to make this into the actual object of representation. An Italian art historian of the seventeenth century praises the practice of important artists of particularly highlighting one specific trait of the character of the portrayed persons, as Titian did with *Ariost the Facundia*.[7] For Rembrandt, however, this solid, continuous, relatively atemporal feature of the personality is dissolved into the flow of its total fates. The multiplicity of life, for whose development its whole temporal extension is required, is not for him divided up into that solid and the relatively random element of mere, more-or-less exterior, "fates." Rather, even were one to describe it as a succession of fates, psychological twists and experiences, life transforms itself at each moment, but remains at all times a unity in which character and history are not internally divided (as Goethe puts it: "The history of a human being is his character"[8]), and, as the object of the portraitist, finds expression in the *totality* of the person's appearance. In that the character, the inner centrality of a human being, no longer separates itself from its fate, these are in turn immersed much deeper into the bed of life. Titian draws more the characterological foundation of the whole life; Rembrandt more its culmination. In between lie the individual fates themselves that, in their determination

as regards content, withdraw themselves from design in painting; the former, the atemporal quality of individuality, which in principle (although not with our actual capabilities) can be described in concepts in the same way that the art of the High Renaissance, precisely in comparison with Rembrandt, has a certain literary quality. With respect to Rembrandt's greatest portraits however, one would run into difficulties were one to explain, or even try to clarify for oneself, which "character" the represented person possesses.

As I shall have to mention elsewhere, in this regard *The Staalmeesters*[9] displays a slight deviation from the other portraits of his late period. If Rembrandt, as it seems to me, wanted to bring forth here a more strictly portrayed similarity than elsewhere, then this could be the reason for the impression of the somehow more descriptive characters that they create. For where similarity is to a degree sought from the outside — that is, has a touch of the mechanical about it — one does not penetrate down into the stratum of ultimate individuality but only to that where something common and comparable with others still exists; in brief, to that possibility of conceptual expression that adheres to the human being that is grasped as "character." The traditional "humors" are indeed nothing other than such fixed characters in a stratum of very high generality, and are therefore very clearly denotable. Because, however, a quite different structure is thereby given than that of the vitality grasped from within — that is, in the unity of the real individuality — as a consequence the figuration in accordance with the latter (if one wishes to express it in character categories) always appears to be composed out of manifold characters. Thus, it has been said of the humors as applied to Hamlet that the melancholic Hamlet fumes cholerically at his phlegmatic nature, and bursts out into sanguine pleasure at the successful ruse. It is evident that it is impossible to approach the real individual as such (in the way Rembrandt and Shakespeare form it out of its innermost singular focus) with such describable, comparatively exterior, characteristic features; as if one sought to draw a curve out of nothing other than straight lines added to one another. The fact that what is called character is composed of describable and therefore general qualities represents a precondition, however negative, for certain ideas of the mystics that must be characterized with this paradox: the individual is the general. Meister Eckhart teaches that one must not love God because He is graceful, just, mighty, and so on, because these are individual, determined qualities which take from Him His absolute unity — His "nonbeing." Expressed differently, in that He possesses these general qualities, He becomes something special, He becomes individualized. One may only love Him precisely

because He is who *He* is. Hence, here He stands beyond all the opposition between the individual (i.e., the here, the singularly describable) and the general. This correlation and alternative does not touch Him, but precisely thereby it is displayed as a correlate, as something belonging together in itself.

By the way that Rembrandt would display his models as "characterless" is in need of no defense, because being characterless would be, in the quite general sense at issue here, a very distinctive characteristic of the person. It is only relevant here that Rembrandt does not emphasize separately or especially that abstract entity taken away from the movement of life that we call the character. It may be correct that this abstraction in a way points to the iron background of subjectivity — to the element that keeps its unchangeable effect throughout all the toing and froing of total existence. More powerful, however, seems to me Rembrandt's undertaking to display precisely this total existence; the "fate" in the undifferentiated form of its changeable and unchangeable elements, at the appearance formed by fait that is now not simply the symbol of the eternal equality of this individuality. If one seeks to take account of all elements in their singularity, so the probability that they will not coincide at the same point of being, and thus their individuality, increases in proportion to the immeasurable multiplications that determine appearance.

BEAUTY AND PERFECTION

Perhaps the responses that some of Rembrandt's figures arouse (particularly after having been impressed for a long time by classical Romanesque art) is connected with this constellation, as if what we call beauty would actually only be an exterior addition to the nature of the human being clinging to its surface stratum, not developing out of the innermost source of the nature in the course of life, as though it were something like a frame or a schema into which a human being is put. Certainly, there are other justified conceptions of beauty that connect it more deeply with life. Yet, it is still a peculiar fact that of all the great values with which our mind gives meaning to existence, only beauty realizes itself also in the nonliving. Only that which has inner life can create moral values. There can only be truth for the mind. Only the living can create power in a deeper, valuelike sense (in contrast to the mere sums of energy of mechanic movement). Beauty, however, can adhere to the stone, to the cascade and its rainbow, to the drift and the coloring of clouds, to the nonorganic as to the organic. Where the specific quality of life seeks its immediate expression, as with Rembrandt, there beauty

is something too broad, something that reaches too far beyond life as such, to bind the object to it. And where beauty is grasped most profoundly, there it is the symbol of the ultimate values of existence, of a moral, vital, generic kind — but still a symbol, even where it may point in a mediated way to the deepest foundation of things. Rembrandt's artistic nature, however, is characterized precisely by the renunciation of all symbolism — by an unmediated grasping of life. In this immediacy, with which Rembrandt's figures allow their life to be felt, rests that which one could call his realism and that which makes him indifferent toward the specificity of beauty. For all art that is limited in its tendency toward the latter is either shallow, or, where it has depth, it is symbolic — that is, it departs from that immediacy in order to supply us with values and meanings in the form of intuition or allegory, of idea or mood. So it may be logical in this way that Rembrandt's figures, whose immense significance and impression develops out of the root point of life left exclusively to its own driving forces, have not been led by all that toward "beauty."

Certainly, it is no historical coincidence that our concept of beauty altogether (admitting any number of exceptions) stems from the classical ideal of form; from that classical ideal whose meaning is not directed toward the creative stream of life but toward the formal qualities deposited in the exterior appearance. If Rembrandt's figures, measured in terms of this ideal, are so often "ugly," so this has the deeper reason that the whole stratum out of which our ideal norm, our conventional concept, emerged is not at all the location of his artistic intention. By that is meant not only the "beauty" of human figures that within works of art in general plays a peculiarly ambiguous role for the not especially critical standpoint. Insofar as this standpoint is the non-artistic popular one, the beauty or ugliness of the represented figure is simply the same as the beauty or ugliness of the real living human being that imagination regards as the former's archetype. Conversely, the formalism of artistry does not allow for any relationship of the work of art to a reality located outside its frame. The human being within its frame means to artistry precisely only that which is visible on the canvas, and its beauty or ugliness is the totally immediate one of the lines and colors, no matter whether these represent a human being or an ornament. Our actual experience of the work of art, however, and its inner intention, seems to be based on a third factor. The idea and image actually and effectively aroused by the object of art seems to bring together each of the one-sided aspects in a manner that cannot for now be properly described. We see, insofar as we see artistically, neither the human being beyond the paint marks that signify them, nor

the paint marks beyond the human being whom they signify, but rather a new object whose unity proves the old intuition to be true, namely that in art the opposition between mere thinking and mere sensuousness [*Sinnlichkeit*] is abandoned. With this the miracle is complete, namely, that a number of paint marks composed side by side receive a complete and coherent life that is something other than that represented by the category of reality. Even if we do not see simply the human being through the portrait, as is naively believed and actually realized in photography, we nevertheless really *see* something other than we would see were we not to know what a human being is. The popular as well as the purely "artistic" view are in fact *abstractions* out of this unified object: on the one hand, the human being insofar as he is a work of art standing beside the other: the human being insofar as he is an empirical reality. Nevertheless, this central experience of art is undeniably surrounded by these one-sided abstractions as if by a fog that dismantles its unity at the periphery, just as a surface illuminated in white dissolves into individual colors at its edges. Thus, no one will fail to recognize in Rembrandt's pictures a pleasure (of course varying considerably according to epoch) at the colored appearance as such. His passion for the beauty of beautiful things — for arms and jewelry, for old fabrics with their dull and their glowing colors, for the sensuously exciting exotic curiosities — also demands from the picture surface, as a symphony of colors, a beauty that is indifferent toward all "meaning," toward all meaning of the objects expressed by it. Here, a pure artistry asserts itself, independent of the central or total value of the work. Here he seeks the beauty gliding above the abysses, totally absorbed in the phenomenon.

In the first place, however, it seems as if, with advancing age and growing intensification, this direction has lost its way — at most living on in the form of changing, technical artistic special problems, and finally dissolving into the vibrant life of total representation, rejecting all singular quality and without leaving a trace in pictures like the *Jewish Bride* and the *Family Group* (in Braunschweig). In *Saul and David* (in the Haag),[10] though only a little earlier, these elements display a certain dualism. Here effervescence and an exhilaration of fabrics and colors is, so to speak, a eudaemonistic beauty and purely artistic perfection that appears to be sought for its own sake. And with it there is now a deepest inner shock — a naked breaking through of the innermost life from which all that splendor is flooding and in front of which it fades. Regarded merely in terms of principle, the conflict is thereby given that rendered Michelangelo's life asunder: the fact that the passion for sensuous beauty in being and the pervasiveness of life's inner

and transcendent values, which in the last instance rescue or destroy life, leave each other untouched — yes, that the way toward that which appears beautiful diverts from and paralyzes the other (namely, that path leading toward the soul and its decision). The contradiction that we gather now and then from Rembrandt's creations is nowhere intensified to this degree for he never demanded from beauty the decisive inner values, as did Michelangelo who failed because of the impossibility of satisfying this claim. However mightily visible beauty, at least at times, enchanted him, it remained as such always something exterior that the soul did not touch, as it were, in its life belonging to itself and in its expression, and precisely thereby accompanied it more peacefully. The juxtaposition of the artistic-sensual and the spiritual-intensive means a greater estrangement between them than their frightful and tragic tension that Michelangelo experienced and, with the power of his creativity, tamed into works. Undeniably, in some of Rembrandt's works that pleasure in the delectation of the visible and the artistic as such stands rather abruptly alongside the expression of the innermost life breaking out of quintessentially nonsensual depths. Though this may appear as an imperfection besides the unity into which Michelangelo forced together the opposites of the values of existence, it is a more singular, so to speak, rougher symbol of that attitude of Rembrandt — for that which only *he* could say, and that which, in his most unified works, rejects, as something toward which it is inwardly indifferent, the will to beauty.

Beauty, in the unity of its form across which the stream of life as such ebbs away, apparently stands in relationship to that which one calls the perfection of the work of art. For aside from its quite general meaning, in which it describes only a rank without any characteristic qualification, it also has a more specific meaning — one in which certain highest works of art nevertheless do not partake. Just as there are personalities to whom one cannot deny the predicate ethical perfection, but who, however, have something inaccessible precisely because of this — who are incarnations of ideal principles and, so to speak, only allow a hopeless admiration to arise within us because they no longer touch the human with its still *possible* sinfulness and inadequacies — so, too, there exists a perfection in works of art with which it does not achieve the deepest impression of empathic experience and appropriation. Perhaps some of the Greek works of the so-called zenith for us correspond to this aspect; perhaps, too, some of the High Renaissance works such that this is the reason why our times now and then display a certain reserve — yes, aversion — toward these undoubtedly "perfect" art objects. Here, where not only the purely artistic, but also the entire

value sphere out of which it, in terms of its content, originates has in principal erased each sign — yes, one wants to say, each possibility of earthly imperfection — from itself, we miss a certain inner tangibility of the work. Perhaps (in connection with what has been said before) this is because the process through which it has come into being evaporates without trace, and we are unable to re-experience it in the comprehensive unity of the finished results. Rembrandt's style of painting, while it may be puzzling and inimitable in technical respects, nevertheless creates the illusion that one could follow the movement of his hand, the single strokes, how the work, in all its supra-subjectivity and unity, grows together, as it were, out of the inner artistic impulses or even imponderables. In contrast, even with Titian, the last trace of the work's coming into being disappears; is completely absorbed into the finality of its representation. The perfect works, in the above sense, lack a moment that, however unconscious it may be, seems to be necessary for the deepest human shock created by a human work, namely, the possibility of failure — just as morality, which most powerfully moves us, presupposes temptation, that is, at least the possibility of sin (which is why religions supply a "story of temptation" even to their saviors), and just as a truth which lacks the possibility of error no longer belongs (if Lessing's conception of truth is right) to the human realm. This seems to me an *a priori* of all human work, and it must remain perceptible, must be immanent to it, if, through this work, the whole life is to grip us. With Rembrandt we never have the feeling, not even in his most superior and absolutely "perfect" works that they had detached themselves absolutely from the ground of life that is at the mercy of chance and fate, nor that they dwell in a perfection that has no longer elevated itself from the possibility of a different existence. As with his figures, so, too, his works are subjected to life's fate with its possibility of failure, even where this possibility has not in the smallest degree become reality. Only in a one-sided sense is there "perfection" in the works of art, if this symptom of the essential, fullest life is expelled. Just as life's bliss, however, attains its whole breadth only if it merges the blissful and the miserable into *one* circle — as life. As life arrives at an absolute sense (I have touched upon this type of concept above) if it grasps in itself the relative sense of life, and the relative sense of death by overcoming their antagonism, so, too, an ultimate meaning of perfection perhaps comprehends perfection and imperfection in itself, whereby the latter appears as the mere possibility of failure in the areas of life that are here only in question. In its deepest foundation this is also closely connected, as indicated, with the antagonism of form and of life. Life does not tolerate that self-contained smoothness that is

characteristic of the "perfect form." As with each general concept, so here, too, where life flows into the concept of perfection, the concept is driven beyond its conceptual borders and, to a degree, forces it to embrace its opposite, to stretch itself so far toward infinity that perfection here at least does not dismiss the human, fatelike possibility of failure as something it does not understand at all — as in art that "attains its perfection" in the redemption of form from life. Certainly, this is not something positive that, as audible overtone, accompanies the impression of Rembrandt's works. It is only a tentative *expression* that helps to interpret the character of his art in that the inwardly opposite art positively excludes precisely this.

There exists, as I have already indicated, a connection between, on the one hand, the beauty that the work of art borrows from the adopted or restylized object, and toward which Rembrandt is indifferent, and, on the other hand, the generalization, the supra-individual classification that to no lesser degree lies off his path. Here a contrast, which is otherwise rightly considered antiquated, still serves to enlighten. In the past the beauty and the characteristic in art were differentiated, and Rembrandt has always been regarded, as long as this distinction was thought valid, as the painter of the characteristic. However, this cannot mean anything other than that in certain works of art the surface of appearance is determined by the innermost root point of the personality, which in this terminology was called simply "character" while in other works the leading, value-giving, norm stems from elsewhere. And what is therefore situated on the other side of the appearance can apparently only be the generalization: the somehow external existence of the inner individuality. Insofar as this is the location of beauty as the principle of art, its opposite is the individual: the location of "characteristic" as the principle of art. With this it becomes understandable why the whole depth, power of impression, connectedness toward which Rembrandt develops the human being (here his religious pictures especially come to mind) does not drive this development toward that form we call beauty. Beauty, in our common conception of the word, is simply in no way a completely abstract concept, realizable in each mode of conception of human appearances. But with their beauty we understand, quite continuously, classical design. And all other types of beauty that we characterize with embellishments like "interesting," "piquant," "demonic," and the like, are marginal phenomena and mixtures containing other directions of meaning. Through the enthronement of this beauty speaks the worldview that sees absolute values in the general (as revealed in the individual phenomenon as the rule of the type), and in the immanent law (which

connects the elements of the appearance immediately and precisely as though free-floating). Therefore, beauty cannot be Rembrandt's ultimate intention: for him the point of individuality is decisive for the human phenomenon, and he develops this out of the flowing liveliness of the whole personality. It is as though beauty (which is valid for sculptural passive viewing) had to appear therefore, as it were, as an abstraction, in a sense that in no way means a judgment of value, but rather a judgment of being.

THE INDIVIDUALITY OF THE RENAISSANCE AND OF REMBRANDT

For all that, it is a quality of the Renaissance portrait stemming from the relationship to the ultimate categories of life that creates the impression of typicality, whereas Rembrandt creates the impression of individuality. And perhaps it is only such an interpretation of the concepts that highlights the difference between Rembrandt's individualization and that of the Renaissance portraits, especially those of the *Quattrocento*, which has also, always and rightly, been emphasized. After the forms of collectivity to which medieval life had bound itself, a reaction took place that found its most extreme expression in the portrait sculpture of the fifteenth century in particular: the representation of the human being could not be strange, exclusive, or characteristic enough, up to the point of the grotesque. Even disregarding this, the will to power that infused the individuals of the Renaissance realizes itself in a perhaps only *quantitative*, singular increase of traits that in the last analysis are *typical*. Thus, in each case the individualization here is still a *sociological* one, consisting of being different from others, of distinguishing oneself. This requires comparison and is therefore something turned toward the outside, toward the phenomenon. It is associated with the will to power, with ambition, with ruthlessly getting one's own way — with the good as well as the bad sides of the megalomania of the Renaissance individual. If, however, one looks at it from the standpoint of nature — *per tanto variar la natura è bella*[11] — so the passionately emphasized individuality in the Renaissance is covered by the no less deeply felt, general lawlike quality of nature. The evenness of the proportions and the expression of style appear as effect as well as symbol of such laws. For the Renaissance individual, nature was of a unified ideal being (speaking to Michelangelo and Correggio, to Raphael and Titian with distinct nuances), out of which grows the variety of individuals without detaching from this rootstock. Herein, individualization finds its limit; one signified by

those common features of form. Such an idea of "nature" is completely foreign to Rembrandt. The nature, which he also seeks, is that of the single being. His portrait figures do not merge with each other in the metaphysical-monistic root as do those of the Renaissance. Their being does not converge into a formulated, or merely felt, or really effective general concept, but exhausts itself completely in each individual figure. This may well consist of the fact that the figure is spun in light and air, or grows out of an ecstasy and storm of colors raging through the picture. The general nature with which it is connected in this way obviously lies in a quite different, much more experiential, stratum than does the pantheistic *natura* of the Renaissance. Here the relationship of Rembrandt to the Renaissance seems to be somewhat analogous to that between Shakespeare and Goethe. Despite all the rich, far-reaching individuality of Goethe's figures, they are still embraced by a *single* intellectual atmosphere. Crucially, he demands from the characters in a literary work, "that though they differ from each other significantly, they nevertheless always belong to *one and the same* genus." The proximity in which their creator stands to each individual character (he, who describes his complete works as a personal confession) finds its objective counterimage in that they all appear as though grown like fruits from one unified nature. A single divine life breathes through all the diverse branches of existence, whose breath Goethe makes tangible as the breath of life in each existence: this god-nature whose children we all are and which thus lives in, under, and above everyone. In Shakespeare, however, individuality develops out of the ultimate foundation — not of existence in general, but out of the personal existence of this particular being. Individuality is not infused by a lifeblood graspable only metaphysically, common to all, and nourishing all with some unity or other. A certain chaotic dynamics of nature, out of which individuals seem to ascend and with which they seem to be surrounded, behave toward these individual beings probably in a much less unified and unifying way than does "nature" — "the good mother" — in Goethe, but it lies alongside them in the same experiential, substantial stratum. It is like the air around us that we breathe, which, of course, contains the materials out of which the main mass of our body is formed. This dark formless, though totally unmetaphysical, atmosphere in which Shakespeare's characters live and that in no way permits their absolutely self-sufficient individuality — forming its unity for itself alone — to reach down into a universal foundation in order to garner a common form, could be most nearlycompared to that sea of light and color that flows around Rembrandt's figures. But in that they seem to crystallize out of

it, it happens according to the individual law of each that imposes no common necessity on any one of them. Here "nature" is — as in Shakespeare — completely absorbed in individuality, and does not retain anything for itself in order to embrace all with unity of form drawn, as was the case in the Renaissance and in Goethe, from ultimate depths.

Above all, however, for Rembrandt's individuality, as I see it here, sociological difference vis-à-vis other beings is totally irrelevant. For him nothing is in this regard socially colored, neither with respect to the aspect of equality of type, nor with respect to quantitative or qualitative being. It would never have occurred to Rembrandt to emphasize, as Bernini did, his intentions to bring out in his portrait model that "which nature had given no one other than to this figure." His individualization only means that the presented appearance in question is determined by, and, so to speak, visually understood with respect to, the total stream of life leading toward it that simply is, and can only be, the life of this one person. It is therefore not at all affected by the fact that another equally valid being perhaps exists next to it, for the particular life cannot be deprived of its being-only-once. In contrast, Renaissance individualism is especially well illustrated by the story that for a time at the beginning of the epoch there was no general fashion in men's clothes because everyone wished to dress in a unique fashion. Despite Rembrandt's immense individualism, there is a lack of that peculiar *accentuation* with which the individual as such stands out in the Renaissance. Everywhere, however, where there is comparison (however much its result is diversely exhibited) there are common premises making comparison possible — a common standard that in our case means in particular a common idea of the human of which, so to speak, some quantum is contained in each personality that, however differently arranged, permits all of these incompatible forms to be infused and governed by a sense of common style and general type. Certainly, the Renaissance supplemented Platonism, which it adopted, with the element of individuality. If we, for Plato, love the beautiful individual person because he reminds us of our pre-existential visualization of the idea of beauty, so the motif of pre-earthly existence and its ideal meaning now seizes the individual. Petrarch says of Simone Memmi's[12] portrait of the Madonna Laura:

> But certainly my master [Simone] must have been in paradise,
> From whence this gentle lady descended,
> There he saw her; from her fair features,
> His earthly work bears heavenly witness.[13]

And then, Michelangelo to the beloved lady:

> Your eyes point to the path that leads me towards,
> The place where once our souls did meet.[14]

The idea of common beauty in general is replaced by the "idea" of the individual personality. It is individualized Platonism — but Platonism all the same — that sees the final essential being in the once and for all presented, so to speak, metaphysically fixed, form. This atemporal form (however passionately its singularity may be emphasized within an empirical real sphere) *cannot* in principle resist realizing itself repeatedly, sharing the same style with others, forming a type. However, Rembrandt's individuality is indifferent toward that sociological singularity, as well as toward this abstract generality, because the *direction* from which it grasps appearance is in principle a different one: not out of its form, but out of the life that forms it as its own singular stream, even though, of course, fed by countless impersonal inflows.

However, in Rembrandt's last period, from time to time this connection between life and individualism appears to be suspended. Life now is no longer directed through the strongly individualized movement of a soul, but spreads beyond the singular being as such toward a vibrancy that completely overwhelms all limitations of this particular human life (even those of the psychological interior), or it withdraws into such dark depths that the exterior appears stiff, impersonal, or masklike. If one compares the *Titus* in the Youssoupoff Palace[17] with *The Staalmeesters* (with which it is undoubtedly continuous), so one sees attained therein a further stage developed beyond that which one is inclined to call individualization; a stage in which, of course, the peculiarity of Rembrandt's individualization perhaps first attains perfection. One might think on Goethe's remark that everything that is perfect of its type transcends its type. In *The Staalmeesters* it becomes apparent how much singular character there is in Rembrandt's figures, while they of course remain utterly Rembrandtian, but nevertheless reminiscent of the classical principle. One can still say "this one is proud," "that one rustic," the "third of superior intelligence," and so on however little such typological concepts dominate the representation for Rembrandt." In *Titus*, this falls away completely: everything is flowing, vibrant life with no conceptually fixed, specifiable point therein. Those psychological qualities are still something substantial, atemporal, abstractable from life. Where life represents itself in its pure nakedness, they are removed, just as there where life is denied at all: in geometric *purely* formal art. In this way, life as such can take on the varying character of its functionality: it

can take its course tragically, slowly, restlessly. This is still something other than the psychological determination of the one who bears this life. We certainly experience life, even for the senses, as a special kind of movement of material. This, however, is still something completely general. In that life, however, generally contrasts with all that is inanimate, it can in the first place inhabit the material appearance to differing *degrees.* This sensual liveliness seems to me to be of different *types,* however. Not only quantitatively, but also qualitatively the liveliness of Frans Hals, or of Ribera or of Goya is different from that of all other painters. What is decisive is completely unclear; maybe the rhythm of oscillation of the smallest parts; maybe the relative proportion of the mix of more latent and more current liveliness that is everywhere present. In any case, the essential psychological singularity has receded into the far distance. It now stands at the periphery of life in which the central differences are merely those of the rhythms of its flowing and its powers. Here is something decisive that remains in the limitation of the personality, but somehow, however, pushes back each describable quality either into the exterior works, or into the unnamed darkness of the inner substance. If one may express this — which is hardly graspable with words — then, for that reason, only as a paradox: it is as though the life of this person were admittedly absolutely their own, and not detachable from them, yet raised above all the *individual things* that one may say about them; as though a stream of life flowed that, although not washing over its shores and as though it were as a whole a totality of unmistakable unity within itself, nevertheless creates no wave of singular characteristic form. Certainly, each picture in this series always comes from the point of individuality, but it is as though it would flow on without losing individuality into a stratum of the general life of this person, and would put yet another mood of its, so to speak, absolute life beyond those traces of its development and its fate that are preserved here, as they are in the other portraits. This, of course, does not have the atemporality that we ascribed to classical art. Just as in the latter, the intellectual process has found the logical qualitative consciousness of its eternal form, so here the current of the emotions, or of the heart, has not yet swept its liveliness over such a height of consciousness flowing, as it were, into a lake that has enveloped the current's movement within its silence.

TYPES OF GENERALITY

The difficulties of an intelligible expression for the configurations of life that are inherent in Rembrandt's art of portraiture — in the relationship of the general to the individual out of which they are formed

— are based for the most part on the fact that we are readily used to understanding the concept of the "general" in its theoretical sense. The theoretically general is the common determination of separated individual phenomena irrespective of whether it is accomplished as an abstract concept or crystallized into the formula of law or into the substantiality of Platonic ideas. This habit of thought has already impeded the understanding of the general in the social sense, and has had the effect that the social unit attained a mysterious quality out of and above individuals. That the state is something other than the sum of its citizens, the church something other than that of believers, and the like, appeared as something dark and irrational, as though one had already explained such constructs as mere abstractions that somehow became independent of that which is common to the individuals (who are taken to be exclusively real), whereas it is obvious that the "generality" of such forms is something quite different from that which is to be legitimized in this theoretical-conceptualistic way. The situation is no different with respect to the generality of metaphysical interpretations of the world whose peculiar truth value we do not feel to be destroyed because they cannot be properly identified at the level of the isolated singularity subjected to them. They merely stand in another stratum of thinking than those generalities that are attained by logical abstractions out of single appearances. Metaphysical interpretations have frequently enough been misunderstood and rejected precisely because of the misdirected, and thus unrealizable, claim to be able to meet the requirements of the norms of this abstract general-being. Yet another generality, no less conforming to logical abstraction, is encountered within art. While feelings within the common course of life attach themselves to some single instances and thereby achieve an individualistic coloring, those embedded in, and unfolding out of, music reject such pointed emphasis, and thus appear as something general that nevertheless in no way displays, in respect to those other particularized feelings the relationship of a general concept to the individual objects subsumed under it. It is, moreover, a generality that is, so to speak, absolute — that is, it requires no particularity as its logical correlate even though it is not simply indifferent to these experienced particularities. Therefore, we experience music, on the one hand, as infinitely varied in meaning, but at the same time as absolutely unambiguous, a proof that the question of its logical generality — its relationship to the multiplicity of life — must be wrongly expressed, otherwise [the question] could not be simultaneously affirmed and negated.

If we now feel about those ultimate, greatest Rembrandt portraits that particularity as a principle has been overcome, that the membranes

have been torn up, washed away by the surge of life in which each singularity of life is enclosed and appears as isolated against the other, so the existing generality does not go beyond the individuality that is the bearer of precisely that life. It is the generality of this individuality itself, not standing above this or some other [individuality], but the unity of life that takes its course in a unique way, of which all its describable particularities are merely products or retrospective fragments. Regarded carefully, this generality has its correlate not at all at the level of the particular (as is the case with the theoretical-logical generality). For, insofar as this type of generality exists, the particular in its special sense does not exist in the way it would have to exist were that abstract generality to be realized.

Therefore, the pictures in this category still represent the opposite of Renaissance-like individualization at an especially characteristic point. We are sure that the individual component of a face acquires its meaning exclusively in relation to all other components. What a mouth contains in inner expression, in beauty or ugliness — yes, in pure form-impression — depends entirely on the nose and chin, the eyes and cheeks to which it stands in relation. Connected with different features, it would, with respects to all of the above, mean something quite different. And detached from the physiognomic interaction, the mouth, like any other individual feature, means nothing at all. Taking this general and basic condition for granted, this interaction, which does not allow the single facial part a monological role, nevertheless does not always constrain to the same degree. The portrait must make a special effort here because, with respect to a real human being, the flooding movement of life, the evenness with which its particular situation and mood marks the whole corporal entity, means that the features of the face do not separate themselves off, but always interact in a unified manner. For the painter, however, who has only the dead juxtaposition of paint spots at his disposal, bringing the features into that interaction and combination through which it alone represents the unity of the person and its condition turns out to be a *problem* of considerable magnitude. What we feel as the "inner necessity" of a portrait is nothing other than this unconditioned connection that allows a valid conclusion to be drawn from the mutual interrelation between each feature of the appearance; this, of course, perhaps only on the basis of an integrating unity of the sum of the features. That this appears to decisively varying degrees is not merely the result of differing levels of skill, but also of stylistically different intentions. There are a number of Italian portraits in which a certain self-sufficient being-for-itself of the individual facial parts is unmistakable. Quite remarkable examples

here are the Giorgione portrait in Berlin, the Palma Vecchio self-portrait in Munich,[16] and Botticelli's *Giuliano de' Medici* in Bergamo. These master portraits nevertheless reach a complete unity of impression of the corporal-inner personality in that each, in this way individualized, feature of the face presents the same expression as every other. It seems to me to be easiest to establish this in the case of the Giorgione portrait mentioned above. I at least do not know of any other portrait head in which the mouth and the forehead, the eye and the nose, each for itself evinces so clearly the same character, even if this is not translatable into words. The basic prerequisite for this is naturally still that functional correlation of elements. Only on its basis does the individual form and self-accentuation of each feature become perceptible. However little one of two principles can dominate alone (on the one hand equality of expression of the single features that are treated like autonomous individualities, on the other hand cooperation of totally dependent features into a unity of expression emerging only out of their common relation), they nevertheless still signify different basic tendencies, and each portrait finds its definitive place on the scale in the proportion in which these principles are mixed. At the one end [of the scale] stand those Italian portraits, at the other end stand, most definitely, Rembrandt's late portraits (Velásquez's *Pope Innocent X* is perhaps a good example of a midpoint appearance). In the late portraits, the unity of the individual life as a whole is so dominating that it completely absorbs the individuality of the separately formed features. Instead of the, so to speak, substantial character that consists of the homogeneity of the expression of individually formed parts, has been attained a pure functional unity within which each part no longer possesses special meaning, boundedness, comparability of its characteristics with those of any other part.

There seems to be a kind of formal law: to the extent that a construct as a whole has a strong, unified individual life, its parts forfeit their individual emphasis, and likewise their evenness of form. As soon as both latter moments decisively emerge, the object will have more of a mechanistic character that, where we are dealing with works of art, can only be overcome by the ingenious vitality of the creator. Otherwise, however, one will observe in ornaments, as in state constitutions, religious communities, and phases of personal existences, that typical association, namely, that the strength and vital unity of the whole stands in a relation of inverse proportion to degree of individual differentiation, and to the formal or inner equality of the parts. Thus, what one can call the generality of these Rembrandt portraits is not that one, to a degree abstract, that emerges as, or out of, the equality of meaning

of relatively individual features, but the unity of the inner life — as its bearer serving the particularly quite dependent features within its complex, without these features, as individual elements, somehow representing the expression of the whole. Regarded with respect to the means of representation individualizing tendencies that comes from without corresponds to the precisely drawn, exactly linearly delimiting mode of representation. It is equally plausible, that the individualizing tendency from within, however, corresponds to the diversifying, boundary-blurring style of painting of the late Rembrandt.

With this immanent generality of the represented individuality, the artistic principle of realism is also thrown into quite unusual light. The "general," in its theoretical sense, appears as something abstract in contrast to which the single, individual object represents the actual, graspable reality. In that this extends to the principles of art, the "idealizing" art that raises itself above mere reality, finds its reproach at the level of the "general" with the typification of objects. Realism — the representation that nestles up to the immediately real object — only sees the particular object, because only the individual fashioning that does not point beyond its own graspable borders is "real." To a certain extent, art history and aesthetic impression confirm these connections. Where there is a strong individualistic accentuation that is not encompassed by a typical style as in the *Quattrocento*, the impression of definite naturalism at the same time predominates. The pronounced individual construct seems to be copied from reality more immediately than that which bears general, supra-individual features. The freer idealizing artist's power of revision seems to play the major role in the latter. Rembrandt breaks through this division of the parties. The relationship of realism and individualization has thereby arrived at a stage of contradiction that is only its own higher development: his art is to the highest degree *individualistic, without being realistic*. He subjugates the given appearance throughout to the ideal, artistic transformation without raising it to a generality that breaks up the particularity of the individual being. He has, if not discovered, at least represented the synthesis between individualism and the liberation of the immediate impressionistic reality in accordance with the highest principles. He succeeds in this because his individualism is precisely an *immanent* generalization — that is, it presents only this *one* life in its personal limitation, but as the totality of its continuous course, as the unity of its by now no longer describable features, as the flowing experience of fate — unconscious of all conceptually set borders — that is mysteriously drawn into the uniqueness of the view without forfeiting the form of time of experience. In this way Rembrandt shows most impressively

which quintessentially specific formations — unattainably for all categories of theory — can be realized by art at the deepest level of mental life. And precisely at this point, therefore, all the lines of direction along which we sought to feel our way toward the understanding of his interpretation of the human being converge.

THE ART OF OLD AGE

As I have indicated, the turn in the depiction of individuality that took place in his last period is clearly connected with the condition of the art of old age, [and] not merely that of Rembrandt. "Old age," says Goethe, "is the step-by-step withdrawal from appearance."[17] The older we get, the more the multicolored experiences, sensations, and fates that populate our path through the world mutually paralyze themselves, as it were. All this forms our "appearance" in the widest sense in which each line is a result of our actual self and of the things and events around us. As I have said, in that the latter balance their antagonism through their increasing abundance, such that nothing singular any longer becomes a decisive impression, a dominating power over our life, the more the subjective element of our being emerges precisely because it steps back from appearance — that is, emerges out of its entwinement with the world. Rembrandt's exterior fate undoubtedly deepened and enforced this process in that it increasingly isolated him from the empirical world, made that world ever stranger, more hostile, more meaningless to him, and thereby focused his life ever more on his own subjectivity. But the external fate thereby became merely the especially powerful executor of a judgment that age in any case pronounces on the work of the great artists. It is a special kind of subjectivity, however, that determines the art of old age — one that shares hardly more than its name with the subjectivism of youth. For the latter is either a passionate reaction against the world, or a carefree expression or realization of itself, as if the world were not there. The former, however, is something that becomes free and steps back from the world, after one has absorbed it within oneself as experience and fate. Therefore, the subjectivism of youth has the ego as its all-dominating content; that one of old age has the ego as the all-dominating form. It actually is a paradoxical sensation: as though Rembrandt were expressing only himself in his very last portraits and other depictions. Wherein lies in these representational configurations that self that, in his earlier works — that represent nothing more objective — becomes so much less, sometimes almost imperceptible? The fact that he, for instance, would have hidden his personal moods behind the mask of his models, would

be a naturalistic poetry that was surely far from Rembrandt's intentions, and cannot represent the meaning of his ultimate subjectivism. In the later work of the great geniuses, the latter means much more that they are indifferent toward the relationship to the exterior objects *as such*; that they indeed express only themselves, *but as artists*. For them, their empirical life — that which constitutes the self of the nongenius — belongs just as much to the realm of "appearance" as do those objects, and is therefore no more important than they are. They now express in their works that superior self that, without forfeiting the character of its subjectivity, became exclusively artistic genius and creativity. We must not search for Rembrandt in these pictures according to the substance of his life, or such moods that may happen to the present, which, from the outset, falls within another realm (as may be the intention of the anecdotal historian). But equally we do not find here an artistry that realizes itself through constriction from the living totality of the human being. Rather, what is decisive is the organic synthesis that can be expressed simultaneously from two sides: that his whole and ultimate nature is completely absorbed in his artistry, or that his artistry has transformed itself completely into the subjectivity of his life. We feel this unity in the late works of Donatello, and in those of Titian, of Frans Hals and Rembrandt, of Goethe and Beethoven. In this unity the somehow isolated or excessive interest in the merely artistic — as in the merely subjective — is extinguished. Because the unification of these poles now constitutes precisely the quintessential creativity, the interest in the independent existence of the objects or models, which have now been absorbed into art, has also ceased irrespective of what they may mean in themselves beyond this absorption in the subject and in art (these are now identical). That the diving down into the depths of all essence of the world that is attained with this stage at the same time understands the ultimate nature of those represented objective existences, is, so to speak, an accidental property of this art of old age, and belongs to that which one may call its mysticism — as little as Rembrandt is thereby a "mystic." However, out of this the feeling induced by certain final works of Rembrandt — namely, that the passionate search for the individuality of the models is now and then weakened — becomes comprehensible. For this individuality exists somehow outside his present artistic-subjective life. It is, in its being-for-itself, not developed within the realm of that life in which all creative powers have now concentrated themselves. For the art of old age, to a certain extent, this still belongs to the "appearance" from which it has withdrawn. And it is, further-more, understandable that, insofar as the personality of the model is here grasped and discovered, this happens precisely only in the return to

that which is individualized within the life as such: to its immanent "generality." For this, rather than its empirical-singular configuration, is to be developed most immediately out of that mysterious deep stratum in which this very late art lives.

THE ASPATIAL GAZE

That flooding of life's represented totality over all that is determinate is exemplified and symbolized at another specific point that can be demonstrated most clearly in the very late pictures, but frequently also in the earlier ones. Its interpretation demands a somewhat wider context. If one observes exactly the difference between the gaze of deep and significant persons and that of shallow and insignificant ones, then the former appear to look not only at the object (which they may fix sharply and attentively), but yet further beyond it, not further in the linear sense but somehow into the trans-local, to some place that cannot be limited that, however, does not have a spatial meaning. In the case of people of a more limited life, the gaze fixes exclusively upon the object that they are looking, at any given moment. For the energy flowing out of the gaze, the object represents a doorless wall. The gaze is simply reflected back. With that of others, it is as if the living power of the gaze would not find its place in the direction determined by the object, indeed in no "direction" at all, but proclaim merely an essentially aspatial [raumlos] intensity, not attachable to a particular thing. The corresponding [phenomenon] can be found in certain gestures within art, and perhaps these make it most apparent what is peculiar to that sort of gaze. St. John [the Evangelist] in Grünewald's *Crucifixion* and many Buddha figures, the figure with the arm stretched high in Rodin's *Burghers of Calais* and the central figure in Hodler's *Day* — all these figures point somewhere or other, or they seem to, or really do, express a certain affect, but beyond that the gestures point to a spatially and conceptually indeterminate entity at the same time; to a nonlocalized being, or, more precisely, they do not *point* at all, but are simply there. Viewed through external categories, they have something vague about them that nevertheless is not open to multiple interpretations, but rather not "interpretable" at all. Thereby they differ from real expressive movements. For the latter also come from the interior, and the ways in which their appearance integrates into the external world is insignificant for them. They each depart, however, from a particular impulse that can be described in terms of its content. Although they reveal the character of individuality in their coloration, this [individuality] is merely something incidental. They are not the movement of

life as such, but always have a representational meaning, even when this is shaped from within. Those gestures, however, do not merely run their course in something spatially and objectively indeterminate, they also originate from the latter. They are not enticed by this or that purpose or feeling, but borne by the movement of life as a whole. The gesture of the hand of Rembrandt's *Homer*,[18] even though he is supposedly scanning verses with it, seems to me to belong to this class. This peculiar situation of a specifiable direction surrounded by a purely immanent stream of life (that can only be externally characterized via its negation) amounts to the same thing as looking in those ways. And this is unmistakably displayed in certain Rembrandt portraits. It is already discernible in the *Portrait of a Preacher*[19] in the Carstanjen collection, in *The Portrait of Nicolas Bruyningh*, many Titus pictures, and in the self-portraits. The looks may each fix on one point, but at the same time they see something that cannot be fixed. What is meant here is something other than the gaze of the Christ child of the *Sistine Madonna*[20] that is likewise not directed toward a given object because it is directed into the infinite, but not toward the nonspatial. The former, in comparison, fixes something finite, and at the same time has a purely interior quality that is just as little oriented towards its outside as is — according to its ultimate meaning — Rembrandt's religiosity, or, just as little as his light comes from somewhere other than the picture itself (on which more later) which means an immanent transcendence. Obviously, Wilhelm von Humboldt had such a gaze in mind when describing the impression given by Goethe in extreme old age: "I found his eye very changed; not dull, but with a wide pale-blue circle around the pupil. As I looked at the eye, I felt, as though it were searching for another light and for other suns." Whereas it otherwise always occurs in relation to something that is exterior to it, this quality of immanence, this representation of the inner life as the pure quality of its bearer, belongs to which is deepest and most decisive in Rembrandt. The means by which he succeeds in representing this are inaccessible to analysis. At best, one could cite the waning of the light in the eye as one of them. This always-looking-further — in a certain way appearing as a by-product of viewing a certain object — is a symbol of that liveliness that is not satisfied by any single content, not even by a subjective-individual one, but flows under or above each content into the infinite; that is to say, it does not flow *toward* anywhere at all because it is not dependent on a *terminus ad quem*. In a conceptual sense, which is oriented toward an object, this gaze may appear somehow vague, but in terms of life it is something quite definite. The fixed point is the symbol of an exterior determination and isolation corresponding to the principle of

form; the categorization that creates itself in the contact between the interior and the exterior, and which is not in question where life expresses its being-by-itself [*Bei-sich-Sein*].

It is instructive to contrast this with the tendency of the Baroque to present the affects of the persons as clearly and intelligibly as possible; to give them that *expressione* that can also be captured in concepts, for which purpose the eye is not really a useful device at all. This is because the eye after all, more than any other single moving organ, always expresses, beyond its reaction to an individual stimulus, a totality of inner life that is never *completely* exhausted in the specifiability of the situation or feeling (even though it is near completion in the case of mundane people). That the eye *speaks* actually means that it says more than can be said. Its expression pours too immediately out of the dark inexpressible qualities of the soul for it to have been particularly useful for Baroque art in its striving for unbroken continuity and unequivocal meaning. One ought to pay attention to the extent to which Vasari already neglected the eye's expression in his art criticism. At best, he speaks of *occhi fissi al cielo fixso*[21]" does not touch "o"or simply of a fixed look, the meaning of which therefore does not actually lie in its life but in its location. In Rubens it is especially noticeable how often he keeps the eyes in a flat generality. The Baroque did not have a sense of the eye's depth-dimension that becomes absolute, as it were, with that aspatial gaze of Rembrandt's figures.

MOOD

With respect to the above context, is it now possible to speak of the "mood" in the appearance presented by Rembrandt, because mood is something interior, personal, perhaps something individual for each, which has nevertheless extinguished all particularity of contents, of conception, such that the pictures with several figures even more clearly characterize this late development. Because now those perceptible qualities of life that are no longer differentiated *mix*, within them individualization once more gains a higher form dissolving its earlier clarity as though into a floating layer of air. In *The Jewish Bride*, the figures are like the tones of the chord that are clearly not external to the individual tones but they are merged in the chord into a construct that cannot be displayed pro rata in each separate tone. A tender, so to speak, motionless, life contained in each of the two figures nevertheless continuously extends into a shared atmosphere wafting around them. A higher unity has absorbed the being-for-themselves of the individuals whose singularity falls away in the face of this unity, which yet nourishes it with the

ultimate generality of their life. If the concept of "*aufheben*" [to abolish/ to preserve] anywhere justifiably unites both its otherwise opposite meanings, then it is in the relationship that the actual individuality of a person has in these late pictures to this dissolved and dissolving atmosphere that evens out all life's vacillations. The fact that this atmosphere is above individuality constitutes the form in which it [this atmosphere] is present within individuality. In this way the following development becomes intelligible: the significance of the moment, the single situation and gesture via which the earlier portraits often present the model, seems to gradually withdraw more and more in order to make way for what is quintessentially interior and beyond the fleeting moment. The exterior attributes at the beginning — still connected to movement, to the represented habitus of the person — appears more and more as an ideally indifferent afterthought that has its rightful place in the picture purely out of artistic motives, and sometimes merely out of technical considerations. The fleeting movement increasingly fades away into tranquility, of course including a trans-temporal interior movement without being combined with a transformation. *The Staalmeesters* still displays a movement adhering to the moment of the individual figures. In *The Jewish Bride*, however, the gestures of the man and the woman are of a completely different character, although they are, viewed externally, merely transitory. How the man leans toward the woman and embraces her, how her hand touches his — at once encouraging and calming — this is not a *transitory* movement. At the same time, it is not a typical gesture that, as in classical art, would indicate something general beyond these personalities. It belongs entirely to the individual, but it forms itself initially in that stratum in which the life of the individual arises like a homogenous sphere from the appearance, dissolving all determinations tied to singularities. Now, here this life encloses two related figures and achieves its zenith, even over the earlier forms of Rembrandtian individualization all the more impressively as it fused them, in a way that is logically inexpressible, into a shared life without abandoning its source in each separate figure.

HUMAN FATE AND THE HERACLITEAN COSMOS

That in Rembrandt it is the individualized and successive stream of life that uniquely bears the specific impression of his portraits clearly means a certain limitation of his conception of the human being that, for instance, contrasts sharply with two types of style: that of Michelangelo, and that of Rodin. In Michelangelo, the classical type grasps the totality of life in a unique way, whereby the concept of life is not

understood as the historical sequence of becoming of an individual existence, but has humankind as its subject and as its content; all that which one could call — in the broadest inner and exterior sense — fate. Certainly, the physiognomies of Michelangelo's figures have the classical general character, which is nowhere personally accentuated. The whole figure, in all its formal unity, tranquility, even gravity, pulsates with life in general; with life as fate, in all its enigmatic intertwining — yes, in that solidarity in which the concept fate places our innermost life, and which external forces impose upon us. These figures are merely like the channels through which life's destiny in general runs. Their life is the life of humankind, which here is grasped through a very definite worldview and way of feeling for which, however, this single individual form is only a vessel or a symbol without individualizing human life into the peculiarity of precisely this stream of life. Just as Rembrandt's figures stood beyond comparability and incomparability because they are absolutely unique, so do those of Michelangelo but for the opposite reasons — namely, because they are absolutely general. The form-generality of classical art is borne here by the generality of life, and has thereby found its deepest foundation. It has grown out of an ultimate meaning, out of the fact that each figure is consistently the revelation of life, transcending each individual form: it is fate as such. Now, whereas Rembrandt's figures likewise do not represent a particular, random fate of the person, but rather the whole life immediately is their fate, so it nevertheless really is *their* whole life in the complete individuality of its course. It does not soar above them as human fate in general only descending upon the individual; rather, it bursts out of them. Out of some deep source that knows nothing of its antecedence or of its transcendence pours forth a development, which is the totality of this life, but according to its reality and its meaning is only an individual *causa sui*.

If fate means that a world-immanent process, independent of the subject, nevertheless stands in a teleological meaningful relationship — positively or negatively — to the innermost direction of the life of this subject, so, for Renaissance individuals, this relationship takes the form of that which confronts them. They are either the proud autonomous personality who, through the recognition and honoring by their peers that has been transformed into assured possession, feel themselves to be masters of their own fate and dependent upon themselves alone, or they battle against fate — might against might — at each point at which the struggle comes to a standstill, as Michelangelo himself did. And even where fate has overpowered them, they insist on an opponent, in a stance that can be fettered from all sides, but cannot be

infiltrated by exterior force. But it is precisely this that Rembrandt's figures display: a heretofore never represented unity of person and fate. The reference to one's own inner meaning of life, through which the objective process becomes fate for and within us, presents itself here in such a way that the person appears completely manipulated and fashioned by fate, but not thereby loosing individuality nor being leveled out, but rather in such a way that being-for-oneself — the inner incomparability of their existence — unfolds. What I mean to say is that the intimacy that characterizes all Rembrandt's representations exists here also between the person and his fate, however dull and ordinary, however wearisome or fragile it may be. We are determined not through a confrontation with fate, but through its proximity. Precisely, therefore, the fate of Michelangelo's figures must be of a general, impersonal nature drifting in from those cosmic grounds and distant parts that the person, as soon as he has found the center in himself, banishes into an antagonism and ultimate strangeness. And therefore, individuals themselves, bearing and defying such fate, can only be something trans-individual, extended into a symbol of humankind. The parties have to be formed in such a way as to display the Promethean defiance and the Promethean shackle. To that close relationship, in which personal life and personal fate do not drift apart, corresponds the "piety" of Rembrandt's religious figures — that natural suffusion of existence by its relationship to the absolute that, nevertheless, does not demand a pantheistic abandoning of the self. For fate, likewise understood as a gift of God, could not nestle up to life so absolutely were it not cause as well as effect of precisely this unity. In contrast, that characteristic of Michelangelo's figures must specifically be called impious. When, in old age, he desperately says that his art had drawn him on to false paths — away from that salvation and love that stretches its arms from the cross *a prender noi*[22] — so he perhaps feels, through art, not only the opposition of the sensuous-earthly confinements and the call to the trans-worldly and to the eternal fate of the soul, but also that precisely *his* art, more than any other, has torn the gulf asunder between the human and that which is more than human; may we call it fate, may we call it God. It is not as though Rembrandt would have flattened out the contradiction into "reconciliation." Each glance at the self-portraits of his old age — where, in a poignant contrast, an almost fearful inner tension in the features shows through their corpulent slackness — falsifies this formula. He has only taken the form of opposition from fate and, with all bitterness and hardship, allowed it to come alive in the form of real lived individual existence.

It is out of these constellations that it becomes comprehensible that Michelangelo's figures, despite all of their mightiness and perfection, give the impression of constraint. Fate and life, because not uniquely their own, but belonging to humankind in general, overpower them. The figures seek to defend themselves against them and shake them off, but cannot do so because they are *nevertheless* their own nature; the nature of the human — a conceptual contradiction of course; something logically incompatible through which, however, precisely the irreconcilable tragedy of these figures can be expressed. In contrast, Rembrandt's figures, lacking the heroic gesture and monumental mightiness of the former, and often enough weighed down and crushed by external forces, still allow us to feel a point of freedom. They do not have to fight against invisible forces that drag them along as the fate of human life in general, and are therefore *nevertheless* outside the opposing individuals. In all those Rembrandtian figures — who frequently represent petit-bourgeois, poorly bred Jewish,[23] intellectually insignificant, persons — is something majestic that, however, does not inhabit their consciousness, but rather the artist's conception of them. He has shown how in the ideal image of each human being there dwells a freedom and self-esteem as soon as the moment, grasped in the picture, really grows out of the continuity of his life. This corresponds to the concept of freedom of his contemporaries: to exist and to act *ex solis suae naturae legibus*[24]; something that comes into being, that has collected in itself the whole course of its development, and could develop and become intelligible precisely out of this, however much the exterior and passivity has been inserted into it. Of course, this has to be paid for with the abandonment of that extension into the general-human. Michelangelo's figures experienced the fate of humankind in general, even if grasped on the basis of a particular visual perspective. The borders of the individual existence are broken through, and what we see is not a current flowing out of *one* spring, into *one* estuary, but a wave raising out of the sea, making its total law visible within itself; or, more precisely, we do not see a wave, but through the wave as though the whole sea had become transparent.

It is not a matter of the pluses and minuses in which each comparison of artistic personalities inevitably but, viewed internally, accidentally results, but of the fact that the positive aspect of each of these conceptions of art, even of life, is inherently bound to the condition that they are mutually exclusive. If, in Michelangelo, it is the gravity, tension, and discontent of human fate in general through which the perceptibly participating figure extends itself beyond the individualistic limitation of Rembrandtian representation, so in Rodin the circle in

which individuality dissolves itself stretches still further. Now the intention of the feeling no longer lies in the fate of humankind as such, but, rather, in the rhythm of movement of the cosmic process in general. Rodin's art, insofar as it is creatively original, stands under the sign of modern Heracliteanism. For the worldview that can be described in this way, all substantiality and solidity of the empirical perspective has turned into movement. In restless transformations a quantum of energy flows through the material world, or, rather, *is* this world. No formation is accorded even the slightest degree of permanence, and all the seeming unity of its contour is nothing other than the vibration and surging movement of the exchange of forces. Rodin's figures are elements of a world experienced in this way. Contours and movements of the body are here the symbols of souls that feel themselves being dragged into the infinity of emergence and destruction, and who constantly stand at the point where becoming and demise meet. Here form, in the sense of classical art, is therefore dissolved just as it is in Rembrandt. However, in Rodin coming into being and into process does not simultaneously accomplish consolidation into totally new meaning, nor the form of a single sequence of individuality. Moreover, the oscillations and turbulence of the cosmic process do not allow for this (I speak here of the nudes, [and] not of those Rodin portraits that require a more complex interpretation). One can characterize the three types of style — which are here at one and the same time symbols of three quite general concepts of life — in terms of their relationship to time. I described the form of classical art as atemporal because, as the abstraction of life's contents or outcomes, it stands opposed to the sequence of the life process. After the development of movement or of life led to this form, for them, as something purely artistically formed, there no longer is a before and an after. In Rodin's creations, however, time is eliminated for the opposite reason. In order for time to pertain to a creation, the latter has to be in some sense something *unified* in which a before and an after can somehow be felt. A time that simply goes by without memory, as it were, would not be time, but rather a moment without extension. Time exists only where a form presents itself in which the past arrives at a synthesis with the present. The world of Rodin's figures, however, is (according to their idea, which visual intuition of course only points to from the distance) precisely such an absolute flow; the abandonment of all solidity in which a before and an after — that is, time — could mark itself. Here, the fleeting moment of life is banished but in such a way that one really feels its passing, while the before, just like the after, remains sunk in impenetrable darkness. The absolute movement into which the souls

and the quivering and struggling, tumbling and flying bodies in Rodin are dragged negates time, just as the withdrawal from all movement in the principle of form in classical art had negated it. Absolute becoming is just as ahistorical as absolute nonbecoming.

Herein lies that which separates Rodin's conception of the human being from that of Rembrandt. The human being in Rodin is dissolved in all the tremblings and contractions of becoming. He only exists, as it were, in the Heraclitean moment of becoming, but we do not feel the coming into being of this moment. He is also torn from his own past, which is to say that he is not an individual. This is the awareness of life conveyed in Verlaine's verse:

> Et je m'en vais
> Au vent mauvais
> Qui m'emporte
> Deçà, delà
> Pareil à la
> Feuille morte.[25]

Rembrandt made visible the connection between individuality and the historical-temporal dimension. On the one hand, the moments of absolute becoming are in fact only to be structured in a before and an after in that they take place in something unified, or at least persistent. Had they disappeared completely with their temporal demise that order and relation that presupposes a certain summation could not have been arrived at. It is with the living that *individuality* appears as this ideal existence on which the emerging and submerging moments of becoming to some degree are summed up. They are now no longer nonlocalized atoms of being, but rather states of one and the same individual (which is not to be interpreted as a solid substance, but as the peculiar identity of the living being with itself). They are now not lost for each other (as they would be from the point of view of the mere mechanistic-cosmic turbulence), but the one really is the earlier, or later, [manifestation] of the other. Therefore, only as the moments of development of an individuality do they collect and order themselves in a temporal sequence. Conversely, individuality for its part is only thinkable through the historical successive ordering — rejecting the absoluteness of becoming — of the moments of life, always assuming that it does not intend the accentuation of particularity, of qualitative uniqueness, but, as in Rembrandt, the continuity of a unified life in which each moment presupposes all past and lays the basis for all future moments, and each intends the continuity of the form in which the totality of this life represents itself. Such a meaning of individuality can obviously only be

realized through the temporal connection of the moments of life, not, however, through their atomizing into the absolute movements of a world that is indifferent toward all synthesis. The feeling of existence and of fate out of which Rodin forms his nudes is, however, precisely bound up with such a world. On the basis of his own conception, Rodin knows of no temporal synthesis that has turned out, as it were, to be only the alternative expression of the idea of individuality. In that the temporal order determines individuality, but is at the same time determined by the latter, each is revealed as merely *one* design of life, but viewed from different angles. Here is unmistakably demonstrated the way in which the individualistic conception of the human being in Rembrandt is at the same time dominated by the history of that human being, and how this contrasts with the trans-temporal character of classical art and with the nontemporal character of Rodin. If I may remind you here once again of the abolition of the particularizing momentariness into the flowing totality of life emphasized above, so in Rembrandt the path leads from the moment to the totality of the individual fate that is temporal. In Michelangelo and Rodin it leads to the totality of human fate and also to that of the cosmos, which, from our point of view, is atemporal. While classical art, however, in its fulfillment in Michelangelo, made forcefully visible the eternal nonredemption of this human fate precisely in the atemporality of the design, Rembrandt in contrast barred his figures from this trans-individual breadth, and incorporated them into their personal fate. Via the linearly fixed course of their individual temporality, Rembrandt excluded his figures from that cosmic fate in which Rodin's figures stand and, of course, dissolve. Just as, in contrast to Michelangelo's figures, those of Rembrandt therefore possess something unrestricted but also something unconnected to the general-human, so they display, in contrast to Rodin's, an ultimate inner security that the latter — uprooted and impersonalized by the turmoil and the absolute violations of existence — completely lack. Nevertheless, however, this state of dissolution is one that reaches into the cosmos. Cosmic life (irrespective of whether this is the definitive formulation) does not allow them to rest from being themselves; they are nothing other than the oscillations in a Heraclitean world. They achieve belonging to the totality of this world at the price of giving up each substance and unity of life to the mere moment of absolute becoming. In that Rembrandt's figures keep this unity and self-assured continuity, they, for their part, pay the price of failing to actually arouse the feeling of the cosmic within us.

Naturally, this should not be characterized as a lacuna, the filling of which would have added another lacuna to the qualities of Rembrandt.

It is, rather, merely the negative expression of the positive aspect of his nature. The latter would not have been enriched had he acted differently in this respect, but would rather have been self-estranged and self-contradictory. The same is true for another expression for Rembrandt's creative nature that carries over the aforementioned feature from the essentially emotional into the more intellectual.

Neither with Rembrandt nor with Shakespeare (as paradoxically as it may sound with respect to the latter) are we are dealing with "the great human themes," as we are with Dante and Michelangelo, with Goethe and Beethoven whose object is the greatness and the depth, the tender and the shocking in human life itself in its inwardness, and in its determination by fate. Neither Rembrandt nor Shakespeare confronts the totality of the world with the eternity of its laws and fates, as do Dante and Goethe in an immediate way, and Michelangelo and Beethoven in the reflexes of their subjectivity. Life, in the specific form of its subjective realization of fate, insofar as it can be found within this realization as its basic destiny, is the task which Rembrandt's and Shakespeare's representation brings to a conclusion. That, however, life can place itself, as it were, beyond its being lived and beyond the emotional and intentional, religious and momentous movement and deepening of that [particular] life in that it forms and can live for *objects* (for the great and absolutely trans-individual ideas and totalities), none of this speaks out of their work as knowledge, passion, necessity. When Dante exhausts himself in the overwhelming longing to copy the plan of this world and eternal world; when for Goethe the point of existence is to attain the nature of God in the unity as well as in the separation of all appearances; when the Sistine Chapel and the Medici tombs, the Fifth Symphony and the Appasionata announce the boundless struggle for freedom and light, for the highest elevation of the earthly and the elevation above the earthly — so with all this is life bound to the magnitude of something objective. The work of Shakespeare and of Rembrandt, however, elects the greatness and depth, the miracle of individuality and the beauty of life remaining within itself. This decision does not weaken but confirms the power of their works that weave in all fate, all that happens, all clarity of the things and forces around us. And just how far life is present for its own sake — as the absolute in all its relations — manifests itself perhaps more fully and from a greater depth there where it is subjected to that given than where it dominates it. The order of magnitude in which the bearer of this counterdirections stand renders all ordering according to their relative value inappropriate. It is only a matter of the pure realization of the creative overall intentions (which are, by the way, merely the culminations

of characterological opposites, even in the case of lower and unproductive strata). The fundamental distinction is this: whether the decisive meaning of an artistic creation — which is not the same as the conscious intention of the creative personalities, nor any of the expressions of the depicted personalities (whose bearer is rather the creator of the total work as such; an ideal construct that has truth but not reality) — turns and devotes itself to the "great human themes," or whether these appear to the artist to be a detour in the life which is lived for its own sake; a detour which life in its purest concentration avoids. This determines the place that Rembrandt holds in the intellectual history of humankind beyond his artistry and merely conveyed through it.

3

RELIGIOUS ART

OBJECTIVE AND SUBJECTIVE RELIGION IN ART

The nature of religion appears throughout human history in two basic forms. Because there are religious facts (God and facts of salvation, cult and church), and because the religious individual behaves receptively or creatively with respect to these — only seeking his own salvation or sacrifices himself selflessly — a double current of religious nature is initiated that can converge on an almost perfect division. On the one hand, there is the *objectivity* of religious or ecclesiastical facts: a world enclosed within itself and constructed in conformity with its own laws — that is, according to its own meaning and value, absolutely indifferent to the individual who can only accept and respect it. On the other hand, there is religion transposed entirely into the *inner life* of the subject; or perhaps better: consisting in the inner life of the subject. Here each transcendence or cult may or may not be a metaphysical reality. All religious significance now lies completely in the qualities and movements of individual souls who may perhaps be set off by, but perhaps also give meaning and life to, religion. In the first case, religion means a distinct opposition and, so to speak, only retrospective mutual receiving of the divine and the inner life. In the second case, religion means inner life itself, pouring out of a deep individual productivity and sense of responsibility that clearly in itself, as religious being, possesses a trans-subjective solemnity.

The greatest historical realization of that objectivity of the religious world is Catholicism. Nothing comparable can be demonstrated for the other source of religious being. This is understandable because the structures through which religion becomes something historical and visible (dogma, cult, church) are at best of secondary importance to those for whom religion consists in an experience, or in a conduct and coloring of life in general, or in an immediate relationship between the soul and God; in a relationship that, as a religious one, can only be played out within the soul itself. Clearly, this type of religiosity does not go beyond the individual and thus creates no complete historical phenomenon. Nor is this represented in any way by Protestantism, because this, too, deals with absolutely objective religious facts that have their place not in the religious soul, but rather are the latter's object: in the worldly rule of a personal god; in the salvation that Christ accomplished for humankind; with fates that enter the soul through the objective-religious structure of being [*Dasein*]. Were subjective religiosity truly to be realized (which happens perhaps no more than *pure* objective religion exists — each of these forms always appearing in a certain mixture with the other), then it would consist in the life process itself — in the way the religious person lives each hour — not, however, in any specific contents, nor in the belief in any specific realities.

Although these two countercurrents of the religious life in general have not meticulously divided up Christian art among themselves along party lines, their purity and their hybridity constitute a scale on which each religious picture finds its particular place. Byzantine art begins with the objective representation of the transcendental world. In the mosaics of Ravenna the figures and symbols of the Christian mysteries are presented in their metacosmic solemnity, with complete disregard for the human subjects experiencing them. The human beings of this religiosity, including the artists, have completely desubjectified themselves. Before them stands a heaven of the gods; enormous self-sufficient powers of being to the envisioning of which individual feelings and inner fates have no relationship, neither as the starting point nor as the point of convergence. Thus, their so-called lifelessness means that the fact that they are separated from the life process (as that which is earthly) is not a deficiency that could be remedied by some supplement. Rather, it characterizes, despite the negative *expression*, the extremely positive religious-artistic nature that must reject its logical opposite, namely directedness toward individual life. With the *Trecento* another point on the scale is reached. With Duccio, Orcagna, and some of their lesser contemporaries, a tone of lyrical humanity flows into the self-contained solemnity of the painting of the saints. The transcendental not only *is* and, as objective power, controls

human beings, but, rather, out of the transcendental, a movement of its own approaches human beings. The expression of religious *life*, however genteel and reserved, has found a way into the representation of transcendental facts. The relationship between objective and subjective religiosity shifts again in High Renaissance forms. Their greater liveliness and naturalism do not allow the representation to appear at all as the expression of an inner-religious dynamic. I exempt Michelangelo, who in this respect adopts a quite isolated and atypical position. But Leonardo and Signorelli, Raphael and Fra Bartolommeo have an astonishing objectivity in their painting of saints that, as I sense it, stands closer to this [objective] end of the scale than *Trecento* paintings did, however much the latter distinguish themselves from the *Cinquecento* in equal measure through their ungainliness and by their religious dignity. One no longer at all has the impression that some religious life has contributed to these compositions out of its own initiative. Even where the pure painterly interest has not rendered all other inner agents imperceptible, the religious intent is still exclusively directed toward the representation of a heavenly or historical existence that is determined from its own center, according to its own inner laws, but not by the piety, or the longing, or the devotion of a soul. The peculiar ability of the human mind to think and view things from some way off — in a sense, disregarding itself — is also powerful in the sphere of religion, and in the Renaissance this power proved itself without reservation. I include Rubens in this. His *Ildefonso Altar*, precisely because of its complete worldliness, perhaps raises religious objectivity to its highest point. The goddess of heaven displays the same noble representative existence as does the prince who pays tribute to her. Between them there is really only a graduated difference within the same dimension, isolated, as it were, from that which lies below. And that the representation of the divine should be determined by a human-personal religiosity would appear just as inappropriate here as, according to the views of the time, would subjects directly electing the Emperor. Concomitantly, the Jesuit Oliva,[1] in his sermons held at the Papal Court, described the Virgin as "princess" or as "empress." The absolute sublimity of divine being may indeed have been humanized here, but because this only happens through the sociological cachet of "nobility," the rejection of any inner religiosity of the subject that would live on in artistic compositions has almost gone over onto the offensive.

PIETY

At the other end of this scale stands Rembrandt. All his religious painting, etchings, and drawings have a single theme: *the religious person.*

He does not make the object of belief visible, and, in his representations of Jesus, Jesus never has the character of a transcendent reality but rather that of an empirical human one: the loving and the teaching, and, in Gethsemane, the despairing and the suffering, Jesus. The existence of the sacred, the objective sublimity that the believers can only accept and that shines upon them, has, for Rembrandt's art, disappeared. The religious element that he calls into artistic appearance is *piety* as produced in its many variations by the individual soul. This soul may be stimulated by otherworldly powers, embraced and determined by divine being. But it is not this that Rembrandt displays, but rather the condition that this soul, presupposing all this and with its specific powers, brings forth; a condition that can only exist within human souls and express itself through human, earthly bodies. Even if all the objects of belief in the hereafter exist, and even if the individual with his qualities were merely a windblown grain of sand within their absolute power and objectively an irrelevance, *religion* can only ever emerge in the relationship between the human soul and this hereafter, and religion is in all circumstances the moment in which this soul enters this relationship, and in which this relationship exists for the soul. This is, in theoretical terms, the basic precondition of Rembrandt's religious art. For the first time in the history of art, this torrent springing from the source of religion is brought to complete domination [*Herrschaft*] so that, irrespective of the belief's contents, its metaphysical basis, its dogmatic substance, as religion it is an act or a specific state of being [*So-Sein*] of the human soul. On those few surfaces on which he represents God the Father, God is in fact insignificant; much less profound and interesting than are the human figures because God, of course, is not pious.

Only Fra Angelico might be mentioned as a comparable case, because for him, too, the pious person as such becomes a problem of representation. Religious content is likewise for him, in the last instance, something general that hovers above the individuals and merely inspires them. They experience it as something received. Nevertheless, dogma is here still too narrowly woven into the pure inner process of pious existence to offer more than a premonition of the quintessentially trans-historical structure of piety in its Rembrandtian expression. In the Middle Ages in general, piety is poured out like a substance that infuses the individual person; whereby, naturally, in the religious geniuses, like Francis of Assisi and Meister Eckhart, the soul's own movement approximates objectified religious values, but sometimes, dangerously, misses this point of convergence precisely when the soul's own movement breaks out of the last depths of subjectivity. With the

religious figures in Rembrandt, piety is on each occasion produced anew from the deepest well of each soul. People are no longer in an objectively pious world, but rather they are, as subjects, pious in an objectively indifferent world. The piety of the Middle Ages is still immediately bound to its transcendent object (precisely because it appeared as a particular sensory empirical given). Were these people to have been robbed of their God, they would — with the exception of their religious geniuses — no longer have been pious. This is not the case with Rembrandt's figures. Medieval people would have remained pious even if there were, so to speak, no earthly life with its contents (as was most closely realized and demonstrated by the saint and by the life of the cloister), whereas this is not something that one can fully imagine in Rembrandt's figures. His figures are as distant as possible from the principle of the cloister, which negates life's content. On countless occasions he presents biblical scenes that, given the absence of all dogmatic elements of belief, one would probably not wish to take for religious art at all: *Erlebnisse des Tobias*,[2] *The Good Samaritan*, *The Return of the Prodigal Son*, and the *Jugendgeschichte Jesu*,[3] envisaged in a completely petit bourgeois manner. Here the religious aspect accrues to these people from within, in the same way in which they are clever or stupid, lively or indolent. They may believe or do as they wish; they have piety as a determination of their subjective being as such, which stands out as a coloration of their personalities all the more clearly in their completely earthly conduct.

Religiosity, as the basic form of personal life as such, makes every scene of this life the place in which a religious tone or value can exist — indeed, must exist, making sure that no place in which one of its contents takes in other objective orders can become a hindrance to life's religious suffusion. Here we have the subjective counterpart to pantheism. That in the latter, divine being bears all things and their meaning without distinction or reservation is translated into the relationship between religious mood and the objects of personal life — not in principle, but with historical graduation and relativization between cosmic absolutes and inner personal life. Just as for Spinoza, God is the origin of all things, and these can only be grasped through Him (not as though He were an external overseer but because, from the beginning, things are nothing other than the modification of divine substance), so in the modest life circumstances of Rembrandtian figures, religiosity is not something that would be added to a different independent quality of their actions and experiences; rather, from the beginning, these actions and experiences of theirs proceed *sub specie religionis*.

And just as the pantheistic god has neither particular qualities, nor could bear and deify any point of being any more or less than any other, so the vital religiosity of these Rembrandtian figures does not divide into the individual motives and traits with which one might normally analyze religion. And it is appropriate to this inner, simple unity of life's mood that no one moment is singled out above another; rather, what is illuminated is everyday life as a whole. Light does not come from outside (such light would inevitably fall unevenly); rather, in order to illuminate its ordinariness, from within, shining through equally in each path that leads from the core of life to life's appearances. This is why, just as this religion clings internally to all contents, so externally it clings to none.

To call Rembrandt a "mystic" on the basis of this stance fails to demonstrate deep insight into the phenomena that happen to bear the name of mysticism. What is specific to mysticism — beyond the phenomena from other spheres with which we like to taint it — is that the inner movement of life is experienced as identical to that of the divine. By locating its nature in the secret dark depths that are not to be exhausted by rational concepts, we commit the popular error of confusing the mystical with the mysterious. The latter, as something purely formal, can be applied to all possible inward and outward phenomena. Certainly it is a logically inseparable part of the essence of mysticism that the experience bursting out of the innermost center of the soul is at the same time an instance of divine life (this is only partly distinguished in Meister Eckhart's teaching that God needs man in proportion as man needs God). The mystic does not experience deity as an object but rather lives it immediately and is in no way thereby required to relinquish the self, but only to deindividualize (because the distinctiveness of individuality is something foreign and accidental around the self's core). Here the "I," without abandoning itself, is still infinitely more than a mere "I" (as Plotinus said of ecstasy, with it God did not enter persons, but rather showed precisely that He does not need to enter them because He was always in them). But this rising of the soul beyond itself is quite foreign to Rembrandt. No more than the god outside does the god inside the person determine the incomparable hue of the religiosity of his figures. Their absorption, their solemn peace, or their upheaval is found only within the course of their own lives, irrespective of the external or internal event through which this is manifested. Precisely the being-more-than-itself [*Mehrsein-als-sie-Selbst*] inherent in mysticism is foreign to each of these souls. Rembrandt is no mystic. One could rather admit that a Christian mood of life [*Lebens-stimmung*] is inclined toward the development of this piety of simple

existence for which, according to its nature (we cannot determine whether or not also according to Rembrandt's consciousness) all dogmatic content remains beyond consideration. It is not far-fetched to think of Luther, who undertook to overcome the breach between holy and everyday domestic life: "servant [*Knecht*] and maidservant [*Magd*], when they do as their master and mistress bid, serve God, and, insofar as they believe in Christ, God is more pleased by them sweeping the parlor or cleaning shoes than by all the monks' praying, fasting, holding mass, and whatever else they boast they do in God's praise."[4] Herein still lies the dogmatic presumption; however, here, too, piety, although so deeply rooted in life that it also encompasses life's most outer periphery, is a *means* to a state of bliss (I shall return soon to this decisive point). This is not about piety that inheres in the deed as such because the doer is pious, but rather is, as it were, only secondarily pious because the doer places himself within an order of life prescribed by God and determined by a particular objective belief. This distinction is very subtle, but no less sharp for this. This-worldly and other-worldly values are clearly brought into a new proximity in Lutheran teaching. However, for the religious uniqueness of Rembrandt's figures (whether it still appears in them as mixed with other elements and not with totally pure dominance), the question of this-world and the otherworld does not arise at all because it is exclusively a matter of inner being that is determined neither by the one nor by the other. In this, the people of these peaceful, familiar paintings do not *have* religion as the objective content of life; rather, they *are* religious.

Certainly, it is an enormous achievement that is to be found in the tendencies of Plotinus, to a degree of Christianity, of Schelling and of Hegel, to have elevated all empirical details, externalities, and accidents of life into the sphere of the absolute, the holy, the absolute sense. Actually, this tendency is to be found in the orientation of every cosmic metaphysics, however little it is realized anywhere. However, greatness of a different kind is to be found in the reversal of the directive: to lead the ideal meaning, the trans-empirical value, down toward the individual life contents left within their own level. The objects continue to take root in the earth, but precisely this taking root and reality shows itself to be shot through with metaphysical solemnity; pervaded by a sense of pure reason — thus Socrates as he brought philosophy "from heaven down to earth" and saw a place for a rational standardizing meaning in the everyday business of humankind; thus Kant as he recognized the metaphysical worth of the free I in the simple fulfillment of duties. The early painters of piety — Duccio, Orcagna, Fra Angelico — followed the first norm: in order to partake in the divine, the earthly became

unearthly. Rembrandt, however, left undisturbed the phenomenon in its relation to the earthly; let the earthly remain as reality, but he displayed the dedication, the absolute value that it possessed through the immanent moment of piety.

This is why Rembrandt's figures are pious in their own right and not because they are placed within a preexisting transcendental order. It is here that they have the *definitivum* of their inner life values such that, put *cum grano salis*, the religious objectivities to which piety usually led as a means and a path, a preparation, and a dignity, are in their turn only the prerequisites and conditions for piety. Otherwise piety appeared only as the springboard from which subjectivity reached up to religious objectivities. Now it is the other way round, and it does not disturb the meaning of religious value existing in such a way if these objective contents are articulated merely as subjective constructs. Whether they are here like this and elsewhere like that, historically conditioned, superstitiously fantastic, the fact that they are subjective is now irrelevant because they are only a means or an expression viewed as a condition. Therefore, the fact that the same effect can arise from very diverse causes is realized through them. The objective and the definitive remain the free-floating — and precisely therefore in themselves the absolute self-certain — piety of souls. This is why the shift from being a means to being an end is indicated in all aspects of the meaning of piety. Goethe once said that, "piety is not an end, but rather a means of attaining the highest culture via the purest peace of mind."[5] Precisely this is not valid for Rembrandt's religious figures for whom this "highest culture" would be quite far from their minds. It [culture] too would be a means (the expression here becomes unavoidably distorted) because, for them, piety really is the "aim," the final value point, of their inner being.

Where another view represented religious values in human form, either the human was deified, or God humanized. Rembrandt goes beyond this alternative because the religious as he presents it is not the objective relationship between human and God but rather that innermost being of the person in which, or out of which, the relationship to his God is established in the first place.

CONCRETE EXISTENCE AND RELIGIOUS LIFE

The interweaving of religiosity with contents of life that as such belong to other orders makes room for a differentiation of direction whose aspects may not be distinguished with demonstrable certainty within the single appearance. Nonetheless, their distinction will help to clarify

the sentiment of Rembrandt's religious art. The question how the details of empirical life are, and should be, related to religious elements is in no way unambiguously answered by historical-inner reality. Where a substantial objectivity of the dogma exists, the religious suffusion of daily behavior has always led the latter into a rigid formalism. Where the otherworldly meaning of life, its overall sacredness, emotion, and cosmic metaphysics of the universe, enters the individual concepts of religious dogma, there opens up for the first time a fissure between these and the individual elements and practical intentions of the external course of life that, clearly, no organic fusion can reclose, but rather only a standardization of these intentions that is called religious can externally bridge. Here one is reminded of the life style of the Brahmins, ritually strict Jews, and many monastic orders. Insofar as food and drink; that which is permissible and that which is impermissible in conduct; the carrying out of every deed is prescribed by religion, the entire mass of atoms of our empirical acts constitutes a religious continuity. It is clearly by *coincidence,* however, that a particular exterior conduct of life is bound to a respective fundamental belief about the divine. For the specifically religious in us to manifest itself in an *internal* relation to external practicality, a source of religious development already flows immediately within the latter. There are countless relationships between people whose emotional aspects have a quality that can, without leaving the empirical domain of these relationships, only be described as religious. In the erotic sphere and in friendship; in rule and in service; in the relationship of the individual to the clan or to the family, to social rank (*Stand*) and fatherland, and finally to humanity; but also in the relationship to fate, to career, to duty, to ideals — everywhere here is to be found a mixture of devotion and a life of one's own; of humility and elevation; of sensual, warm intimacy and shy distance; of trust and fate belonging to the essential conception of religion. It is not as though all this needs to display religious underpinning or sanction. Rather, those elements of feeling are merely the ones that mentally bear religious creation, piety, conduct as soon as they are no longer bound to the substrata of empirical relations, but create their own transcendental object (God or the gods). Religious feelings and impulses develop in the full breadth of empirical life as its immanent force, irrespective of whether or not they bear this name and are elevated into special concepts, special structures, or into a specifically "religion," thereby becoming autonomous and allowing themselves to be legitimized through their sacredness. The contents of life and their relations are here, to an incalculable degree, the sources that are combined to form the religious current. This [current] resembles

a chemical substance whose particular and new qualities are found in none of its constitutive elements. The connection between religion and empirical details of life is carried out starting from the latter in that religiosity and religion do not exist on their own, but emerge as the character of certain internal events of life.

Besides the connections running in this direction stands its other functional possibility: from the start a religious mood in the pure sense is available as life's basis or as the coloring thereof, a dynamic that is not first spread through life as the most diverse categories of feeling and as a specifically religious dynamic first flows out of the latter, but rather is immediately purely religious and on its own basis pervades and draws into itself the interior life and its expression. The connection between religion and all concrete action and occurrences is here shaped by the former. Religious conduct and structure emerge not in the further growth and convergence of feelings and impulses that the pre-religious being, carried out by singularities, develops, but rather is itself something primary that provides just these singularities with direction and mood. Within art, the former case might only be displayed in hints. There are some still lifes and landscapes that display rapt attention to the represented existence, a premonition of universal affiliations, an effusive blessedness in existence combined with a reticence before its secret depths, all of which have no need to emerge from religious foundations, but rather are either precisely identical to religious being or develop into it. Rembrandt's religious paintings, however, reveal things from the other direction, in which the singular visible existence attaches itself to the religious. This is now not the fruit, but the root. Furthermore, that the exterior — yes, the banality — of the phenomenon is shot through with religious spirit is not its own achievement but, rather, as it were, its unavoidable design that piety furnishes as its *a priori* essence of being. How should religiosity not shine out of all contents of life that are received and formed by a *religious life process*?

Herewith, we have actually identified where the point of contact between Rembrandt's art of portraiture and his religious art lies. The point lies fairly deep under the surface of both spheres, because, on first examination, they appear to stand alongside each other without a stronger relationship. Now, however, that which they have in common becomes evident: instead of the substantial contents of life that are congealed into solid components, the life process itself has become the essence and the intention of Rembrandt's art. In the case of the portraits, this concerned the individual qualities, characters, temporal or atemporal persistent appearances into which the life process of the

personality crystallized, and which Rembrandt's human representations display as though dissolved in the fluctuations of precisely this process. Correspondingly, in the sphere of religion we find the relationship of the dogmatic formulations, the fixed types, the transcendent structures and their symbols to the process of religiosity — to the religious *life*. The latter may find its expression, its expressability, its self-contained clarity, in all those. Rembrandt, however, grasps religious life in a prior inner stage: in or before the *status nascendi* of those contents, whether or not they are, in historical-psychological development, already required as stimuli and signposts. Not what a person believes, not the specific content of the religious life, but the particularity of the life insofar as it is religious constitutes his problem. In the portrait, as in the religious painting, it is the event that is borne by the soul — as pure functionality — that he brings out; and he is alone among painters in doing so with the full force of the expression of precisely this element. In the portrait this element is the individuality of life, in these paintings it is its religiosity. Just as individuality is not grasped in the portrait as a timeless quality, but as the particular form of a living movement [*Lebensbewegtheit*] that is not to be separated, even ideally, from it, so the religious here is a way in which life is lived; in no way, however, something that could be represented in a state outside its process. From this it is immediately evident that the figures in these religious paintings do not appear to be individual in the same way and to the same degree as in the portraits. This is so because life here is viewed from the perspective of a different immanent category from that of the latter. What they have in common, however, is that here, as there, instead of the contents and results of life, that which is quite primary and functionally determining stands at the center of the artistic intent. In order for simple piety to represent itself as the continuous state of being [*So-Sein*] of a person, closely bound into each single situation, in Rembrandt's religious painting the specific warmth of life is given to religion: a warmth that can easily desert it when art adheres either to those objects of this piety that have acquired autonomy, or to the strongly emphasized events and culminations that transpire, as it were, in the external contact of life with these objects.

In this last respect, it is instructive to clarify the inner structure of the greatest classical religious painting (with the exception of the Sistine Chapel), Leonardo's *Last Supper*. The incomparable here is this: an event that is to a degree external — the words "I say unto you, that one of you shall betray me"[6] — occurs simultaneously for a number of quite distinct persons, thus releasing an effect that brings precisely each individual peculiarity of character to its highest and most unmistakable

expression. It is as though, despite all differences, the spiritual-corporeal element in them is so ordered that this shock going, so to speak, through them, without resistance, drives precisely their diversity to the surface. In Raphael's cartoon *Christ Handing over the Keys*, it is also a word that calls up an expressed answer from the Twelve. This answer, however, does not converge in the revelation of the individual ultimate nature of each one, but stops short of that expression that objectively suits the situation, at most with a division of roles, while the situation with Leonardo is merely the causal occasion for the unfolding of individuality. The outcome is that in Cenacolo [di Santa Maria delle Grazie] these appear much more decisive and more nuanced than in Rembrandt's religious paintings. But again it is only in the build up to this moment, or in statuesque timelessness, that the most external, most isolating, characterization of the individual is achieved.

THE TYPE OF UNITY IN THE RELIGIOUS PAINTINGS

The sociology of such group paintings in Rembrandt poses a subtle problem. Where a number of persons are gathered within a frame (in both a literal and a figurative sense), we generally experience a unity that is something higher and more indivisible than the sum of its parts, just as the state is something other than the sum of its citizens, the will of the collectivity more than the addition of individual wills. And in art even those groups that are in all respects as divergent as Orcagna's *Paradise*[7] and Titian's *Assunta*[8] in each case form a unity that somehow lies beyond the participants' individual qualities. Where a meaningful unified geometrical form is to be abstracted from the groups, it becomes the most external symbol of that totality which is formed and borne by the elements, but not pro rata to be found within them. The unquestionable discernibly of this unity is often difficult to interpret. Rembrandt's paintings do not display this, in a narrow sense sociological, unity of form. We have already established that in *The Night Watch* unity weaves itself immediately out of the living spheres of the individual acting persons; that it is not an autonomously all-embracing whole mingling the figures, as it were, merely as limbs. This applies to the religious painting, too, although here the unity of the religious atmosphere can easily appear as a stream that, so to speak, springs up from beyond the group and, by flowing through it, holds the group together. This, however, would not be an accurate expression of the facts. Rather, this mood has its origin entirely in the individual, the unity of the whole stemming exclusively from the combined effect of these purely personal spheres easily realized in their substantial equality. The whole remains

bound to the personal elements in their individuality, and their unity demands no reduction of the latter. That this is likewise not discernible in Italian Renaissance painting can be traced to the leveling out of the dominating unity of form of the whole by the proud emphasis that the personalities give themselves. Rembrandt stands outside this entire polarity. He requires no leveling reduction or elevation of the persons, because, from the start, they all live in the same mood. In this way he is able to draw the represented moment much more into the flowing temporal entire life of the persons, thereby clearly omitting all emphasis achieved in the encounter with the situation. What is, however, achieved in this way is an incomparable increase in the religious character of the work. It is most noteworthy, that in Cenacolo — despite the coherence supplied by the one word of Jesus that runs through the figures like a continuous surge, and despite the wonderful perfect rhythm of the whole composition — there is a failure to achieve that unity to be found in Rembrandt's representations of Christ at Emmaus, or in the etchings of *The Entombment of Christ* and *Christ Preaching*. In the former case, the figures stand out from the totality due to the monumental statuesque culmination of their individuality. They are in the first place something for themselves, and only retrospectively are they seized by a shock emanating from a *single* source. This measure, or, rather, this type, of individualization is, however, incompatible with the immersion in each religious mood that surges over the whole and turns the individual into its vessel filling it to the brim. It is not as though religiosity discards the greatness and power of its bearers in general. The way, however, in which the Renaissance individuals behave there (proud of their greatness and power — a pride that lies not in the first place in consciousness, but rather immediately in the person's being), the way in which they present themselves in the formal closeness of their state of being [*So-Seins*] — this is something *other* than the specifically religious. It inhabits much more the dynamic *life* that does not stand there in stylized self-sufficiency. Life, as something flowing, lacks these sharp contours. And the fact that in Rembrandt's paintings piety is the way in which the individual lives stands precisely in mutual determination to the unity of the way they are brought together. When I spoke of the wave in Cenacolo flowing through the beings as their bond, so in Rembrandt these beings are fully submerged in the surge, and fully dissolved in the common ground of a life because each already has for itself its momentarily decisive life, not in the elevating selfhood of the classical closed stroke, but rather in the flooding of the life process that, without resistance, mingles with the others. This is, if you wish, more humble, but at the same time more

sure of its religiosity, because the latter is not a trait of an already formed personality, but rather the way in which that person's life itself is lived.

INDIVIDUAL RELIGIOSITY, MYSTIQUE, AND CALVINISM

This religious individualism seems to be a continuation of a new emerging current within Rembrandt's surroundings. In the circles of the Dutch seventeenth-century "*Collegiants*"[9] one finds a strong distrust of the worth of the existing churches, to the point of complete rejection of the confessional form as such. A religious subjectivity emerges that grants the individual a considerable scope for discrimination.

There is something of deeper significance in this absence of the objective general character of religious values out of which Rembrandt's conception of the religious personality is so completely distant from any statuesque representability. Sculpture is the most unindividualized art. It is, at least up to Rodin, the art of the most general form. In this way it becomes understandable that in the Italian Renaissance figures in painting also frequently stand there like statues. This is even typical for some series [of paintings]. The substantive generality of Catholicism corresponded to the formal generality of art, while Rembrandt's way of perceiving — in which the problem of generality makes no sense — could create no place for that design intention that finds its highest expression in *sculpture*. The religiosity of his figures lack generalized character not only because the latter is an abstraction, not only because the religious *life* (in contrast to religious *contents*) can only adhere to individual bearers, but also because it is something commanding, something oppressive vis-à-vis the individual. These Rembrandtian figures are farthest removed from any religiosity of "law" that, as something general and dominant over the individual, has found expression in the church. Not only is law something universal, but also the universal is law. In those Ravenna paintings of divine and holy creatures — insofar as they have any access to a relationship with the human at all — it is precisely the *lawlike* nature of religion — the *magisterial* about the church — that is an unmistakable trait. They announce the truth and the absolute as the universal and as unity as such. It is precisely this unity that is so foreign to Rembrandtian figures because their religiosity is not the emanation of any content (however little it may reject [such a content]), but rather a life process, a function that can only take place within the individual. This appears most peculiar in some of his representations of Jesus. In several etchings, Jesus

appears as a boy: needy, almost suppressed by the surrounding figures; or, in the Berlin picture of the *Samaritan Woman*, almost as a shadow, without substance in comparison to the powerful woman who is, as it were, solidly rooted in the earth. If one looks only a moment longer, however, this weak as well as swaying being is after all the one really fixed thing. All the other strong and substantial figures are, in comparison to him, insecure and as though uprooted; as if not they, but only he, had that ground under his feet on which people can really stand. And this is not achieved via a ray of transcendence; not via any suggestion that the Redeemer is shown to belong to another order in an objective-metaphysical sense. He only has the stronger, the strongest, *religiosity*; that absolute security as a quality of his human being that is only given to people as a consequence or an aspect of their religiosity.

This is all the more moving because in the very early paintings, in which he had not yet attained the feeling for this religiosity, Christ appears, conversely, precisely as a mighty personality — as the great, beautiful, magical person who dominates his environment from without. How far the deviation from this line to that other must from the very start have been immanent within his innermost nature is illustrated by the fact that this tendency was also capable of being developed toward the ultimate religious depths. In a particular, if also modified, sense Grünewald has demonstrated this. In the crucifixions — in Colmar[10] just as in Karlsruhe[11] — and in the predella, Christ is the giant elevated beyond human measures — untouchable for all that surrounds him due to his greatness, and yet felled by human powers: a totally contradictory and the most inconceivable fate. Here we no longer speak of the soul or an individual inner affect. Here the greatness of existence as such is represented, and the secret or the absurd that underlies it may be religious, but really only insofar as the darkness of this event is so impenetrable that it appears to reach into the ultimate depths of the world. This existence symbolizing itself in such exterior measure and its fate stand in such a paradoxical relation to each other that a solution from within is out of the question. It is, rather, only a metaphysical idea, a divine council, which can reach across this enormous gulf. Nothing of the sort is the case with Rembrandt. In his most profound religious paintings, the appearance of Jesus is brought into such a proportion that it is fully permeable for the soul; rendering its life and its fate perfectly determinable by the soul. In the types of painting with which I am concerned here, Jesus is merely the most heightened of Rembrandt's religious figures whose dissimilarity to the nonreligious is determined exclusively by their respective individual inwardness. This may be borne by a grace, by some power

flowing out of the sphere of the superhuman, but Rembrandt does not enquire after this. He restricts his problem to the inner being of humans that has taken up its probably existing determination from the beyond completely within its life and no longer makes the determination especially recognizable as such.

Precisely this *certainty of life's fundament*, as it lies in the religiosity expressed by Rembrandt, relieves the subjectivity of religiosity from its mere accidental nature as though it were an ebbing and flowing "atmosphere" with which the subject had to come to terms without it having an objective meaning. What is great and unique appears to me much more to be that here religious conduct residing exclusively in the individual is made felt as an eternal value. To grasp this conception of religion, the objectivity of its values must absolutely no longer be determined from a "localization" outside the person. The religious quality of the subject is itself something objective, is an existence that in and of itself has metaphysical meaning. The bad, downgrading meaning of the "subject" appears only where one allows its whole meaning to be determined by an *opposition*; where the habit of thought that is more sensory-bound locates the subject in something separated, counterpoised, great and small. The shocks and the ecstasies that overcome figures in other representations in the face of a revelation, a vision or message from the beyond, may be subjective in the sense of their temporariness and, from the subject's point of view, accidental. Where, however, the religious facticity is anchored in, or rather anchored as, the subject's being, the person's religiosity is itself something objective: a value that once set down makes the being [*Dasein*] of the world absolutely and timelessly that much more valuable.

It may not be so easy to understand the difference between this religious value, in contrast to the mystic value that I rejected earlier, with respect to Rembrandt's figures. This requires further investigation. Our sense of value is much more consistently relativistically determined than is generally admitted. By this I mean here that we give or legitimize the value character of certain ultimate and absolute values naively, as it were, via something even higher, more comprehensive. The value of moral deeds does indeed appear — precisely the more deeply and purely it is comprehended — to reside completely within itself, and to reject all determinations that would come from outside the moral willing soul. However, the thinkers who have most fervently defended the autocracy of morality have finally deduced its dignity from "reason," that is, from the association of individual action to a general ideal realm consisting of norms and principles. That we subordinate ourselves to this realm, and obey its laws, may be praised in

as much as the test of our "real I" — as the sense precisely of moral autonomy — the root of moral value is still nevertheless transferred out of its innermost self. Thereby the act is, insofar as it is valuable, precisely not purely just the act, but rather it must extend itself beyond its own borders and absorb a meaning that comes from an ideal, already existing, and, so to speak, absolute totality. The same applies to truth. A knowledge claim appears only then to be the most exact and certain if its boundaries — precisely demonstrably in each individual case — correspond with those of its object. The more profound theories of knowledge, however, believe that the essence and claim [of knowledge] is thereby not exhausted. For such theories, such a singular determined accuracy is only truth insofar as it is located — in principle — in the totality and unity of all truth as such. This is not something added to the individual truth that is legitimate in itself. Rather, in a precise sense, the latter does not exist as such. It acquires its value as truth only by dint of belonging to that total context. The precision of the individual realization may be sufficient for the practical procedure, though this itself does not find its justification within the boundaries identified in such a manner, but rather *is* from the beginning, so to speak, only the cloak in which that truth-totality is clothed precisely here and now in this isolation. It is in this form that mystical religion situates itself. It may concentrate religious life inwardly, placing it on the final point of the soul that belongs above all to itself. Nonetheless, the soul is only capable of the reception of the highest religious value in that it is simultaneously more then itself — that it is also the place of godly life. Inner life and the divine may be an undifferentiated single entity, but this single entity receives its value from its being divine, not from its inner being. Despite all real or metaphysical indivisibility, in an ideal sense it is nevertheless through the relation that the divine being has to the inner being that its religious rank is determined. In contrast, the religious mood of Rembrandtian figures stands out delicately and clearly. That which is specific to their religious value has suffused their inner quality and has been absorbed into it, whether or not they also have a relation of belief to the objectively divine. With a certain paradox, one can characterize religious nature that is abstracted (if naturally not emerging in abstract isolation) from all mysticism as from all theism thus: they would live in this state of piety even then when no God existed or was believed in. Piety has peeled off its relational character as the latter exists in other phenomena. Just as this piety does not need to extend outwardly beyond the soul, so it also does not borrow its religious *value* from a source outside the soul. If, in mysticism, too, the soul encloses religious value fully within itself,

then this is because it stands within the aspect of an absolute divinity beyond inner life. In the Rembrandtian figures, however, this value cannot be expressed at all other than through the pure life of its own of the person's soul — through a piety, completely balanced in itself, that is not too proud, but rather too modest, to allow itself to be legitimized via the divine absoluteness of being.

It is perhaps more difficult to make visible the lines via concepts that separate this religiosity from Calvinism. However, the effort is necessary precisely because the general emphasis on individual elements in Calvinism — on the responsibility of the individual soul, on quite personal election or damnation, on the effect of grace sensed only in the loneliness of the soul and calling it to individual activity — can appear related to, and perhaps as having shaped, the Rembrandtian experience of the religious person. If I interpret Calvin's basic position (later Calvinism partly altered it) correctly, so precisely the opposite is the case. Calvin's religious thought assumes two elements: the holy and the unrestricted will of God on the one hand, and the objective order of the empirical human world on the other. This contains in itself the life of the community just as it does the profession [*Beruf*] and the economical useful activities of the individual. The great synthesis is now that the life conditions should be brought to that type of completion that is predestined on the basis of its own immanent, purely objective norms and demands, and thereby best fulfilling God's will; most clearly symbolizing God's blessing on our deeds. With this, a wholly new form of judgment on life emerges that deviates from the original Christian view in two contradicting ways. While original Christianity was principally indifferent toward earthly conditions, these are, for Calvin, on the one hand the location of state of sin, and in equal measure worthy of damnation for which that sublime indifference toward the earthly conditions had no place at all. Just as little, however, had this indifference a place for the peculiar judgment of the correct, earthly, dutiful, materially successful order of life that Calvinism now developed, albeit via all sorts of speculative means. Certainly the value of these objective orders was determined according to its *ratio essendi* through divine will, but its *ratio cognosendi* at least developed according to the degree of its practical successes and requirements that interweave earthly existence in terms of its internally closed normative logic, and would interweave the empirical aspect even were — expressed somewhat extremely — no God to exist. Calvinism thereby has transposed a not uncommonly religious-philosophical interpretation of the relationship between God and the natural laws of existence into an ethical and social problematic. One had, namely, characterized this relation

thus: God, once He had given the world its laws of motion, so to speak, withdrew from the world leaving it to what were now its own and strictly exceptionless laws such that these laws, without having to refer back to their originator, are graspable and understandable in terms of a purely earthly plane. Thus, the world receives from God norms as to how the world should be, but these are now exclusively rooted in their earthly home — appearing derivable from their own facts and relations, and sanctioned by those measures that, so to speak, are handed down, of their own accord, by the soil planted by God. The objective earthly order, the objective dutiful and successful action, certainly do not stand for Calvinists within the absolute value that belongs to the divine alone, however, they have — and here I can only use an externally contradictory expression — an absolute value within the relative, a value that adheres to the objective existence of this order; to the determination of its objective worldview through these activities and these successes. For the Calvinists, God's realm is the end per se, but only for its sake is the earthly dealt with *as though* it were the end. For the Calvinists, all metaphysical meaning is laid out between these two absolutes. The individual as such is excluded from it. The individual is only the bridge over which, or the unavoidable material with which, so to speak, the traffic of each is carried out. It lives, as meaningful in terms of value, not on its own accord. It has, within the level of relativity that is allocated to it, not the absolute meaning that, within that level of relativity, belongs only to the objective value, to the transpersonal structure of individuality, and above all to the life of the community. Here we have the fundamental difference between conceptions of life: whether one draws up the sense and meaning of actions and relations out of the deep dimensions of the individual (whether their subjective life gives the real value of existence, forms the root as well as a center of interest), or whether all these accents (the values' final from whence and where to) adhere to the objectivity of the conditions — to the trans-individual — without delving into the individual's own life. In that Calvinism, according to its decisive basic motif, is on the latter's side, the religiosity of the Rembrandtian figures stand decisively opposed to it. Here once again is repeated that opposition, discussed so many time on earlier pages, between the Rembrandtian attitude toward human values, on the one hand — [an attitude] that is directed toward the essential being of the individuals and toward their fate as it unfolds for its own sake, as it were, and, on the other hand, the classical-Romanesque attitude for which the general — the conceptually graspable design — is the focus. This is a repetition of the ultimate metaphysical motivations with appropriate modifications; [a repetition]

that, however, is characteristic in that measure in which the classical-Romanesque spirit is nonetheless different from the Calvinistic. The latter goes beyond the former with respect to both: the side of transcendence and that of earthly practice, as well as the unique tension and unity of each. For the former, the metaphysical basic tone lies in the form that had an effect directed toward the exterior (not only toward the physically exterior), and developed into general conformity to a law. With the latter, it lies in the objective powers of the divine will and the earthly, planned successful orders, and ways of behaving. They have their common counterpart in the value in itself of the determination of life that follows purely from within; from out of the point of individuality of the ultimate metaphysical cause of formation and value authority.

INNER QUALITY [*SEELENHAFTIGKEIT*]

In contrast to all this as well as to mysticism, I interpreted the living religious attitude in Rembrandtian art as appearing in his work neither as an aspect of, nor as a special climax to, life, but rather as the way in which these people live as such, and that, however, this subjective religious being does not exhaust its meaning in its psychological reality, but rather is itself something *metaphysical* (a value outside time that is borne exclusively by the inwardness of these temporal individuals). This interpretation should become clear in the course of the following points.

First. Such an interpretation of the religious soul is based on the interpretation of the soul as such. Were one, from the very beginning, to characterize Rembrandt as the "painter of the soul," then this somewhat sentimental expression may well emerge from a correct impression but its full significance becomes clear only in the documentation of its opposite. It is a strange fact that the philosophers, for whom all turns on the totality of the conception of the world (on a systematic conceptualization of its unity), display a nearly uniform indifference toward, even an inclination against, psychology. However varied the manner in which this motif appears, such that, particularly when we sink into the finality and depths of the foundation of our own soul, we reach the very basis of being [*Dasein*] or the point where God is tangible and accessible to us, so is this precisely a transposition of the soul into the metaphysical; precisely a transcendence of the specific characteristic inherent in the soul. And however much one entwines the soul in the world, and understands it as the high point of the world's development, or, conversely, locates the world within the soul as its

imagination and product; precisely there where the soul purely as soul lives and is experienced is to be found a mutual exclusion between it and the world that is not negated by all those mediations, but rather is displayed precisely as that which has first to be overcome.

Not only in philosophies but also in religions and in the arts it is the case that where the totality of being is to be grasped, symbolized, and dominated in its breath, or in its own objective center, the *soul* loses that particular accent that, of all worldly things, only the soul can attain. On the other hand, where it finds this particular accent there is no path from the soul to the feeling of domination or to the imagination of the cosmos. Precisely because Rembrandt is the "painter of the soul," his figures (and this has been grounded in another contrast above) lack that difficult to define cachet of the *cosmic* as it exists, for example, in many of Hodler's figures, who do not express themselves psychologically but rather somehow express the cosmic of which they themselves are, as all else is, a part. The decision about the artistic or psychological *rank* of one or other piece of art is not affected by this categorical determination. Even Buddha figures with their acosmic quality — their passionate passionless dismissal of the world — themselves thereby have a decisive, when at the same time negative, relationship to the deepest conceptual level of this world, and thus they can in a psychological sense easily appear "soulless," while the Rembrandtian focusing of all interest on the soul does not allow itself to arrive at such a relationship in either the object, or in the way in which it is represented. There is a painting by Rembrandt — *The Resurrection of Christ* (in Munich) — in which all this achieves a positive expression. In the foreground soldier-vassals tumble from a raised memorial slab — the whole meaningless, partly violent, partly ridiculous chaos of earthly mortals — above them the angel in a flood of unearthly radiance as though he had left the gates of heaven open behind him from which glory pours forth. And now, right in the corner, almost a shadow as if from afar, the head of Jesus appears with an almost unrecognizable expression. And at once we know: here is the *soul* before whose wan, suffering life — still half paralyzed from rigor mortis — that earth and that heaven pale and become nothing. No sensual-artistic or mystical-religious emphasis rests upon this head, rather that which is quite simple: it is the soul that, as soul, is not from this, but also not from the other, world. It is the soul beyond the tremendous antithesis — embracing all other existential possibilities — in which earth and heaven are here situated. This painting, painted in his thirties, is like a symbol of, and program for, his later greatest art. It makes explicit how, with the soul, something simply incomparable

is given; an existence and a worth that is sovereign and to a degree untouchable with respect to all others; a valuable realm of subjectivity in itself that clearly lacks the inclusion of and by the worldly, and perhaps also the otherworldly, cosmos. But only this absoluteness of the principle of the soul can bear that religiosity whose metaphysical content is not a given sacred fact, but is the religious life of the soul itself.

RELIGIOUS–ARTISTIC CREATION

Secondly. That the religiosity of the Rembrandtian representations clings to the subject, just as their life does because it is simply the way of their life, that in these representations an objectivity — something beyond coincidence and ideally solid — is nevertheless manifest (even though in a different sense from that of the Calvinist order and outcomes of actions), is perhaps to be understood on the basis of a yet different orientation.

The deeper appreciation of art distinguishes precisely between the *representation of the religious* and *religious representation*, however much individual works display both in a unity. Such a division — necessary with respect to all possible artistic contents — is more commonly acknowledged in principle than carried through in actual appreciation. The poetic or pictorial representation of a strongly sensual scene does not need to be sensual but can be of a purely artistic formal nature. Conversely, the artistic representation of a totally indifferent content in this respect can contain something highly sensually provocative, as in some of Aubrey Beardsley's ornaments, for example. The representation then corresponds to the effect of music that, devoid of all representational content, can express and evoke extreme sensual excitement. The general formula for this relationship is that particular existential contents as realities, or as experienced in the empirical world, possess particular qualities and colors that they no longer self-evidently have as soon as they are transposed into the form of art. But art, for its part, in its individual execution may or may not possess these qualities. The form of art as such can be saturated with them whether or not the form of reality of the same content displays these qualities. It is thus all a matter of the principle recognition that there are religious works of art whose object does not at all need to be religions, just as — as is generally more commonly recognized — there are completely nonreligious art works whose object is religious.

Perhaps this is why in Rembrandt's biblical representations — which on first impressions only offer something of a petit bourgeois milieu scene — that which is moving is to be expressed thus: the [act of]

representing itself, the artistic function of the painting, so to speak, the manual control of needle, pen, and brush, is filled with religious spirit. The dynamic of the creative act itself has a particular tone that we call religious, and crystallizes within the region of historical piety and transcendence into the actual "objects" of religion. Thus, absolutely no individual religious details are required within these paintings. The whole is religious because the *a priori* energy that has created it is religious. Thus, what the creations display is founded in their creator, namely, that his figures do not need to do anything that has a religious content because their life process automatically passes on its religious character to each of its contents. Only in this way is this relation underpinned by its deepest productive stratum. That the occasions for these paintings are biblical is merely stimulus and relief for the painter to let this function have its effect, and for the viewer to feel it. The way in which the painterly possibilities stand here corresponds to particular facts in the history of vocal music. In song, as in opera, text and the music are for some composers completely independent. Mozart composes even for the most impoverished text in the sure knowledge that the self-standing beauty of the music would drown the text. Here, as with other cases, words and notes from a genuine unity, but they [the words and notes] stand at a completely different level of meaning. Matters are somewhat different in, for example, Bach, and particularly later in Schumann. Here there is such an engagement with the text that appears to be completely formative for the impression. The most intense general mood that it can create becomes the root from which the total work of art [*Gesamtkunstwerk*] grows. In that the music itself is determined by the basic mood of the text, it feeds the mood back into the text. Its own essence, purified and strengthened through the form it attains in music, embraces and shapes it [the text] anew. The first of these relations — transposed onto the religious subject and its artistic representation — can be found in the High Renaissance, and in Rubens. The inner meaning realized by a Madonna is irrelevant for Raphael. That realized by a descent from the cross does not interest Rubens. In each case the painting, so to speak, is left to its own devices such that its impression is not affected if it contains the object in its inherent meaning merely as though it were a foreign body. With Rembrandt, by way of contrast, the painting itself draws its sustenance from the general basic motif of the represented event; its religious being, and it is through the medium of the artistic process determined in this way that the event is in turn drawn into religious being. The subject is formed and animated in the process of becoming art in such a way that it becomes completely absorbed into the character of the artistic

process whereas precisely this character of the artistic function is fed by the most general meaning of the subject, far transcending its individual details.

Here the interpretation must avoid an obvious subjective error. Despite all this, we must not claim that Rembrandt as a private person, so to speak, was a religious person, and that he transposed this quality of his personal life into the products of that life. We do not know what his inner relation to religious matters was, and the evidence we do have suggests to me that more speaks against than for a very positive religiosity. At most, one could believe in a general, so to speak, undifferentiated depth of life into which the inner development and external fates had guided him, and which constituted his subjective personal foundation, namely that he as *painter* — functionally, as the creator of the paintings — is religious. Here, once again, lies the difference between him and the other painters of piety. As a person, Fra Angelico was quite unmistakably of a childlike, pious disposition. He carried over into his work the real mood of his life with an immediacy that one may call naturalism, not with respect to objects but to the subject, while, as far as we can judge, in Rembrandt's case it was the artistic process rather than personal existence — the manner in which the creative process was conceived — which gave the work its all-pervasive religious quality. This is why this quality is not merely due to the realistic observation of pious persons. As I noted earlier, his figures certainly appear as though they lived in the religious sphere from within. Behind this immediate appearance lies, however, as its functional *a priori*, that which we must call religious painting, as opposed to the painting of the religious. This religious quality really does cling here only to the [act of] painting. It is the latter's immanent law, and not a living reality in its own right for which the painting is merely a means of expression. It is not only in the figures that this artistic *a priori* is represented in detail, but rather it is in the totality of the picture. Light and air, the composition and the whole milieu, have this religious atmosphere that frequently cannot be demonstrated in the specific details at all. Such a character of the whole can [evidently] only emerge from a totality; that is, from a general stylistic gesture of the production, regardless of whether it only expresses itself within a particular circle of problems of the production. The rendering of painting and drawing has the inner style, the movement, the solemnity, the mix of dark and light, the inexpressibility and the self-evidence all of which must be called religious. This rendering itself *is* religious. It does not simply *have* religion, either as the profession of a real personal belief, or as an account of an observed religiosity, or as representation of religious contents as such (although all of these may

also be present). I know of no creator of religious works of art with whom the religious moment was located within this layer; so free of all that is merely conditional, a design law of creation itself, which is thus visible as "general and necessary" in the created [object].

LIGHT: ITS INDIVIDUALITY AND IMMANENCE

Thirdly. With respect to the figures and to the artistic arrangement, the uniqueness of Rembrandt's religious representations is that religion here is grasped in its inner functional sense, as *religiosity*, excluding all church traditional and its otherworldly content, and that this primary subjectivism turns out to be an absolutely objective value in that it, on the one hand, represents in the figures something metaphysical in itself — the absolute significance of the religious soul — and, on the other hand, the art itself has become an *a priori* that possesses the full objectivity of the form of art immanent within the conditions of objective creation. Rembrandt has a means to realize this constellation beyond human individuality: *light*. This light behaves like the religious expression of being in Rembrandtian figures who bear the thus characterized meaning immediately within themselves, and not as though it was something transcendental — a dogmatic fact that was manifested by them. This light is, so to speak, religious as a natural reality just as those figures are religious as inner reality. Just as, however peasantlike, narrow, thoroughly earthly they are, their religiosity bears in itself metaphysical solemnity and is in and of itself a metaphysical fact, so in his religious etchings and paintings Rembrandtian light is something clearly sensually earthly that points to nothing beyond itself but is as such something beyond the empirical. It is the metaphysical transfiguration of visible being that does not raise the latter into a higher order; rather, it makes tangible the fact that it is itself and immediately a higher order as soon as it is seen through religious eyes.

By this I do not mean pantheism that in any case can only find a free-floating symbolizing atmospheric expression from afar in visual art, no matter how much artistry as such is rooted in pantheistic preconditions. Religious pantheism is either the reconciliation of a dualism whose marks are not, and must not be, fully eradicated in order for the unity attained to remain tangible, nor is it an explicit or discrete negation of sensory reality to the advantage of the exclusive reality of the absolute. Both are far removed from Rembrandt's manner. His specific light may well emanate neither from the sun nor from an artificial source, but rather out of the artistic imagination. On this basis, however, it has completely the character of an inner-sensory intuition,

and its solemnity, and the fact that it is not from this world, is a quality that it, as a phenomenon of this world, possesses perfectly, so to speak, as an artistic experience. One needs to recognize an analogy with historical realities at this point. When one looks at the Dutch as they appear in peasant and bourgeoisie paintings — with their zest for life, deeply rooted in the soil, inclined in their hearts toward good food and drink — it is a shocking prospect that precisely these people are prepared, without a second thought, to face death, and fates worse than death, for their ideals, for their political freedom, and for their religious salvation. This almost appears to be symbolized in many of Rembrandt's religious paintings and etchings: simple characters lacking any subjective imagination, earthy, gruff — and in themselves already participating in that immanent religiosity they are once more embraced by light in order to bear a totality that manifests the same character of a pure inner transfiguration — an earthiness that is transcendent without reaching beyond itself. Pictures such as *Ruhe auf der Flucht* in the Haag Museum,[12] or the grisaille of *The Good Samaritan* in Berlin, are quintessential unique manifestations in the history of visual expression. Just as the music of the great composer transcends each individual and conceptual content of the song's text and precisely thereby expresses its ultimate meaning in an absolute unity and purity, so here, too, we find each particularity of the almost unrecognizable figures, [and] each specification of the occurrence completely dissolved in the drama of light and darkness through which the most general metaphysical and inner interpretation of the event profoundly moves us as vision. This light is religious solemnity, the sign of divine origin in the atmosphere, in the spatial world around us, whose pure inner quality alone thereby finds expression.

One cannot turn away from the problem of the way in which the emphasis on this most general element stands in relation to the individual orientation of Rembrandt's art. I have already explained that the religious figures do not show the lonely uniqueness of the portraits. Just as little as their religious character is divided from their life, but is much more its modus, so, too, it is itself undeniably such a describable quality and as such something general, uniformly adhering to many people. The uniqueness of the portrait figures resided precisely in the indescribable quality of any of the figure's characteristics, because, as soon as the latter can be described, it exists ideally outside its bearer, and is not reserved for his exclusive possession. That loosening of the principle of individuality — and more than a loosening it is not — is carried forth in the meaning and emphasis of the light. Individuality appears to be dissolved by light into something general and worldlike,

but the world of this light is at first the world of the *soul*. It is as though the animate quality had abandoned the form of individuality and dissolved into the deep surge of the dynamic of light and shade. This is not to be understood in terms of the subject as though it meant the expression of a "mood" of the artist or viewer. This lyrical element is completely foreign. Nor is the inner meaning of this light a "symbolic" one. This may be the case with some of his landscape paintings and etchings. Here the light should represent differentiated affects or ideas, and thus it is more allegorical than symbolic. However, in those representations light is an immediate religious atmosphere, a religious coloring of the world. While in other paintings a shaft of light pouring from an open heaven or emanating from the Christ Child, for example, are symbols, here it does not symbolize anything. Only the *words* in which artistic facts may be inadequately fixed can be nothing other than symbolic. It is as though light itself were alive; as though struggle and peace, contrast and relation, passion and gentleness immediately bore this play of the struggle between light and darkness not as something existing behind it that finds its first expression in this play, but rather in the same way as we in the statics and dynamics of our individual conceptions and affects think we perceive the deeper rhythm of inner life in general. This deeper rhythm, however, is not the puppet master, or the "thing in itself" of those phenomena, but is rather its power, its living animation itself, and is divided from it only in reflexive expression. The ever more apparent "warmth" of Rembrandtian light is identical with this living animation. In contrast, the light in Correggio's *The Holy Night*, for example, has something mechanical about it. Whereas the latter corresponds to Newton's conception of light, Rembrandt's corresponds to that of Goethe. Light has here the intensive depth, the rhythm of contrasts, the flowing and vibrant qualities that we otherwise know only as the principle forms of inner life. In this respect light, however much it is a basic element of the world, is to a degree given an individualistic twist. I have frequently emphasized that this peculiar dimension of sensibility, of viewing, of forming that we label "cosmic" is not the location of Rembrandt's art, and that I hold for a misinterpretation the hope that we can see this in his treatment of light. It is the nature of the cosmic, in its broadest sense, to go beyond the principle of the soul. Yes, it is this transcendence — going even beyond the soul's infinity (the broadest and deepest of all nameable earthly elements) — that characterizes its real and full meaning. Stemming as it does from this absolute earthly power, Rembrandt's light does not, it seems to me, bear witness to this absolutely earthy power as does that of, say, Correggio's cathedral dome in Parma, or as in distinct shaping of the golden sheen

in some *Trecento* paintings. Even in the use of light, which in itself reaches beyond all human individualization, Rembrandt's use always remains within the boundaries of the inner meaning and the inner dynamic. Just as it is for the soul of his portrait figures, so light is for him a being centering in itself, in its own inner meaning. It does not turn outwards toward a world that is continually connected with and represented by it, as shines out of the paintings of van Gogh, or to a lesser degree some of the modern French Impressionists. Particularly with respect to the paintings and etchings that all but relinquish objective forms, consisting exclusively of light and shadow, and their relations, I would like to describe the impression given as follows: one does not experience light as a part of the world of light, but, rather, precisely and exclusively as the light of this occurrence, as unique, as something living only in this place. This is related to the point emphasized earlier, namely, that the specific Rembrandtian light does not originate realistically from the sun or from an artificial source of light, but is rather the product of his individual artistic imagination. Therefore, it possesses, so to speak, no bridges to a world outside its own, but rather unfolds itself within, and is confined exclusively to its frame. The same is true for the negation of light. The darkness in some of his etchings does not belong to the half of the world in which it is night. One does not feel that it is dark because night surrounds the depicted scene. Whereas in other cases an object is to be found that could exist as such just as well in the light as in darkness, but now is darkened because it happens to be night, in the Rembrandtian night pieces, darkness is an immanent quality of the content of the painting itself. Because darkness creates itself only in and through it [the content of the painting], it cannot darken beyond the boundaries of the latter, just as Rembrandtian light — because it is born in and with the painting — *can*not shine forth beyond it in order to appear in back projection, as it were, as if emerging from a surrounding world of light (as in Manet's or in Liebermann's paintings). Certainly, the light that is used in the painting (rather than the line of the objects) is something general, but is not the universal that this painting shares with other paintings or things, but rather is the generality of itself. It is the elimination of the individual details through the simplest, purest possibility of expression of the meaning of the picture, but not the elimination of its uniqueness, of its being-for-itself enclosed within itself. The Baroque style has been characterized as the specifically "painterly" — in contrast to the linear style — in part because it places the accentuation of value on the boundaries of the things, while in the latter, however, the phenomenon tips into the unbounded. This appears to be the case with Rembrandt also. He,

too, dissolves the limiting line, and in the place of its immanent direction sets a shimmering life oscillating and vibrating in all directions. But what is incomparable in Rembrandt is that the infinities to which I have referred are immanent within the painting; that he tied these — which dissolve all that is solid out of themselves — back to the interior of the painting. It is a new solidity in place of the immediate solidity that clings to the components [of the painting] as, or through, absolute intellectual control of the relaxed nature of the components. In some postclassical painters the blurring, the dissolving, of the borderlines intangibility of the appearances somehow leads out of the painting, although not in the literal sense of a spatial stepping out. But the way in which Rembrandt contains the light within the painting and uses its infinity only for the painting's interiority — in that the light appears to originate exclusively from within the painting and does not flood from some other point beyond it — so he captures all that is transient — that which bursts beyond the outline of his objects — strictly within the realm of the painting directing it in each of its turns and meanings toward the enclosed individuality of this realm. With this, light, speaking metaphysically, attains the same form of animation that the portraits display. What is there tangible as soul is not a component or a pulse of a mystical animation of the universe (in the way that we experience it in figures in east Asian art), nor is it the appearance or representation of the most general human fate in the full breadth and depth of tragedy that is born with the nature of humankind itself (as illustrated in Michelangelo's figures); rather, it is the soul that originates and is lived out within the boundaries of this personality with its fate. It is merely that this individuality presents itself in its most general form insofar as no individual detail of a describable content becomes visible, but rather only, so to speak, the functionality of the soul in its purest inner life, in its composition and fatelike determination. Thus, Rembrandtian light is restricted to the space and action of each respective painting, but this means (at least in the case of those compositions with almost unrecognizable details consisting actually only of light and shadows) the elevation of the picture over each particularity into *its own* highest generality; into the highest possible expression of its pure and sublime nature. It replaces, so to speak, the external generality with the inner one. It displays, as I have already said, not the unity of the painting with something that is external to it, but the final and simplest unit of the painting itself. This is the context through which Rembrandtian light achieves that unique animation. Because, of all empirical givens, it is only the soul that lets all diversity arise within, or out of, the unity of its own life, so Rembrandtian light must possess

that power, otherwise only possessed by the soul, in order to gather up within the individually encloses unity of its life and weaving the full works the full and richness and range of oscillation of a, frequently multifigured, religious event: to form out of empirical diversity a unified generality; to resolve the contradiction of individuality and generality out of the former.

The fact that light, where it possesses, so to speak, that more abstract generality is not so tightly bound to the totality of the respective painting in its inner and artistic sense as it is in Rembrandt makes these relationships clearer. This manifests itself most decisively in the majority of Baroque painting. Here light is really only an aspect brought into an already existing totality of the painting with the purpose of making clearer, and perhaps more stimulating, certain values and emphases that are already disposed in the totality of the painting, for example that of the outline of the figures. If in the great painters cosmic light through its existence beyond the painting affects a mysterious expansion of the viewing and atmosphere, so, in the case of the mediocre Baroque painter, this external existence of light only makes clearer, as it were, the mechanical composition of the painting created out of diverse elements with distinct roots. But even for the masters of color, with the exception of Rembrandt, light-dark [*Das Helldunkel*] is, as it were, a functional *means* for adding nuance to the more substantial colors, and giving power and emphasis to it. With its instrumental quality, light-dark does not, however, exist within the same stratum as the actually constitutive color values of the painting. This ideal externality is not the case for Rembrandtian light. It is precisely a living element within the individual paintings itself, in that unity with its other elements that only exist in the form of individuality. This is why it is understandable that the colors within his light-dark do not attain the purity and, so to speak, the particularized beauty that the greater separation — which is not suspended by the form of individuality — of pictorial elements can allow.

This individuality of the painting's totality must, just like the relationship to the surrounding world, also relinquish the specific emphasis on the painting's elements, because only in this way does such a unity, which cannot be broken even from within, emerge. The degree to which Rembrandtian light bears this [unity] becomes clear in comparison with Caravaggio. In that the latter uses light and darkness to the highest degree, but basically in order to bring out the individual pictorial elements, there emerges really only a cutting contrast in the mutual restriction of light and dark. In contrast, Rembrandt, who renounces the emphasis on the part to the advantage of the individuality of the whole, never allows it to come to this kind of separation. Light and

shadow are not for him, as Caravaggio almost appears to represent them, hostile forces due to individualization *within* the painting, but rather, because only the whole is an individuality, they are for him like siblings whose essential natures and spheres of activity merge gently into each other, and who never forget the commonality of their origin, that is, the unity of the picture itself that pervades all singular elements.

When this light purely from within is at one with the painting's individuality, and therefore cannot be cosmic, transcendental, or symbolic, so it rejects even this final reaching beyond this immanence: the relationship to the external light-*reality*, to the objectivity of the depicted scene. As I have already established that the animation of Rembrandt's portrait figures is not attained by the view of the reality of the life of the models, but rather much more in the absolute and self-sufficient work of art in which the animation is identical to the physicality of the appearance, so Rembrandtian light does not lead us to that which a corresponding real scene makes apparent. Here, too, the demand on the pure work of art is realized: to obtain its effect from within itself, and, however much it draws from the world, not thereby to build bridges back to that world in order to supplement itself.

Even such a fantastic light as that in Correggio's *The Holy Night* appears to be a reproduction of light that belongs to the whole real event reproduced by the painting, even given the limitation that it does not even light up the room, but rather only the surface of the actors. It is first with Rembrandt that we find a light that originates entirely from within the painting, only relating to that which is pictorially visible [and] without — as though looking through the painting — being induced to imagine a corresponding event in the real world. Yes, it is this immanent aspect of Rembrandtian art, and the fact that it remains confined within the sphere of his creative animation, that can be ascribed precisely to this unreality of the light. Real light, shining equally on the just and the unjust, connecting that which is most distant, sensed everywhere in its original unity, lending evenness of light and shade to that which is least comparable; this light, above all, relates each occurrence with all that which occurs beyond it. Thus, it is to the highest degree an element that *realizes* the existence of individual aspects, and that negates most strongly the completeness of things in themselves. Reality belongs to the individual contents only in relations to, or as the relation with, the world's totality. It is a relational concept like weight that the individual earthly thing attains only in its interaction with the totality of the earthly body. The creation of this relationship — that is, reality — is, as already mentioned, an essential function of empirical light. Rembrandt's light rejects this function

through which light in other pictures floods out, so to speak, of the frame of the painting's content, and thus locates this content itself in a reality outside the painting. This reference to a real model is omitted by him because his light *is only the light of this painting.* Thus the painting is released from reality more than in any other case. It grows self-sufficiently out of different roots from that of earthly reality. Only the lightless paintings of the *Trecento* have this unreality for the same reason, yet in its negative sense.

Excursus: What Do We *See* in a Work of Art?

Given the overwhelming reality of natural light, the relationship, touched upon here, of art to light perhaps offers us a profound opportunity to go into the most crucial aspect of the problem of realism. That the scenes based on light in Rembrandt are, with respect to light, self-contained — that each is, so to speak, a cosmos that is nourished by light — precisely this distances them from that realism that sees reflected in the work of art a slice of reality. This is because, in each slice of reality, light is a fragment, or a derivative, of externally flooding cosmic light as such. It is precisely with this realism that the theory that art is an "appearance" is most closely associated.

An appearance is the appearance of something; indeed of that which represents something that awakens the *illusion* of its reality, just as reality is the *true* image of precisely this something. The emphasis that the theory of appearance lies on the unreality of the work of art is itself only an appearance. According to it, what is decisive for the work of art is that it produces, through an apparent representation, precisely the same image psychologically that otherwise derives only from reality. Earlier, I rejected this [view] in the case of the portrait in contrast to photography, and than again in the case of movement within painting. The orbit of the question goes far beyond these individual cases because in its general form the question runs: What do we actually *see* in a picture that "represents" something? And here we actually find ourselves at the center of the problems of the philosophy of art.

In a famous etching of his mother (supposedly dated 1628) Rembrandt added a fur collar that is a true miracle of the art of etching. The unique materiality of the fur is absolutely convincingly achieved with a couple of dozen minimal little strokes, apparently added rulelessly. A very small sketch represents a rustic drive leading toward a copse. Here the extension of the fenced

path, the distance to the wood, the immeasurably of the atmosphere over it are brought into view with unimaginably few strokes. The landscape stands there in all its solidity and without ambiguity. What do we find in these (naturally, arbitrarily chosen) examples? Do I see with my inner eye a real fur collar and a real landscape again made present to me like the memory of such an image after I have glimpsed it in empirical reality? The aim of the work of art would then be to somehow call up from within an inner vision of reality, and with that it would in its immediacy be as insignificant as a bridge is as soon as its function of being crossed has been performed. Then the work of art would really be an "appearance" receiving meaning, value, and substance from a reality beyond it, because a similarity of form binds it to the latter and gives it the right, as it were, to the inner reproduction of reality. As earlier on, with regard to a particular case, I now plainly deny that one "imagines" a "real" fur collar or country path when one looks at the respective prints. How should this real landscape look? Does it have, as one would at least expect, green vegetation and a blue sky? While I observe the black-and-white drawing, I can find no such thing in my consciousness. Apart from the strokes that I sensibly see and consolidate into a unity, I do not have the fantasy of extension and variety, the colors and the movement that an empirical landscape would have. I also do not know with what material this should happen, because I know of no landscape that corresponds exactly to this one in such a way that the drawing performs the function of a photograph for such a scene, and it would be senseless even to discuss the hypothesis that we synthesize elements from separate dispersed bits of memory. The object does not even psychologically come into being for which the drawing is merely the "appearance." Aesthetic theory performs a strange contradiction when it sees in a work of art a gift to us that goes beyond our given reality, and at the same time presupposes that we supplement this image from within ourselves in order to complete the representation of reality. The saying "drawing is a process of leaving out" cannot possibly let the artistic language appear to be a kind of telegraphic style whose condensed structure we, without further ado, fill out into the complete form of a normal sentence. In fact, we see in each drawing exactly that which stands on the paper and we do not, in a far-fetched meaning of "seeing," lend it some substantial addition out of some other order of things. And if that actual seeing has or creates another object as the sum of proximate strokes, so

this other, or this more, is something immanent in that which is immediately seen: a particular *way* of seeing that which stands there; a functional relationship between its elements. Never, however, is it a substantial gift by grace of memory. We say that here we "see" fur, there we "see" a landscape, and certainly this is more than a factually ungrounded transposition of expression. Equally beyond doubt is the fact that we can only do this on the basis of a knowledge we bring to these objects; a knowledge that now must, as if in contradiction to my claim up to this point, stem from experience of a reality from elsewhere. The answer to the question, "What do we *see* in a work of art?" must comply to both of these apparently contradicting conditions. On the one hand, it must leave the work of art as self-sufficient, requiring no borrowed supplement; on the other hand, render intelligible how it came to pass that what we claim "seeing" in a work of art is

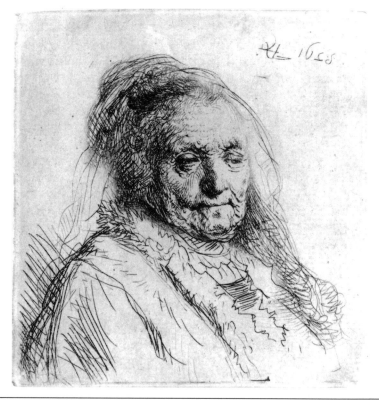

Fig. 3.1 Rembrandt Harmenszoon van Rijn. *The Artist's Mother, Head and Bust:Three Quarters Right* (1628). With kind permission of The Pierpont Morgan Library, New York. RvR470.

derived only from experience that is taken from the sphere of reality as distinct from the artistic realm.

In the face of this problem, one must be clear about what we see in the "real" object. We certainly do not see that which is meant by the entire concept of a fur collar. In plane seeing we have rather an impression of color that is purely optical, and, in the absence of tactile experience, the impression is not three-dimensionally substantial. That the fur collar stands out from its environment as something particular, and, as a unit as such, is also not afforded by merely looking. This is so because seeing displays only the varied colors built up in changing relief, but within a surface image of the respective total field of vision that is in itself continuous. The fur collar, as something meaningful in itself, grasped by, and whose nature is realized in, a unified concept, is the result of deductions and syntheses fashioned by the sense of touch, activities, practical aims, cognitive categorizations — in brief, from a large number of inner factors beyond the optical. We do not *see* that it is a fur collar at all. Rather we have an optical impression that, on the basis of occurrences of quite different origin, we experience or characterize as a fur collar. And only when by the "real" fur collar we understand that whole complex [sphere] of optical *and* tactile, material, and practical occurrences, can we in fact characterize that which is *drawn* as an "appearance." For then one can trust that the drawing seeks to awaken this complete complex just as the image that really belongs to this complex did, and this must clearly mean an illusion because the connections which convey it within the sphere of reality are attached only to that latter visual image, but not to the former. Within these connections and this sphere, the optical image has a particular form. As soon as viewing this stimulates the artist's productivity, however, a structure emerges from it for whose form this productivity alone is responsible. In any case, it follows that this form possesses a relationship with the latter. But just as the fact that a love poem is no less the product of a totally self-contained artistic germ because it is prompted by a real experience of love the content of which is expressed as a poetic form that has nothing to do with the form in which love was experienced within the sphere of reality, so this relationship is not a hindrance to the inner autonomy of the work of art, nor to its self-determination of the inner growth of the former. The *artistic* vision and the arrangement of the structure that, in those three-dimensional and practical spheres is a "real" fur collar, emerges — in

terms of its origin, form, and sense — exactly as autochthon within the artistic spirit and its creative categories, just as the three-dimensional fur collar does within all other genetic and correlative elements by which we label it "real."

The question as to which meaning the content or the object of the work of art really has for the work of art as such demands, I believe, an answer that is underpinned and clarified through this diagnosis. That the theory of *l'art pour l'art* denies every meaning of the object as such so that the painted head of cabbage and the painted Madonna are *a priori* of equal value as works of art was an understandable reaction against art that made itself a medium for anecdotal, historical, or sentimental messages, or which borrowed meaning and value from sublime and profound "ideas" in order to decorate a picture. If the slogan "the head of cabbage and the Madonna" arose as a response to this, then it was justified at least as the negative reaction: it is dishonesty and distortion to smuggle an attraction and meaning into a work of art that is simply transposed from another sphere of value and has not itself been earned on the basis of work done within its own grounds. This is the same kind of illicit acquisition as when a bad dramatist secures interest for his work by introducing great historical personages whom the audiences bring with them into the theater from historical knowledge garnered outside it. The statement "the object of art is irrelevant" has legitimate sense in that the meaning and value that the object possesses on the basis of other — nonartistic — orders, must not be imported into the artistic value of the work, and therefore, are irrelevant to it. That, within the religious sphere, the Madonna is an object of prayer is of as little relevance to the work of art as the fact that, within the sphere of praxis, a head of cabbage is an object of nutrition (irrespective of whether a religious feeling beyond its psychological or ecclesiastical realization can be designated as a content of pure artistic design). This indifference of the object toward its meaning outside art is, however, quite wrongly interpreted as indifference toward the object as a pure content of the work of art within the clear-cut immanence of its artistic use. To declare it indifferent in *this* sense is an arbitrary dismemberment of the unity of the work of art that permits no indifference for any of the elements it contains. It would be very strange if whereas, for example, the material of a drama or epoch can be well or badly chosen, can (according to purely artistic designation) be a superior or inferior, this value of the material should fail for the visual arts. This apparently purely

artistic claim can in reality be traced back to a naturalistic lack of differentiation: one distinguishes the meanings that clothe an object in the category of reality not purely from the functions that it [the object] adopts when formed as a work of art, rejecting the latter because one fears or allows the former to be a contributing factor. The Madonna is clearly not a more "worthy" object of representation because she is worshipped, and the head of cabbage is only eaten, but rather because her representation offers more opportunity for the unfolding of *pure artistic* qualities. Were someone able somehow to claim the contrary consequences for artistic values for these objects, so the head of cabbage would indeed be the worthier pictorial content.

This seems to me to be a quite clear decision as soon as one accepts the basic precondition that reality and art are two coordinated possibilities for shaping the identical content. The resulting structures have no relevance for each other. The orders of values in one category occasionally converge with those of the other; occasionally they diverge. It is therefore just as false to transpose the meanings and shapes of one content, insofar as it is real, into its artistically formed image as it is to make the relationships and values of the latter into properties or criteria of its reality.

This essential equivalence or parallel between the real and the artistic structure does not, of course, suffer because experiencing the former is an empirical-psychological precondition for, and must precede, the individual production of the latter. It is thereby similar to figures in geometric science. The mathematical circle as such has nothing at all to do with round objects in the real world. It belongs to a completely different order and cannot be produced in the empirical-physical one. But probably no one would have hit upon the idea of the mathematical circle were round things not somehow to be seen in the latter. This is equally true of the viewer as it is of the creator. Had one never seen a real fur collar, one would never grasp (just as one would never be able to create) this complex of lines. However, this kind of technical indispensability, as it were, of this mediation does not establish any kind of necessary connection between it and the kind of category that is attained via it. However necessary it might be for accomplishing the jump, the springboard is naturally not the jump's aim. Here lies the most basic error of historicism and psychologism that is repeated in the naturalistic theory of art. With respect to diverse contents, all these intellectual tendencies bear a formal resemblance, namely they bind the specific quality and essence of

an attained result, a being or work that has come into existence, a realized category to the quality and essence that are specific to the conditions and realizing mediations of those achievements. Those theories are ultimately opposed to [the notion that] there might be contents, categories, and worlds — that are not deducible from each other — within the objective realm; and that there might be a genuine creative act in the subjective realm. For them, an existence or a sense, a value or an arrangement, should be nothing other than that which we are presented with by the various phases undergone by that which has come into being. They do not sense that a central autonomous drive exists within every organic and psychological process with which conditions and causes preceding each phase merely cooperate, as it were. The establishment of the real objective does not come from them, but from that internal development. And to construct the latter from individual specifiable conditions, a culture out of economic circumstances, an idea out of experiences, a work of art out of impressions from nature, is no more sensible than developing the fully formed bodily figure out of the foodstuffs *without* which it clearly could not have come into being. The *path* on which we reach the structures of the nonphysical categories has as little to do with the nature of the end that we reach on the way as the mountain path does with the view from the peak. The fur collar in Rembrandt's etching is not, as a photograph would be, a surface picture of that which his mother really wore. Rather, it is exactly as autonomous as the real collar — a structure no less growing from its own roots, so to speak. It is not an "appearance" of a reality. On the contrary, it belongs to the artistic world and to its powers and laws, and therefore is thoroughly released from the alternative reality or appearance. Appearance still belongs to reality, just as a shadow still belongs to the physical world, because it is only through the latter that it exists. Both stand within the same plane although in reverse ratio, as it were. Art, however, lives on a different plane which does not come into contact with the other, even where the artist — just like the viewer — must transverse it to reach the artistic plane. *In* the creation — that in the end exists in independent objectivity — the psychologically prior stages and preconditions are overcome in the process of its creation.

Because from that deepest point out of which art is art at all, art has nothing to do with reality — whereby the question of its relationship to reality is in principle wrongly posed — the contradictory character of the answers to this question becomes

intelligible. With respect to a question that is contradictory in itself, a "yes," just like a "no," can lead up to that point at which one's opponent is refuted, but not to the point where one's own answer is positively vindicated. The division between naturalistic or stylized (idealizing, decorative, phantasmagorical) art has nothing in common with that which is considered here — namely, the distinction between the conception of art as appearance and deduction of reality, and as an autonomous structure: a quintessential primary category. This is because the former question refers only to the particular design *within* art while our question, however, refers to the nature of art as a whole. The first applies to the morphological relationship between the product as it finally exists and the reality which bears the same content. The second [our question] applies to the precondition of all artistic manifestations as such.

It is logical to think of the basic motif of the Platonic doctrine of ideas: the individual observable thing exhausts its essence not in its unique reality; reality is, so to speak, not enough to produce the sense of things and to make them intelligible. Empirical reality is, rather, only the transient form in which the "idea," the true content, the essential sense of the thing, is clad. Now, we want to reject without further ado Plato's metaphysical speculations about ideas, namely that a substantial — yes the "authentic" reality — is attached to them, that they form an inner logical-coherent realm. Their deeper meaning — that things have a sense or content independent of their reality — nevertheless remains intact. But Plato could have taken a further step: the empirical reality is not the only form in which that meaning or content of things is represented to us; that it exists also in the form of art. The real fur collar and the etched fur collar are one and the same essence, expressed in terms of two fundamentally different and independent types. If one can put aside the metaphysical burden of the word, so it is quite legitimate to say that the idea of the fur collar is pronounced by reality and by art as by two languages. That the former is, so to speak, our mother tongue, and that we have to translate the contents of existence or ideas from this language, where we encounter them for the first time into the latter, this psychological-temporal necessity alters nothing of the autonomy and fundamental status of each of the two languages; alters nothing in the fact that each expresses the same content with *its* vocabulary and according to *its* grammar and does not borrow this form from the other [language] despite that psychological

sequential order that, in view of the factual parallelism of both languages, is fundamentally coincidental. The latter [parallelism] is the real basis on which the paradoxical theory could be founded that it is not art that imitates nature, but nature that imitates art.[13] That is to say, in each epoch people see nature in the way their artists have taught them to. We experience our real fates in the way, and with those emotional reactions, that our poets had already anticipated. In the field of vision we glimpse the colors and forms suggested by our respective painters and are completely blind to other inner visual formations, and so on. Whether fully acceptable or not, this reversal of the temporal relationship between the experience of nature and of art is in any case an accurate symbol for the fact that no direction of this relationship is internally necessary, because each of its elements is in itself the autonomous expression of an ideal content that clearly only becomes accessible in the form of some such expression. Art does not elevate itself through an immediate relation to reality — not as a transposition of the surface appearance of reality onto the canvas, but rather both are bound together only through the identity of that content that is in itself neither nature nor art. This is why none of the following expressions applied to the nature of art capture its inner essence: overcoming, redemption, distantiation, conscious self-deception. This is because all these would still be a reduction of art to its relationship to reality, even where this relationship is negative. Indeed, however, this relationship serves only to gain the content which art — when it has first torn the content from the form of reality — forms into an equally deep-rooted autonomous structure just as reality does. That art *provides* relief from reality, is just as secondary as the fact that its psychological genesis requires observing reality.

With this, the question, "What do we really see in art that represents a given reality?" is at last answered. It has been shown that this latter expression does not at all describe the resulting essential manner of art, that it instead makes believe the psychological preconditions of art — the necessary *path* for the creator and the viewer through the form of the content's reality — to be something final. In consequence thereof, there is no option but to declare the work of art as mere appearance garnered from reality and psychologically representing reality. Artistic seeing is not a deviate according to its objective content, but merely according to the psychological sequence of consciousness, and as soon as it is productively and receptively successful, it has left behind the

conditions of its becoming. Alongside the intellectual energies that shape empirical-real seeing, stand, in independent equivalence, those that create the artistic picture, irrespective of whether they are underpinned by deeper psychological or metaphysical layers. Their content is identical where we label it with the same concept without it being "real" within the one and being merely mirrored within the other, and without requiring, in order to exist, transcendental autonomy like the Platonic ideas within the ὑπερουράνιος τόπος [a holy place/a place above the sky]. That which we call reality is also only a category in which a content is formed, thus producing a completely unified structure. Art is no different, and when we see Rembrandt's fur collar, we really see only these particular strokes that do not "represent" a fur collar that exists elsewhere and has been associatively transposed; rather, the strokes "are" just as much a fur collar as "are" the sum of the individual hairs in that worn by Rembrandt's mother. It is only that one must not associate the "are" here with its practical-real meaning, but rather grasp it in the pure sense as it is linguistically used for an etching: "This is a fur collar" or "This is a landscape." Once one has seen through the confusion of the preconditions and developmental stages of creation and perception with its material and definitive sense and content, then it is no longer paradoxical that we glimpse in works of art precisely the opposite and precisely the same as that which we glimpse in reality. It *can*not absorb reality within itself at all because it is already a completely closed experience, completely self-sufficient according to its own laws and therefore excluding every other experience of precisely the same content that as "reality" has become no more and no less self-sufficient.

DOGMATIC CONTENTS

Having established this interpretation of Rembrandtian light as a whole, let us now return to its meaning in religious art as such. With this general interpretation the decisive rejection of all dogmatic content has been accomplished. This is why I know of no paintings in the whole of art, at least until the dawn of modernity, that belong so little to cult — that are so little suited to being church paintings. The totality, the scene in general, remains within the objectively holy tradition as long as the biblical event is still the real object of representation, even if its personal bearers completely transpose its ecclesiastically traditional meaning into the autonomous meaning of subjective religious

being. But even this is now omitted where light is no longer there in order to illuminate that scene, but rather inversely: light in its self-sufficient dynamic, in its depth, in its contrasts, is the object of representation for which the human biblical event is, so to speak, merely the causal occasion. How this is expressed in the individuals, what reaches beyond all dogmatic particularities or even founds them [is] genuine *piety*, the inner existence in its religious meaning as such. So the event as a whole — its historical, religious fixed form — is now reduced to that which is most general: to light manifesting the whole atmosphere, as it were, of a trans-individual soul whose religiosity flows through this portion of the world; a religiosity clearly whose elevations and descents, sorrows and blessedness embraces this as well as every other confessional content because they underpin each as the generality of its nature as such.

This must not be understood as though Rembrandt had created the real and only religious painting. On the contrary, the whole uniqueness of this art only manifests itself in its opposite and the justification of the latter: in *objective religious art* whose precondition is the existence of religious facts and values outside the individual soul. I sketched this contrast earlier, and we now only need to characterize some limits that the religiosity of the individual soul and its expression finds in the fact that it is reduced to itself, and that its religious life is carried out purely internally, and without implied reference to its transcendence. It is a matter not only of art representing for an objective religion the holy creatures and events in their intrinsically meaningful existence freed from their accidental psychological reflexes, but rather is precisely a matter of those subjective processes within the believing soul that are triggered by the emphasis on that otherworldly world; on those objective facts of salvation. Naturally, the figures of Rembrandtian religiosity are filled with otherworldly premonition, certainty, tremulousness, but the transcendent existence that confronts them is not primary for them; it is not, so to speak, that which is substantial in their religious conduct. What remains decisive is always the current that breaks from the soul itself: this own inner being as their religious fate. But precisely because of this, the sphere of psychological experiences in Rembrandt's religious representations has unmistakable lacunae.

In the first place, an essential motif of Christianity is absent: hope, an affect that — clearly only in the sense of a positive relation to the beyond — comes to life in the soul as something that transcends it. While Dante's *Paradise* hovers over all figures in the *Trecento*, and while, in the eccentric motion of the Baroque, people all but soar into heaven, in Rembrandt there is neither hope nor hopelessness. His

figures stand outside this category. The soul has withdrawn from the effusiveness of heaven and hell into that which, in a more immediate sense, is its possession. Likewise, the religious experiences of the need for salvation and of grace are not to be found in these figures. The inner conditions, described in this way, may create themselves out of the soul's internal powers. They gain their specific nature only with the conscious examination of something outside the soul on which they are totally dependent. Here a far-reaching form of human conduct becomes manifest. We may be psychologically persuaded that there is only immanent consciousness for us; that our contents of life are only modifications of the self-consciousness and, metaphysically, that all our experiences and acquisitions of values lie on the path of the soul to itself; that it can find only that which was its own property from the first. But countless times this inner development is nevertheless channeled via something external, and — even accepting that these lie exclusively within it — it cannot attain its aim and its zenith of value directly, but rather can only acquire them via a detour that it acknowledges as external to it. This may be related to the fact that it is the nature of life as such to transcend itself, as it were; to allow each moment to reach beyond itself, as the drive for self-preservation, as procreation, as imagination, and as will. This urge to go beyond itself and to objectify outside itself is to a degree reversed. Once it has taken the path via external and ideal objectivity, life returns back into itself with properties and reactions that may only be valid for it, but that can only be attained or produced by traversing something external. Even accepting that the soul revolves within its own orbit, the oscillation beyond itself, the creation of another, the vis-à-vis, with respect to which the soul only reacts — that would be precisely the form of its inner life. Now there are certainly culminations of the soul that remain totally enclosed within its limits, values of being, of feeling, of the own development, of struggling. And in the atmosphere and intention of such values the religion that Rembrandt expresses occurs. Even if one accepts that in all religions it is in reality a matter of this internality, of a kind of self-sustaining life of the soul, and that all extra-psychological objectivity is merely a myth, reflection, hypostasis, or some such, then it is undeniable that certain purely inner experiences only come into being where that atmosphere of immanence has been broken through, and the soul lives with a centrifugal pull toward objective structures, and in the form of a detour via those structures. Only in this way is there "belief" even where the "religious faith" may be a purely inner-psychological relation. Only in this way can hope and condemnation, salvation and grace dominate the respective religious expression, no

matter whether that opposition which determines all this appears to a nonreligious (e.g., intellectual) standpoint as a structure of the soul itself. This is why the moment of danger is absent in this religiosity. All the frightful uncertainties, the helplessness, the feeling the way in the dark, is not to be found here; not the peril [*Gefährdung*] via the absolute demand coming from beyond that tore Michelangelo's life apart and, in however many variation, was carried through into the lives of his figures. With this no philistine sense of security should be imputed to Rembrandt's figures. It is much more that they stand totally beyond the alternative of temptation and salvation, because both of these, along with all appearances in the series determined by it, only appear with the transposition of life's religious emphasis onto objective religious content. When this emphasis rests on the subjective religious process, however metaphysical and eternal this may appear to be, as soon as the religiosity in its deepest sense precisely does not occur in the form of the opposition of subject and object, the precondition for those affects is absent. This is why the fact that they are not to be found in Rembrandtian art is not a deficiency, but rather the necessary and vindicating consequence of its essence — namely, that it diametrically, and with unique decisiveness and greatness, opposes the types of art of objective religion.

IN CONCLUSION

THE CAPACITY TO CREATE AND TO FASHION

The achievements of intellectual history are shot through with a contrast that can be characterized as that between the capacity to create [*Schöpfertum*] and the capacity to fashion [*Gestaltertum*]. Given a certain extension of these concepts, there is no human work, beyond pure imitation, that is not simultaneously fashioning and creating. Just as we cannot create physical substance (all external action is actually the reworking and reforming of material elements), so there is no activity and work of the mind that does not presuppose some intellectual material or other. On the other hand, however, the capacity to create means bringing into being something that was not yet there, at least in the sense of the refashioning or extension of that which is to hand through the individual's own power that is not deducible from elsewhere. In all such activity can be found an element through which all that is given and handed down is multiplied by a certain amount, and it is this — developed out of that which has been found and inherited — that is the source of the work's unity. This peculiar combination makes humans into historical beings. An animal simply repeats that which its species has done since time immemorial. This is precisely why each individual animal starts from the beginning; from the point where its forbearers had begun. Humans, precisely because they do not merely repeat but create something new, cannot start anew each time. Rather, they need a given material, a given antecedence on which, or on the basis of which, they accomplish their achievements as a reshaping [of the material]. We would not, however, be historical beings were we absolutely creative; were our work to create the new as such. We would then be, so to speak, transhistorical. Nor would we be historical beings without creativity, holding on absolutely to that which is given and its mechanical rearrangement, its reforming in a narrow sense. We call

historical a being that creates something new and *its* own, but on the basis and as the further development and shaping of something that is already to hand and passed down: the organic synthesis of creativity and fashioning that we live.

Having acknowledged this general common foundation, we may now distinguish within it between that which is essentially fashioning and that which is essentially creative in the productivity of human individuals, however difficult it may be to draw this distinction according to objective criteria. Perhaps such criteria are simply not to be found. Rather, perhaps one can only make the distinction clear by pointing to individual cases exemplifying one or the other characteristic. If one examines individual peoples from this perspective, then it is beyond doubt that the classical Greeks must count as fashioning. This, of course, does not distract from the incomparable creative genius of their intellect, but should, rather, only characterize its particular mode of expression. With Indian, as with many later Western European, conjectures one has the impression that they sought to delve into the basis of things in order to allow a new world (that clearly should be in agreement with the given world) to grow out of them. For the Greeks, however, the given world is the irremovable material in whose cognitive and artistic fashioning intellectual effort is exhausted. They need be neither empiricists nor naturalists, since they are in no way satisfied with the given world that is for them the material — the ὕλη [matter] — that they form philosophically and artistically such that it accords with the all-powerful need for vivid unity and a reason that is in harmony with itself. In contrast not only to majesty but also to the contemptuous and negating neglect of the given with which the hieratic art of East Asia and Egypt sets down the products of their fantasies, the Greek always remains a son of the earth. This is so not merely because the never-quite-abandoned given quality of the material constitutes his formative activity, but also because that which is fashioned in this way is itself set into, or should itself bear the character of, the given. The Platonic ideas — as both logical meaning and demanding norm of the earthly — nonetheless forms a *world* beyond the heaven that the soul, in its pre-earthly existence, views as a given on the basis of which it intellectually and practically configures the earthly. Even the affect of love is, for Plato, not a genuine spontaneity of the soul, but rather comes into being because the earthly given reminds us of the original image [*Urbild*] of beauty given within the realm of ideas. The longing of classical Greek thinkers — or, rather, their unshakable dogmatic center — is the being: the solid self-sufficient substance. Under this condition, it is self-evident that their creative activity is confined to

fashioning that which is given. And even their dramatic poetry manifests this characteristic when it makes the ever-new reshaping and reforming of the same handed-down mythical material its task. This is why its drama knows no genuine guilt. The tragic for them is the given. The person is such and such, does or suffers this or that. The problem is merely how their power and their ethos form this given, and how the poet shapes it into a structure. They never descend to the boundless, unyielding base of the never "given" freedom out of which guilt directly springs. The problem of freedom in its full depth never arises for them, because they stand exclusively on the ground of being, and of the given world that the spirit determines via forming.

However much, and however great, the creative power that this shaping presupposes, one can, nonetheless, call another type creative in a specific sense — namely, that whose productive power produces materials and forms of its creations in a stricter unity. With some paradox, one wants to say: [creates them] "out of nothing," because one does not feel here, as with the classical creations, a preexisting given on the basis of which only now a new creating form is reached. Naturally, in any case, the integration of already existing pieces is not excluded, no more than is the work of art's truth to life [*Naturtreue*]: difference of intellectual will, of intention, is not affected by this. Equally, it is self-evident that no historical being is the absolute, conceptually pure embodiment of one of these sides; that not only are there transitional forms and mixtures, but also questionable and ambiguous allocations to the one or to the other often displaying in reality an indeterminacy or reconciliation between the sides of which they as principles themselves know nothing. In certain individuals (and this is particularly instructive) these aspects also come together in the form of constraint and struggle. Michelangelo was certainly the most perfect type of the creator whose world, populated by his creations, grows exclusively out of his own intellect. He formed them, however, according to the norms of classical tradition, and the latter exercised the compulsion on which the impetuousness of his powers of creation constantly broke in that it felt constrained to the point of tragic conflict. Classical design imposed upon him a rule that was intrinsically foreign to him, not merely because he was a Gothic soul, but also in principle, because these forms as such bear the pre-eminent quality of preexisting rule-boundedness that contradicts creative freedom. Despite this, the power of his genius achieved unity in the works. Just as peace is a unified form of heterogeneous elements, so, too, is struggle. What has from the start been found in Michelangelo's figures is the force of a passion breaking from within, wrestling against a strict form,

a dynamic that is formless in itself is placed under the influence of the classical rule-boundedness of the contour; and the unity of the whole is grasped as the moment of the balance of forces between these elements. With respect to the subject, this is nothing other than the simultaneous domination of the antagonistic duo: creativity and fashioning. Raphael, in contrast, does not allow this dualism to be felt. From the beginning, his problem is the reshaping of the given into a world of beauty whose undisturbed nature is guaranteed by laws that are unbreakable due to their natural character. The individual figures appear as though developed out of a general principle of form, just as a logical argument produces a determinate conclusion from two general premises.

Now, the capacity to create, in the narrower sense indicated, is less amenable to analytical description than is the capacity to fashion. This is because its creation does not grow out of specific elements, but rather emerges as an immediate unity out of the deepest, generative basis of the personality. Here there is no law of preexisting forms of any kind that would apply to a given world (whether or not these forms in their turn are products of the mind); there is no substantial general basis of things that fashioning would supply with clarity and reason, as was the case in classical antiquity, in the Renaissance, and also in Goethe. Here life speaks much more in the absolute sense in that it does not stand in any kind of opposition to form, but rather has sprung, as itself, from a form that is attached to it alone and is inseparable from it. With the greatest representatives of this type — with Shakespeare and Rembrandt (the late Beethoven also belongs here, but taking up his example in this context would complicate matters too much due to the particularities of music) — we do not view the figures through a sense or form that could be expressed outside these individual realizations. To see Othello as the embodiment of jealousy, or Macbeth as the embodiment of ambition, makes no more sense than seeing the tower of Strasbourg Minster as the embodiment of the abstract geometrical triangle. Shakespeare and Rembrandt must be characterized as creator, in contrast to the fashioner, not because of their personalities, nor as an expression of their rank in value, but because of the immanent *type* of their creations. Here one may draw into the discussion various ideas about divine power as a clarifying symbol. On the one hand, one imagines divine power as creativity per se, the substance of existence, and likewise its forms and fates, springing from nothing out of the creative act of God. However, because this notion of springing out of nothing presents thought with a problem that can hardly be overcome, so one is inclined, on the other hand, to view substantial being as something that has existed for eternity to which divine power

has lent the form of the given world. In the former case, the unmediated existence of the whole being [*Dasein*] in which matter and form are indivisible is proof of divine creation because this being demands an absolute cause. In the latter case, the law-governed nature and the practicality, the beauties and harmonies, of the world's construction point to a master-builder who has formed existing bare raw material into something meaningful. These are clearly the religious absolutization of that antithesis which, in the sphere of art, is under consideration here.

If we grasp the capacity to create in this specific sense (in a wider sense, as suggested, the capacity to fashion is naturally also creative), so this is really merely a summary of all that which has already been proposed — namely, that Rembrandt is to be located on this side of the opposition. The principle of life, as of individuality, in the meaning granted it here, resists the separation of form from the totality of being [*Seinstotalität*], even if this form is not inherited but is completely original: a self-production. It is sufficient that form within the work has that accent that renders it divisible (even if only as something merely ideally general) from the being of this individual total structure. Where this is the case, form appears more and more to come over a more-or-less willing given material, in this way producing the individual figure; while in the creative act it arises in an immediate unity. Historically, the latter appears more suited to the Germanic spirit, whereby it evidently becomes understandable that for the other type of mentality this spirit appears ungainly — yes, even lacking in style, because style is always something formally general that imposes the law of its appearance upon the real individual thing. And at the same time, we thereby grasp one of the reasons for the inaccessibly of the Germanic character [*Wesen*] to outsiders. General forms of acting and shaping clearly simplify the access to objects. The point at which the Rembrandtian-Germanic sense of individuality is deeply bound to its capacity to create lies in the rejection of the generally valid form (or, what amounts to the same thing, the rejection of that form that is valid in itself). The fact that Shakespeare and Rembrandt often appeared barbaric to classical-oriented times is the artistic metamorphoses of a fundamentally Germanic trait that undeniably appears to the outsider to display a particular clumsiness and formlessness, and which as an artistic metamorphosis emphasizes as well as moderates and reconciles the fundamental opposition. The solitude and inaccessibility of the German spirit that is demonstrated again and again in its relation to the rest of the cultural world is grounded in the absence of that general form that, to a degree, could serve as a bridge to individual reality.

ANTITHESES IN ART

The antitheses between the classical and the Rembrandtian style, just like that between the art of objective and of subjective religion, seem to bring with them the appearance of an antagonism: an inner hostility, a positive mutual exclusion, each [position] standing at the extreme poles of human possibilities as though offering each of us the choice between the one or the other. Here, we now find a highly effective division within the great spheres of intellectual life. Within theory, only *one* truth is recognized. There may be various equally valid paths to truth, but each definitive decision is made in the absolute exclusion of every other answer to the question that has arisen. Practical conduct — determined by emotion and will — sometimes takes this form, radically rejecting one possible route if an alternative decision has already been made. But sometimes we nevertheless attempt to follow two logically contradictory paths, or to arrive at a mixture or compromise between them; or, the decision having been reached, we at least acknowledge the other path as equally possible and equally valid. The antitheses found in art, however, demand a much more peculiar interpretation. For the creator the problem is not discussable precisely because he is simply the creator of one side of the antithesis. But a value judgment [Wertentscheidung] does not appear to be reached merely through a viewer's subjective and irresponsible taste. Rather, by making a judgment we also mean to judge objectively; at least we intend to do so even if we are not free from one-sided emphasis. Even so, the decisive one-sidedness in the mode of experience and in the direction of the style of the work of art still does not contain that partiality, that more-or-less aggressive mutually antithetical emphasis common to all other human expression. A great work of art may represent a conviction or a style that is as radical as can be, but it is never something exclusive that, in rejecting its opposite, still demands it; rather, somehow, the totality of life lies within it, transcending all antitheses. This is inconceivable in logic, but is nevertheless an undeniable possibility in art, namely, that is gushes out of the deepest — yes, the most singular unique — aspect of the personality as its expression, and yet allows this peculiarity to be experienced as a vessel of that which is general and all-unifying as such. That one-sidedness reveals a stream of life [Lebensstrom] for which it — like every other element within the same stratum — is an undulation. There is little that is analogous to this. For example, each nation character, insofar as it is of world-historical significance, bears in its particularity transindividual humanity as such, and this is precisely the condition of its world-historical significance. One can also think of religions and of the absolute that

their respective characteristic historical condition grants. Compared with art, however, religion has a less favorable form. The actual basis of its essence and its becoming as a construct is the absolute. Religion emerges out of and flows back into the transindividual. Wherever it appears as a particularity taking a stand within the relativities of life, wherever it manifests itself in an other-excluding effect or characteristic, it somehow abandons its ultimate meaning. For religion, the unification of transindividuality and individuality is a constriction because religion is grounded in the former. In contrast, for art, whose roots lie in the latter, this self-same unification means an expansion. For the former it is a kind of turning away from its own definitive meaning; for the latter, a step toward it. However one may assess the total values of other spheres in respect to the artistic sphere, of all great areas of intellectual endeavor the possibility to express in the full peculiarity of style, in artistic personality, in individual works, the totality of meaningful existence without contradiction and as though there were no duality, is given to art alone. Here, perhaps, lies one of the deepest symbolizations of the structure of life as such through art. I remind you of the consideration with which these pages began. The life of each person who is the bearer of that life does not have its totality in the sum of its individual moments (nor does one know how that sum is to be arrived at), but rather each moment is the whole life whose essence it actually is to soon be weaker or stronger, colored this or that way, realizing this or that content. Into each of these respective forms the whole of life is poured. There is no life beyond its individual moments; it is, rather, always the one and the whole, however much its continuously alternating forms — according to their conceptually expressible meaning and isolated content — contradict each other, or stand unconnected side by side. And this is carried over into life's artistic expression (which is clearly only valid for that most general level that the antithesis of *specific* affirmation or negation of this mood of life encloses within individual artistic styles). It is only because we are concerned here with a partial area, and with an objectivity that crystallizes out of the life process, that the fashioning of life into individual works of art can be more-or-less complete, and all the more decisive because "life" here has a broader, transindividual, sense. If the content and the functional diversity of the life-moments do not hinder the representation of the respective whole life of the person who bears that life, so each artistic style can be distinguished from all others in terms of its specifiable characteristics, but can still be a vessel whose particular form accommodates the life's totality. Pointing to this perspective will be enough to prevent the suspicion of a mutually hostile scale of values in the contrasts of artistic styles

expounded here. Where this, I admit logically obscure, relationship exists — namely, that each of the parties contain the whole, though not in a conceptual-numerical sense the selfsame, life — it may be necessary to separate them, but not to choose between them.

APPENDIX
WORKS OF ART MENTIONED
IN THE TEXT WITH THEIR DATES AND
CURRENT LOCATIONS

Works by Rembrandt Harmenszoon van Rijn (1606–69)

Title	Date	Location
The Angel Leaving the Family of Tobias (panel)	1637	Musée du Louvre, Paris
The Artist's Mother (etching)	1628	
Belshazzar's Feast: The Writing on the Wall [Mene Tekel]	c. 1635	National Gallery, London
Christ at Emmaus [The Supper at Emmaus] (drawing, paper on panel)	c. 1629	Musée Jacquemart-André, Paris
Christ at Emmaus [The Supper at Emmaus]	1648	Musée du Louvre, Paris
Christ Healing the Sick [The Hundred Guilder Print] (etching)	c. 1649	
Christ and the Samaritan Woman	1659	Gemäldegalerie, Berlin
Christ Preaching [La petite tombe] (etching)	c. 1652	
The Entombment of Christ (etching)	c. 1654	
A Family Group	c. 1666	Herzog Anton Ulrich-Museum, Braunschweig
The Good Samaritan	c. 1648	Gemäldegalerie, Berlin
The Holy Family	c. 1634	Alte Pinakothek, Munich
The Holy Family	1640	Musée du Louvre, Paris
The Holy Family	1645	Hermitage, St. Petersburg

(continued)

Works by Rembrandt Harmenszoon van Rijn (1606–69) (continued)

Title	Date	Location
Homer Dictating Verses	1663	Mauritshuis, Den Haag
The Incredulity of Saint Thomas	1634	Pushkin Museum of Fine Arts, Moscow
Isaac and Rebecca [The Jewish Bride]	c. 1667	Rijksmuseum, Amsterdam
Jacob Shown the Bloodstained Coat of Joseph (drawing, pen, and brown ink)	1653–1657	Fitzwilliam Museum, Cambridge
Landscape with path (drawing)		
The Mennonite Minister Cornelis Claesz. Anslo in Conversation with his Wife, Aaltje	1641	Gemäldegalerie, Berlin
The Militia Company of Captain Frans Banning Cocq [The Night Watch]	1642	Rijksmuseum, Amsterdam
Portrait of a Gentleman with a Tall Hat and Gloves	c. 1658–1660	National Gallery of Art, Washington, D.C.
Portrait of Jan Six	1654	Six Collection, Amsterdam
Portrait of Nicolas Bruyningh	1652	Staatliche Kunstsammlungen Kassel, Germany
Portrait of the Physician, Ephraim Bonus (etching)	1647	
Portrait of the Preacher, Cornelisz Claesz. Anslo (etching)	1640	
Portrait of the Preacher, Cornelisz Claesz. Anslo (drawing)	1640	Muséet de Louvre, Paris
The Rape of Europa	1632	J. Paul Getty Museum, Los Angeles
Ruhe auf der Flucht		
The Resurrection of Christ	c. 1639	Alte Pinakothek, Munich
The Return of the Prodigal Son	c. 1668	Hermitage, St. Petersburg
The Sampling Officials of the Amsterdam Drapers' Guild [The Staalmeesters]	1662	Rijksmuseum, Amsterdam
Saul and David	1650–1655	Mauritshuis, Den Haag
St. John the Baptist Preaching	c. 1634	Gemäldegalerie, Berlin
Self-Portrait	1666–1669	Wallraf-Richartz Museum, Cologne
Self-Portrait with Saskia in the Scene of the Prodigal Son in the Tavern	c. 1635	Gemäldegalerie Dresden

Works by Other Artists

Artist	Title	Date	Location
Botticelli, Sandro (Alessandro di Mariano Filipepi) (1446–1510)	Giuliano de' Medici	c. 1478	National Gallery of Art, Washington, D.C.
Correggio (Antonio Allegri) (c. 1489–1534)	The Holy Night/ Nativity	c. 1530	Gemäldegalerie Dresden
Frescos in the Dome of Parmat Cathedral		1520–1523	
Dürer, Albrecht (1471–1528)	Melancholia (etching)	1514	
Giorgione (Giorgione da Castelfranco or Giorgio Barbarelli) (c. 1478–1510)	Castelfranco Madonna	c. 1506	Castelfranco Venero, San Liberalre
	Portrait of a Young Man	1505/1506	Gemäldegalerie, Berlin
	Portrait of a Young Man (possibly Antinio Broccado)	1510	Szepmuveszeti Museum, Budapest
Giotto (Giotto di Bondone) (1267–1337)	Prayers of the Suitors (fresco)	1304–1306	Cappella Scrovegni (Arena Chapel), Padua
	Scenes from the Life of Saint Frances: 3. Apparition at Arles	1325	Bardi Chapel, Santa Croce, Florence
Grünewald, Matthias (c. 1475–1528)	Isenheim Altar	c. 1515	Musée d'Unterlinden, Colmar, Alsace
	Crucifixion	1523–1524	Badische Kunsthalle, Karlsruhe
Hodler, Ferdinand (1853–1918)	Day	1904/1906	Kunsthaus, Zurich
Holbein, Hans, the Younger (1497–1543)	The Merchant Georg Gisze	1532	Gemäldegalerie, Berlin
Leonardo da Vinci (1452–1519)	Mona Lisa	1503/1506	Musée du Louvre, Paris
	The Last Supper	1495/1497	Santa Maria della Grazie, Milan
Michelangelo Buonarroti (1475–1564)	Sistine Chapel Ceiling	Completed 1512	Vatican City, Rome
Orcagna, Andrea (Andrea di Cione) (c. 1308–c. 1368).	Paradise from the The Last Judgment fresco, Santa Croce Altarpiece	c. 1350	Santa Croce, Florence

(continued)

Works by Other Artists (continued)

Artist	Title	Date	Location
Palma Vecchio (Jacopo Negretti d'Antonio Palma) (c. 1480–1528)	Self-Portrait [probably *Portrait of a Young Man* more usually attributed to Giorgione and thus dated earlier]	1516–1518	Alte Pinakothek, Munich
Raphael (Raffaello Sanzio) (1483–1520)	The Entombment	1507	Borghese Gallery, Rome
	Sistine Madonna	1513/1514	Gemäldegalerie, Dresden
	Christ Handing over the Keys (cartoon)	1515	Victoria and Albert Museum, London
Rodin, (François-) Auguste- (René) (1840–1917)	Burghers of Calais	1886	Calais
Rubens, Peter Paul (1577–1640)	Ildefonso Altar	c. 1630–1632	Kunsthistorisches Museum, Vienna
Simone Martini, (Simone Memmi/di Martino) (c. 1280–1344)	Madonna Laura	c. 1340	lost
Titian (Tiziano Vecellio) (c. 1485–1576)	Portrait of a Man (Ariost)	c. 1512	National Gallery, London
	Portrait of a Man [Young Englishman]	c. 1540	Palazzo Pitti, Florence
	Assumption of the Virgin [Assunta]	1516–1518	Santa Maria Gloriosa dei Frari, Venice
Velázquez, Diego Rodríguez de Silva y (1599–1660)	Pablillos de Valladolid	1634	Museo del Prado, Madrid
	Pope Innocent X	1649–1650	Galleria Doria-Pamphili, Rome
	The Family of Philipp IV [Las Meninas]	1656	Museo del Prado, Madrid
	The Duke Olivarez on Horseback	1634	Museo del Prado, Madrid
	Portrait of a Gentleman, Probably Juan de Mateos	1631–1632	Gemäldegalerie, Dresden

NOTES

Notes to Editors' Introduction

1. From Schiller's "*Durch das Morgentor des Schönen drangst Du in der Erkenntnis Land*" in *Die Künstler* (1789).
2. This is our translation, as the standard English translations are rather loose at this point. The original reads: "Aber auch hier tritt hervor, was überhaupt nur die ganze Aufgabe dieser Betrachtungen sein kann: daß sich von jedem Punkt an der Oberfläche des Daseins, so sehr er nur in und aus dieser erwachsen scheint, ein Senkblei in die Tiefe der Seelen schicken läßt, daß alle banalsten Äußerlichkeiten schließlich durch Richtungslinien mit den letzten Entscheidungen über den Sinn und Stil des Lebens verbunden sind" (Simmel 1995 [1903], 122).

Simmel's Notes to Chapter 1

i. Especially in relation to this characteristic emphasis of expression, it is particularly telling that in some forged drawings the affects are presented with exceptional — yes, crass — clarity. The forger obviously believed that through this vehemence of expression he would infuse the pages with Rembrandtian inner quality with the greatest possible emphasis and conviction. But precisely thereby the forger gives himself away: the insistent openness of the inner expression makes precisely the purity and the indivisible framings of the Rembrandtian expression of affect all the more unmistakable, such that the all-too obvious psychology of these pages would justify their rejection.

ii. Particularly informative here is the psychological fact that we speak of a "shocking similarity," with respect to some portraits, but never say this of a photograph. This can occur when and because a portrait confronts us with the immediate and, so to speak, irresistible reality of the model. We feel a sense of horror (*Goethe* in this case spoke of "apprehension") if a particular order of things is disrupted by the incision of a phenomenon from a completely different order. The reality of the living and the ideality of the work of art characterize two separated worlds, and a piece from the one suddenly confronts us in the other like a ghost, only, so to speak, in an inversion. The photograph cannot catch us out with such a shock, because it does not belong to the abstract order of art but rather from the start wants nothing other than to lead us psychologically to an impression of reality.

iii. Here artistic naturalism is neither intended nor involved. Rather, the decision for or against this is completely indifferent toward the question as to whether the work of art possesses its sense in its pure immanence or as a means to represent the reality of the

model. This is because, on the one hand, the purely artistic intention, which closes up the meaning of the work within its frame, might be committed to a realistic representation — and to the most precise reproduction of reality, thereby thinking that it has attained the inner perfection, even of the absolutely self-sufficient work of art. On the other hand, the artist who wants to lead to the visualization of the model does not have to aim to reach a true representation of it merely via a realistic conception. Rather, he might want to produce its most precious and, in the deepest sense, correct, image just by stylizing or embellishment, of perhaps even by exaggeration and caricature.

iv. Exempt from the genuine character of his art are several Italianate works of which *The Hundred Guilder Print*, due to its popular success, is the most notable. The significance and value of Rembrandt's etchings are not at all easy to grasp. For the assessment of *The Hundred Guilder Print* the way is accessible to most people because it approximates the Classical form to which—as its dominant and educating potency—the European artistic sensibility is adjusted. So far insufficient attention has been paid to this character of the sheet. Here the geometrically clear construction; here the "beautiful" folds of the cloths (particularly clear with the kneeling woman); here the representative posture of the figures which always remind us a little of the "living picture," here the clarity of this one conceptually graspable life moment of each of them is acquired at the price that the dark flowing totality of life is reduced to it. Something of the tragedy of the German spirit, which its relationship to the Classical-Roman, produced again and again, lies in the fact that the most valued Rembrandt sheet is exactly the one in which the pure Rembrandtian spirit is least evident.

Editors' Notes to Chapter 1

1. *Aus Meinem Leben. Dichtung und Wahrheit*, Part 2, Book 6, *Goethes Werke*, Weimar Edition, Volume 27, 23.
2. *Belshazzar's Feast: The Writing on the Wall* (c. 1635). "Mene, Mene, Tekel, Upharsin" were the words written on the wall (Book of Daniel, 5).
3. C. 1634.
4. "Intuition" is the standard translation of Kant's term *Anschauung*, and "intuitive" of *anschaulich*. We have followed this convention.
5. Presumably a reference to Kant's *Critique of Pure Reason*, I The Transcendental Doctrine of Elements; Second Part: Transcendental logic; Introduction: The idea of a transcendental logic: I. On logic in general. Both the Kemp Smith translation (1929, 93) and the Cambridge edition (1998, 193–194) translate the relevant passage as, "Thoughts without content are empty, intuitions without concepts are blind."
6. From Schopenhauer, *Die Welt als Wille und Vorstellung*, Volume 1, Book 3 ("Die Welt als Vorstellung zweite Betrachtung"), §36.
7. There are a number of portraits by Velázquez of Duke Olivarez, the best-known of which is *The Duke Olivarez on Horseback* (1634).
8. *Portrait of a Gentlemen, Probably Juan de Mateos* (1631–1632).
9. *Pablillos de Valladolid* (1634).
10. A reference to any of a number of Velázquez's paintings of court dwarfs.
11. Since the nineteenth century, the popular name for the portrait showing a couple thought to be dressed as the Old Testament figures Isaac and Rebecca (Genesis, 26).
12. "Die and become!" from Goethe's poem "Selige Sehnsucht," "Moganni Nameh: Buch des Sängers" from the *West-östlicher Divan* (1819). *Goethes Werke*, Weimar Edition, Volume 6.
13. From the title (Joseph's Bloody Coat) and from Simmel's description, this may be a reference to the drawing *Jacob Shown the Bloodstained Coat of Joseph* now in the

Fitzwilliam Museum, Cambridge. However, this drawing (which may be the school of Rembrandt) was at the time in the possession not of the Earl of Derby, but of the painter and President of the Royal Academy Sir Edward J. Poynter. Our thanks to the Fitzwilliam Museum for this information.

14. *Critique of Practical Reason*, Part I, Book II, Chapter II, §iv. The translation used here is from the Cambridge edition, edited and translated by Mary Gregor. Simmel has cut the quotation. The whole reads: "*The Eternal being*, to whom the condition of tempo-rality is nothing, sees in what is for us an endless series the whole of conformity with the moral law, and the holiness that his command inflexibly requires in order to be commensurable with his justice in the share he determines for each in the highest good is to be found whole in a single intellectual intuition of the existence of rational beings" (1997 [1788], 103).

15. He is referring here to the depiction of the crucifixion (1523–1524) in the Badische Kunsthalle, Karlsruhe, referred to later in the text as the *Karlsruhe Crucifixion*.

16. By Giorgione.

17. The popular name for *The Militia Company of Captain Frans Banning Cocq*.

18. We have been unable to trace the source of this quotation, which Simmel also used on other occasions, in other texts.

19. *Scenes from the Life of Saint Francis: 3. Apparition at Arles*, Santa Croce (Bardi Chapel), Florence.

20. *Prayers of the Suitors* in the Cappella Scrovegni (Arena Chapel), Padua.

Simmel's Notes to Chapter 2

i. That the facades of secular buildings developed relatively late architecturally — in any case first during Christian times, and then with full force in the court building of the Baroque period — is the consequence of parallel motives that may in essence be of a practical nature.

ii. I shall later discuss the restricted sense of individualization, especially in his religious painting vis-à-vis the portraits.

Editors' Notes to Chapter 2

1. Nor does the term translate well into English, hence the increasingly common usage of the German word in English. The *Oxford-Duden Dictionary* suggests "snugness," "informality," "unhurried." *Gemütlichkeit* also has strong connotations of cosiness, homeliness, etc. (cf. *Geborgenheit*). Persons as well as situations can be characterized as *gemütlich* or *ungemütlich*. The stem word is *Gemüt* meaning soul or mind, or, in everyday usage, (a person's) nature, disposition, mood. For a discussion of the philo-sophical connotations and ambiguities of the term *Gemüt*, see Caygill 1995, 210–213.

2. The will of all and the general will. Rousseau draws this distinction in Chapter Three of *The Social Contract*: "There is often a great deal of difference between the will of all and the general will; the latter considers only the common interest, while the former takes private interests into account, and is no more than the sum of particular wills [. . .]" (Rousseau 1973 [1762], 185).

3. *Schuld* means both "guilt/blame" *and* "debt." See Nietzsche's *On the Genealogy of Morals*, Second Essay, §4.

4. *Self-Portrait with Saskia in the Scene of the Prodigal Son in the Tavern*, 1632. See cover.

5. He is referring here to the *Self-Portrait* of 1666–1669 now in the Wallraf-Richartz Museum, Cologne. See p. 75.

6. *Das Stunden-Buch*, Book Three (1905). Oh Lord, give each a death of his own/The dying that emerges out of that life/In which he had love, meaning, and need.

7. *Portrait of a Man (Ariost)*, c. 1512.
8. *Wilhelm Meisters Lehrjahre*, Book 7, Chapter 5 (1797). Goethes Werke, Weimar Edition, Volume 23, 40.
9. Popular name for *The Sampling Officials of the Amsterdam Drapers' Guild* (1662).
10. The later of two depictions of David playing the harp to Saul (I Samuel 16:23).
11. However much altered, nature is beautiful (attributed to Leonardo da Vinci).
12. More usually, Simone Martini.
13. The second verse of Sonnet no. 77 (*"Per mirar Policleto a prova fiso"*) from Petrarch's Rime in vita e morta di Madonna Laura (Canzoniere), c. 1327. We have given a close-to-text rendering of the German translation used by Simmel. The original reads: "Ma certo il moi Simon fu in paradiso,/onde questa gentil Donna si parte;/ivi la vide e la ritasse in carte,/per far fede qua giù del suo bel viso."
14. We have been unable to trace this quotation, which Simmel gives only in German and without the reference, but it is almost certainly from one of Michelangelo's poems, as Simmel quotes both the Petrarch and the Michelangelo in a much earlier article on Michelangelo as poet written for the *Vossische Zeitung Berlin* in 1889 (Simmel 1989).
15. *Portrait of a Gentleman with a Tall Hat and Gloves*, c. 1658–1660. Now in the National Gallery of Art, Washington, D.C.
16. The Berlin portrait is *Portrait of a Young Man*. The "self-portrait" by Palma Vecchio to which Simmel refers is probably the *Portrait of a Young Man* in the Alte Pinakothek in Munich. The painting is in fact attributed to Giorgione, but has been thought by some to be by Palma Vecchio.
17. *Schriften zur Kunst 1800–1816. Maximen und Reflexionen über Kunst. Aus Dem Nachlaß [Schönheit der Jugend aus Obrigen abzuleiten]. Goethes Werke.* Weimar Edition, Volume 48.
18. *Homer Dictating Verses* (1663).
19. This is presumably a reference to the etching or drawing (both 1640) *Portrait of the Preacher, Cornelisz Claesz. Anslo* (1641), or to the painting *The Mennonite Minister Cornelis Claesz. Anslo in Conversation with his Wife, Aaltje* (1641) now in the Gemälde-galerie, Berlin.
20. By Raphael (1513/1514).
21. "With eyes fixed on the sky", Dante, *The Divine Comedy, Purgatory*, Canto 15.
22. To take us in. Michelangelo poem 285 (1967).
23. "*schlechtrassig jüdisch…*" could be translated as "racially inferior Jewish…," but to do so now would be to locate it very specifically within the vocabulary of National Socialism.
24. Only in accordance with the laws of one's own nature. Presumably a reference to Spinoza's *Ethics* (Part One, Proposition xvii): "*Deus ex solis suae naturae legibus et a nemine agit*" (God acts only in accordance with the laws of His own nature, and is compelled by none).
25. "Chanson d'automne" (Autumn Song) from *Poèmes saturniens* (1866). "And so I leave/On cruel winds/Squalling/And gusting me/Like a dead leaf/Falling". This is Martin R. Sorrell's translation from Paul Verlaine, *Selected Poems*, 1999, 25–26.

Editors' Notes to Chapter 3

1. Gian Paolo Oliva (1600–1681). Jesuit scholar and cleric. Vicar General (1661), Superior General (1664) and Papal Orator. Apostolic Preacher of the Palace under Pope Innocent X and three succeeding popes.
2. Probably a reference to *The Angel Leaving the Family of Tobias* (1637).
3. A number of depictions would fit this characterization including *The Holy Family* of c. 1632 (Alte Pinakothek), that of 1640 (Louvre), and that of 1645 (Hermitage).

4. Sermon for the second Sunday after Epiphany on the text John 2: 1–11 (the wedding at Cana) from Luther's Church Postal of 1525. The original reads: "Knecht und Magd, genau so, wenn sie tun, was ihre Herrschaft sie heißt, so dienen sie Gott, und, Wenn sie an Christum glauben, gefällt es Gott viel besser, wenn sie auch die Stube kehren, oder Schuhe auswischen, denn aller Mönche Beten, Fasten, Messehalten und was sie noch alles für hohe Gottesdienste rühmen."

5. *Maximen und Reflexionen über Literatur und Ethik. Aus Wilhelm Meisters Wanderjahre*, Book II, Ch. 11 (1821, revised edition 1829). *Goethes Werke*. Weimar Edition, Volume 42, 178.

6. John 13/Matthew 26 (cf. Mark 14 and Luke 22).

7. From the fresco *The Last Judgment*, Santa Croce, Florence.

8. *Assumption of the Virgin* (1516–1518).

9. Liberal Dutch Protestant fellowship formed around Leiden (Warmond and Rijnsburg) in the 1620s (see Israel 1995). Like the Baptists, the Collegiants practiced adult baptism, while, like the Quakers, they were opposed to organized church religion. Israel quotes John Locke (1684): "they admit to their communion all Christians and hold it our duty to join in love and charity with those who differ in opinion" (Israel, 395). Rembrandt is said to have had sympathy with the principles and practices of the Collegiants (Schama 1988, 122).

10. On the *Isenheim Altar* (c. 1515), Colmar.

11. *Crucifixion* (1523–1524), Badische Kunsthalle, Karlsruhe.

12. The only Rembrandt painting with this title (*Rest on the Flight [to Egypt]*, 1647) is in the National Gallery of Ireland, but this work was never in the Haag. Our thanks to the National Gallery for this information. It could thus be one of a number of depictions of the flight to Egypt.

13. A view famously expressed by Oscar Wilde in the dialogue *The Decay of Lying* [1891] (1991). Warning against the "careless habits of accuracy" (74), Vivian, one of the two characters, declares, "Paradoxical as it may seem [...] it is none the less true that Life imitates art far more than Art imitates life" (87). Simmel's following sentence closely echoes Vivian's further assertion that "Life holds the mirror up to Art, and either reproduces some strange type imagined by painter or sculptor, or realizes in fact what has been dreamed in fiction" (90–91), and, in line with an antirealist view, "Art never expresses anything but itself" (93). Wilde's objections to the (social) realism of the modern novel are also in some respects similar to Simmel's criticisms of photography in Chapter One. The dialogue was influenced by Wilde's teacher, Walter Pater, whose antirealism is again close to, though perhaps more extreme than, Simmel's here (see Pater, *The Renaissance* 1986 [1873]). Pater also shared Simmel's concern with the alleged differences between the "southern" (Italian/Romanesque) and the "northern" (Teutonic) aesthetic — see especially the first chapter of *The Renaissance*.

REFERENCES FROM EDITORS' INTRODUCTION AND NOTES

Bourdieu, P. 1993. Principles for a sociology of cultural works. In *The Field of Cultural Production*, edited by R. Johnson. Cambridge, England: Polity Press.

Caygill, H. 1995. *A Kant Dictionary*. Oxford: Blackwell.

Gassen, K. and Landmann, M., eds. 1958. *Buch des Dankes an Georg Simmel*. Berlin: Duncker & Humblot.

Goethe, J.W. 1995. *Goethes Werke (Weimarer Aufgabe)*. Cambridge, England: Chadwyck-Healey (also at http://goethe.chadwyck.co.uk).

Hollis, M. 1998. *Trust within Reason*. Cambridge, England: Cambridge University Press.

Israel, J.I. 1995. *The Dutch Republic: Its Rise, Greatness, and Fall 1477–1806*. Oxford: Oxford University Press.

Kant, I. 1929 (1781/1787). *Critique of Pure Reason*, translated by Norman Kemp Smith. London: Macmillan.

Kant, I. 1998 (1781/1787). *Critique of Pure Reason*, translated and edited by Paul Guyer and Allen W. Wood. Cambridge, England: Cambridge University Press.

Kant, I. 1997 (1788). *Critique of Practical Reason*, edited and translated by Mary Gregor. Cambridge, England: Cambridge University Press.

Michelangelo. 1967. *Rime, di Michealangelo Buonarroti*. Bari: Universal Laterza. 1st electronic edition, 2nd April, 1998: http://www.liberliber.it/biblioteca/b/buonarroti/rime/html.

Nietzsche, F. 1996 (1887). *On the Genealogy of Morals*, translated by Douglas Smith. Oxford: Oxford University Press.

Pater, W. 1986 (1873). *The Renaissance: Studies in Art and Poetry*. Oxford: Oxford University Press.

Rilke, R.M. 1962 (1905). *Das Stunden-Buch*. Frankfurt am Main: Insel-Verlag.

Rousseau, J-J. 1973 (1762). *The Social Contract*. In *The Social Contract and Discourses*, translated by G.D.H. Cole. London: Everyman's Library, J.M. Dent & Sons.

Schama, S. 1988. *The Embarrassment of Riches: An Interpretation of Dutch Culture in the Golden Age*. Berkeley: University of California Press.

Schama, S. 1999. *Rembrandt's Eyes*. London: Penguin.

Schopenhauer, A. 1986 (1819). *Die Welt als Wille und Vorstellung*, Volume 1. Frankfurt am Main: Suhrkamp Verlag.

Simmel, G. 1989 (1889). Michelangelo als Dichter. In *Georg Simmel Gesamtausgabe*, Volume 2. Frankfurt am Main: Suhrkamp Verlag.

Simmel, G. 1989 (1890). Über soziale Differenzierung. In *Georg Simmel Gesamtausgabe*, Volume 2. Frankfurt am Main: Suhrkamp Verlag.

Simmel, G. 1989 (1892). Die Probleme der Geschichtsphilosophie. In *Georg Simmel Gesamtausgabe*, Volume 2. Frankfurt am Main: Suhrkamp Verlag.

Simmel, G. 1990 (1900). *Philosophy of Money*, translated by T.B. Bottomore and D. Frisby. London: Routledge.

Simmel, G. 1995 (1903). Die Großstädte und das Geistesleben. In *Georg Simmel Gesamtausgabe*, Volume 7. Frankfurt am Main: Suhrkamp Verlag.

Simmel, G. 1996 (1911). *Rodin (mit einer Vorbemerkung über Meunier)*. In *Georg Simmel Gesamtausgabe*, Volume 14. Frankfurt am Main: Suhrkamp Verlag.

Simmel, G. 2003 (1913). *Goethe*. In *Georg Simmel Gesamtausgabe*, Volume 15. Frankfurt am Main: Suhrkamp Verlag.

Skinner, Q. 1969. Meaning and understanding in the history of Ideas. *History and Theory* 8:3–53.

Spinoza, B. 1996 (1677). *Ethics*, translated by Edwin Curley. London: Penguin.

Verlaine, P. 1999. *Selected Poems*, translated and with an introduction and notes by Martin R. Sorrell. Oxford: Oxford University Press.

Wilde, O. 1991 (1891). The Decay of Lying. In *Oscar Wilde: Plays, Prose, Writings and Poems*. London: Everyman's Library, David Campbell Publishers.

INDEX OF NAMES AND WORKS